Photography

the art of composition

Photography
the art of composition

Bert Krages

ALLWORTH PRESS
NEW YORK

09 08 07 06 05 5 4 3 2 1

Published by Allworth Press
An imprint of Allworth Communications
10 East 23rd Street, New York NY 10010

Cover design by Derek Bacchus
Cover photo credit: Bert P. Krages II
Page composition/typography by Bert P. Krages II

Library of Congress Cataloging-in-Publication Data

Krages, Bert P.
 Photography: the art of composition / Bert P. Krages II.
 p. cm.
 Includes index.
 ISBN 1-58115-409-7
 1. Composition (Photography) I. Title.

TR179.K73 2005
771—dc22

 2005007652

Printed in Canada

To Kathryn and Meredith

Thank you for your patience

Table of Contents

Acknowledgments

I wish to express my appreciation for some of the people whose efforts and contributions helped me immensely with the book. Daryl Stewart deserves recognition because his quest for expansive landscapes exposed me to the many smaller scenes in which I found inspiration for much of the material in the book. Likewise, I am much indebted to John Kirkley, whose broad knowledge of things artistic and literary was immensely helpful. Special kudos go to Charis Barasch, whose approach to teaching drawing showed me that learning to see allows a person to understand the world in a totally different way.

I also thank the staff at Allworth Press for their assistance; Nicole Potter, for understanding the purpose of the book; Jessica Rozler, for her thoughtful editing; Derek Bacchus, for his insight regarding design; and Nana Greller, for her efforts at getting the word out. Their patience and guidance are much appreciated.

I would also like to thank my parents, whose gift of a Yashicamat 124G when I was in high school got me started in photography in a serious way. Finally, I thank my wife Kathryn and daughter Meredith, who have enriched my life in so many ways.

1

The Importance of Visual Skills

Seeing is the ability to observe what is before the photographer and visualize how it will appear in an image. It is the most fundamental skill because it not only determines which visual elements will appear in an image, but also influences the decision to make the image. Many people believe that seeing is a mysterious gift, the so-called "artist's eye." The reality is that almost anyone can learn seeing, particularly when they understand the basic processes by which the brain perceives visual information.

For most people, the difficulty in seeing originates from a tendency to rely on analytical processing by the left hemisphere of the brain to interpret visual information. Unlike the right hemisphere, which processes visual information as it appears, the left hemisphere abstracts information and symbolizes it. When processing visual information using the left hemisphere, people register the objects they are looking at but do not really perceive them as they actually appear. For example, they will perceive telephone poles as perfectly vertical even when they are slanted one or two degrees. People are fully capable of seeing objects as they actually appear, but many need to train themselves to use the cognitive functioning of the brain's right hemisphere more effectively.

Compared to the many other skills associated with photography, seeing is relatively easy to improve but, ironically, can be one of the biggest challenges to a photographer. Seeing is easy to improve because it generally only requires the

photographer to shift into the cognitive form of visualization that is controlled by the right hemisphere of the brain. The challenge comes from the fact that most people are educated in matters that require left hemisphere skills and have not been taught skills that engage the functions of the right hemisphere. Also, developing the ability to perceive diverse elements such as shapes, emotions, temporal change, and metaphor as a unified whole seems daunting at first but becomes fairly effortless once you achieve a certain proficiency at seeing.

Composition is the arrangement of visual elements so they agreeably present themselves when viewed as a whole. Many people consider composition to be distinct from seeing, but this book works from the premise that composition is so intermeshed with seeing that the two are best learned concurrently. While it is true that engaging in composition prior to seeing can be problematic, the brain can largely perform seeing and composition simultaneously. In this framework, there is really no need to engage in composition as a sequential analytical process. Likewise, once seeing skills are sufficiently honed, good composition can be realized by evaluating images as wholes rather than applying rules and guidelines to their individual elements.

Learning to See

Photographers can learn a lot about seeing and composition from fine artists who work in other

two-dimensional media. One of first areas to examine is the learning process itself. Visual artists, when learning to draw and paint, immediately recognize the need to improve their perceptual abilities. This is because they work in media where the values are placed by hand onto a blank surface. Unless they learn to perceive how objects actually appear, it is nearly impossible to depict them realistically. Photographers are less likely to recognize this kind of problem with perception because cameras automatically address visual issues such as contour, perspective, and value. By subsuming the mental tasks associated with rendering scenes, the camera can mask areas where improvement of visual skills is desirable.

The camera's ability to record visual features without human cognition of the scene has markedly affected how photographic composition is taught. Since the end of the nineteenth century, when photography became feasible for the masses, photographic composition has generally been taught as the application of design principles from the graphic arts. These concepts range from the very basic, such as the "rule of thirds" and "s-curves," to the more esoteric, such as "notan," which is a term from Japanese art that pertains to the balance of dark and light masses. Traditional art skills such as discerning edges, determining proportions, and judging perspective have not been taught to photographers because they are largely unnecessary to the process of fixing a photographic image. However, most artists learn to see by practicing these skills.

A major difference between the graphic arts and fine arts is that graphic arts education emphasizes the expression of concepts through visual images over the realistic depiction of objects. Graphic design principles are particularly useful for communicating abstract concepts such as "calm," "uneasy," and "velocity." Such principles can be and often are applied to photographs

and are likewise used to varying extent in abstract art. However, achieving the sense of realism associated with traditional forms of fine art requires cognitive skills that differ from those required for graphic design. The "something more" aspect is the ability to perceive the elements in a scene and depict them on a two-dimensional surface.

The problem many people have with perception has been explained by neuropsychologists. Their research has shown that the model of the eye as a camera that sends images to the brain is largely false. Instead, the eye and brain work together in several ways that provide the brain with the information it needs, depending on the tasks before it. Much of the time, the eye-brain combination disregards most of the visual information collected by the eye. For example, if you are reading a book, you probably are not conscious of the gutter where the pages connect, the margins surrounding the text, your hands, or the table on which the book is resting. Reading is an analytical skill in which the brain assembles the visual elements produced by letters and abstracts them into conscious thoughts. When people read, their brains register the thoughts abstracted from the words and suppress the extraneous visual elements from conscious thought. On the other hand, if you are looking for the attributes that distinguish one style of typeface from another, you are unlikely to be conscious of the thoughts expressed by the letters but, instead, become cognizant of features, such as the serifs, weight, and descenders, that make up the type.

Most of the time, limiting conscious perception to the elements that are relevant to the task at hand is a good thing. Otherwise, you would suffer from information overload. However, the brain's propensity to process information analytically can present a problem to photographers. Analytical tasks such as reading and mathematics rely extensively on symbols and the discretionary

elimination of sensory clutter. Since this kind of thinking acts to suppress visual perception, it can impede acquiring proficiency in the visual arts. When people become conditioned to relying on symbols to discern their environment, they tend to overlook visual details and misconstrue spatial relationships. For example, when asked to sketch a human face, most people will place the eyes in the upper third of the skull, although they are almost always located near the middle level. If you want to test whether your brain has the tendency to rely on symbols instead of reality, try sketching a face, working from a real person or a photograph, and see how well you do.

The inability to shift readily into a cognitive perception mode can present problems during photography. One problem is that perception is needed to ascertain the visual opportunities to take photographs. For example, photographers who want to photograph insects will not be very successful if they cannot find insects to photograph. However, one of the ironies of cognition is that while insects are the most abundant form of animal life, many people can go days without consciously noticing any. Typically, the problem is mostly not knowing how to look for insects rather than not knowing where to look. Unless the brain is cognitively attuned to insects, it will often fail to consciously register information that there are insects within the field of vision.

Another common problem with perception is the failure to notice important detail. In this aspect, photography is more difficult than visual arts such as drawing and painting because the camera records the objects in front of the lens irrespective of whether or not the photographer notices them. For example, if an artist drawing a flower fails to see lint stuck between the petals or on the stem, it will not show up in the drawing. Photographers do not have the luxury of unconscious omission. This is the reason why many

The brain has a natural tendency to filter out what it considers to be extraneous visual information. Failing to notice small details when taking photographs, such as the lint on the lower petals of this black-eyed Susan (Rudbeckia hirta) is a common problem caused by not sufficiently engaging the brain's perceiving mode.

photographers fail to notice objects in backgrounds and foregrounds that end up detracting from their images.

A related problem caused by the brain's left hemisphere abstracting mode is the omission of elements that were intended to be placed into a photograph. A classic error is failing to include a person's feet in a photograph when the intent is to take a full-length portrait. The brain registers that the person is encompassed by the viewfinder, but unless it goes into the perceptual mode, it does not register that the feet lie outside the frame of the image.

Although Western education has traditionally emphasized analytical skills such as reading, writing, and math, it is not difficult to develop one's perceptual skills. The landmark work in this area is the popular art education book, *Drawing on the Right Side of the Brain*, by Betty Edwards, a professor emeritus at California State University,

Long Beach. Her book explains how the left hemisphere of the brain is responsible for analytic thought and the processing of symbols, and the right hemisphere is responsible for spatial cognition and intuitive functioning. By integrating the principles of neuroscience into art education, she found that almost anyone can learn to draw realistically through a series of exercises that cause students to shift from the left hemisphere mode of thinking to that of the right hemisphere. Professor Edwards' exercises progress through five skills needed for drawing realistically:

- the perception of edges
- the perception of spaces
- the perception of relationships
- the perception of lights and shadows
- the perception of the whole

Photographers also need to acquire these skills, although the reasons differ somewhat from those associated with persons learning to draw. In photography, the camera handles the delineation of edges without inviting mental effort on the part of the photographer. Nonetheless, skill at perceiving edges is important to photography because it is needed to recognize the details that will augment or detract from the image. It also helps to discern how shapes will relate to each other after the camera makes the visual translation from three to two dimensions.

The perception of edges is also one of the skills in which the abstracting and symbol imposing abilities of the left hemisphere of the brain are most apt to interfere. When this happens while drawing, it typically results in a work that does not look very realistic. In such cases, artists can reevaluate the scene, erase the incorrect areas, and redraw. Repeated observation and revision thus serve to improve perceptual skills. Unfortunately, the intrusion of the left brain into photography is more difficult to detect, because realism is not dependent on seeing.

The ability to perceive spaces is of equal importance in drawing and photography. Many photographers are not even aware that there are two kinds of spaces to perceive. Positive space is the shape of a tangible object, and negative space is the space that surrounds it. Proficient artists constantly make use of negative space because depicting the negative spaces often results in more accurate depictions of objects and their relationships to each other. Developing the ability to perceive negative spaces in photography is just as important, even though the camera automatically takes care of the accuracy issue. The reason is that the size, shape, and distribution of negative spaces frequently dominate compositions. When adequate attention is given to the negative spaces, the basic composition will usually take care of itself. Negative spaces can be used to accomplish many things, such as evaluating the composition of moving objects, heightening the awareness of extraneous objects in the foreground and background, and discerning the existence of mergers where a background object appears to be superimposed onto the subject.

The perception of relationships is as critical to photography as to drawing, possibly even more so. When drawing, artists invariably move their heads around a little bit, which results in minor variations to the viewpoint and perspective. When working from real subjects, this can cause artists to vary their seeing, and allows for some refinement as they proceed with the drawing. Because the camera records relationships as they exist at the time of exposure, subsequent adjustments to relationships are impossible.

The perception of light and shadow presents something of a dichotomy in photography. In one sense, the camera is a highly proficient tool when it comes to recording tonality. The variety of tonal values in simple photographs will usually far exceed those found in very complex drawings

4

and paintings. On the other hand, the human eye can discern much more detail in shadows and highlights than photographic equipment can record. Although this limitation can sometimes be used to advantage—the zone system of exposure being one example—photographers still need to understand that film will record shadows and highlights differently than the way they are seen. Perceiving light and shadow becomes an important skill not only for recognizing the visual information in a scene but also in predicting what information will and will not be recorded in the final image.

Perception of the whole is of equal importance to drawing and photography, although its influence on each medium differs. When drawing, the general process begins by putting down the arrangement of edges in conjunction with their relationships to each other. The remainder of the process involves working on details while occasionally "stepping back" and assessing how the drawing is developing as a whole. By using this process, the artist creates a framework in which the drawing matures over time. With photography, the whole is captured when the shutter is tripped, and relationships between objects can afterwards be modified to a much more limited extent through means such as cropping. Recognition of the whole frequently requires rapid judgment, in which case there is little opportunity for progressive feedback. However, developing the ability to perceive scenes as wholes gives photographers an enormous advantage over other visual artists when it comes to eliciting images from dynamic settings. For example, the pattern of footfalls by galloping horses was not accurately known until Eadweard Muybridge made sequences of photographs that showed the progression of movement. Prior to that time, as eighteenth-century paintings of English hunt scenes show, galloping horses were often depicted with

Being able to perceive and assess light and shadow is an essential skill for photographers because cameras record only a fraction of the range of brightness that humans can perceive. Details such as hair texture, clothing, and wall coverings in the dark areas, and the the hood of the car in the bright areas were readily visible, but were not recorded by the camera.

their forelegs and hind legs extended away from the torso in a manner resembling jumping toads.

Although photography does not necessarily encourage the shift in mental processing from the left hemisphere to the right hemisphere, the exercises in the book are intended to facilitate it. Once the shift happens, people will experience enhanced attention to the lines and shapes associated with forms and the spaces between them. This feeling is sometimes described as looking at the scene through "soft eyes." As the brain shifts more into right hemisphere functioning, the sense of understanding is dominated by a spatial

awareness that is nonverbal and often difficult to articulate. The person will comprehend the things that are being seen but will be unable to describe them with words. During the mental shift, one's awareness of time will also diminish.

For some people, this state does not come easy when it is first experienced. Learning to shift to the right hemisphere mode of perception is sometimes accompanied by feelings of agitation and even anxiety. Some photographers experience this feeling intensely the first few times they use a view camera. Faced with an inverted backwards image on the viewscreen, they feel anxious,

squirm, look away, and sometimes hurry the process to end the discomfort. This is a classic left hemisphere reaction to a situation that it is ill equipped to handle. Presented with an unfamiliar orientation, it has difficulty coming up with symbols and registers discomfort. The best thing to do, should this happen, is to persist. If necessary, relax your muscles and check to see that you are not holding your breath. Shortly thereafter, you should start seeing detail and complexity that previously went unnoticed. For example, you may notice that lines you assumed were vertical or horizontal appear as tilted diagonals on the

Gestalt theory provides insight into how people perceive objects in images. The principles of similarity and proximity state that people tend to see objects that are similar or close together as groups. The principle of continuity maintains that people prefer to perceive objects as elements that form continuous figures or

lines. Some people perceive the pedestrians in this photograph as a single group, while others see them either as two groups of four or as a single pedestrian between two groups. Many people who have backgrounds in the two-dimensional visual arts immediately perceive that the pedestrians are arranged in an S-shaped line.

viewscreen. Likewise, objects that you assumed were large may occupy a small fraction of the area of the viewscreen and vice versa. At this stage, the viewscreen will become a two-dimensional surface that you look at rather than a framing device that you look into. With experience, the shift from left to right hemisphere processing can be made painlessly and at will.

The Importance of Composition

Composition is important because it makes visual communication easier to comprehend. It is similar to grammar in that both:

- can be analyzed in terms of rules.
- are acquired naturally by children without formal study.
- can be exercised fluently without conscious thought.

However, while children retain their grammatical abilities as they mature, they usually lose their natural abilities to compose an image. In addition, grammatical skills are almost always practiced unconsciously, but many adults who relearn compositional skills consciously rely on compositional guidelines when they engage in visual expression. But the most significant difference between composition and grammar is that grammar is mostly a left hemisphere function and composition is mostly a right hemisphere function. This is why it is so easy to respond to photographs intuitively but difficult to articulate a response verbally.

Composition basically comes down to determining how objects should be arranged and balanced within the boundaries of the image. Generally speaking, any image that succeeds in communicating its subject in an efficient or interesting way can be said to have good composition. Although photographic lore is steeped with guidelines on how to achieve good compositions, it is important to understand that an image's composition should be judged by how well it works and not by whether the elements of an image conform to preconceived notions.

Composition can be studied and applied in different ways. Psychologists tend to look at how composition affects the ability to perceive the content and meaning of images. Graphic artists use compositional principles as means of attracting attention and expressing concepts. Fine artists also use compositional principles but typically place much less emphasis on them than do graphic artists. Photographers vary substantially in their approaches to composition. Some rigidly apply principles derived from graphic design as if departing will result in inherently bad images. At the other extreme, some photographers give no thought at all to composition and simply center the subject in the viewfinder and shoot. Most serious photographers fall somewhere in between.

Research into visual cognition by psychologists and neuroscientists has revealed a lot about how people process visual information. With regard to the perception of images, the most prominent contribution has been Gestalt theory. Developed during the first part of the twentieth century, Gestalt theory maintains that the mind perceives the whole image without having to first analyze the parts. In other words, the larger picture will be seen before its components. According to Gestalt theory, human perception is governed by the following principles:

- People tend to perceive by distinguishing between a figure and a background (the figure-ground relationship).
- Objects that are close together are likely to be seen as a group (the principle of proximity).
- Objects that are similar are more likely to be seen as a group (the principle of similarity).
- People tend to see complete figures even when part of the information is missing (the principle of closure).

The main benefit of the rule of thirds is that it encourages photographers to put the subject matter off center. When applied in practice, it should only be used as a starting point. As the image on the right shows, compositions often suffer when the guideline is applied too mechanically. Many visual elements can affect a composition, and placing a single point at the intersection of the thirds rarely results in the best visual balance.

• People tend to perceive subjects as continuous figures (the principle of continuity).

Although Gestalt theory provides little direct guidance on how to compose photographs, it is useful to photographers by showing how compositional choices can affect the way viewers perceive an image. Gestalt theory is also useful to photographers because it helps to explain why people can perceive scenes so differently from the way they record photographically. In visual perception, factors such as the distance of the subject from the background provide important visual clues. In photographs, other clues such as contrast, tonality, and color may dominate. When making images, photographers need to take such factors into account and not rely solely on their initial perceptions.

Gestalt theory and other research into visual perception also show that people recognize subjects by evaluating images in their entirety. In other words, the process of perceiving a subject does not involve the sequential mental analysis of the discrete elements. Although there is a tradition of explaining composition in terms of "leading lines" and other visual devices that supposedly direct the eye to the subject, science does not support this premise. Good composition may depend on the relationships between elements, but the brain nonetheless perceives them as an integrated part of the whole.

The traditional principles of composition, most of which are derived from graphic design, do nothing more than provide a catalog of elements that tend to create favorable impressions on viewers. There is no reason to refrain from using them if you find them useful but, they are not inviolate rules, nor do they apply to all situations. Most photographers, once they acquire

enough experience, tend to rely on their intuitive sense of composition and generally stop using guidelines at the conscious level.

The best known of the compositional guidelines is the rule of thirds. According to this guideline, the important compositional elements should be placed at the intersections of imaginary lines that divide the image into thirds horizontally and vertically. A significant strength of this guideline is that it encourages beginning photographers to move away from the natural tendency to place dominant elements at the center of the image. Placing the subject off center often results in images that have a more pleasing visual balance. It also helps photographers avoid discordant effects such as the "dividing a picture in half" effect that occurs when the horizon is placed halfway up the photograph. However, it is important to remember that the "rule" is only a guideline that is useful when it improves an image, and should be freely disregarded in the frequent situations when it does not.

Another compositional principle that covers the placement of visual elements is the rule that mergers should be avoided. Mergers occur when an object in the foreground is superimposed on an object in the background. According to the traditional theory, viewers will perceive such objects as joined together. The classic example is the lamppost growing out of a person's head. However, even a cursory look at a few photographs will show that this principle is poorly founded. As Gestalt theory explains, people instinctively distinguish between a figure and its background and are not readily confused by most superimpositions. Mergers seem to really interfere with the perception of images when the colors, tonalities, and shapes of the subject and background objects are sufficiently similar to mask the edges that provide information about depth. The role of seeing with respect to mergers should

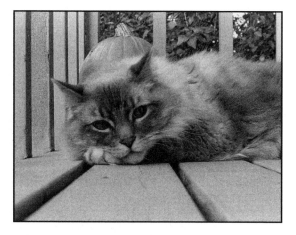

When mergers occur, they are generally caused by similarities in shape, color, and tonality between the subject and an object in the background.

therefore not be overly concerned with avoiding superimposed objects but rather with avoiding situations in which it is difficult to distinguish between the edges of the figure and ground.

Other traditional principles pertain to the positioning of linear elements in a composition. Lines are important because they, along with points and shapes, are a fundamental geometric element. Under traditional composition theory, the lines in an image direct the viewer's attention to the interesting parts of the image. Lines are also supposed to be important because they contribute to the sense of mood in a photograph. According to tradition, horizontal lines are associated with serenity, vertical lines are associated with strength, and diagonal lines tend to be associated with dynamism. When used in the context of graphic design, these principles may hold up for images with a few simple elements. However, most photographs have lines running at multiple angles and obtain their sense of mood or expression from factors other than the orientation of their lines.

Curves are another kind of lines for which principles of composition have been developed.

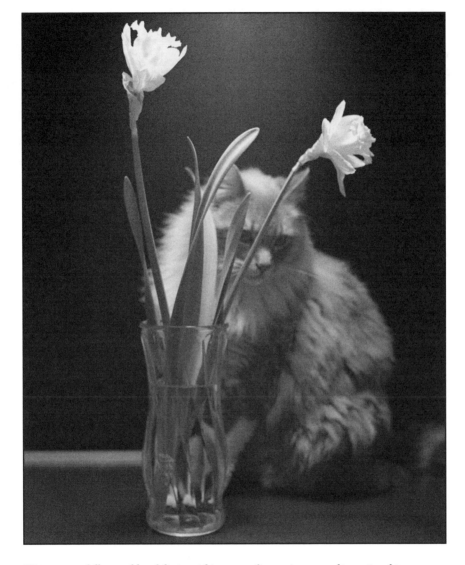

Viewers are fully capable of distinguishing most figures in a two-dimensional image—even when they are superimposed. The "rule" against mergers is often overstated.

In general, curves are supposed to contribute grace and dignity to an image. The s-curve tends to be the one most commonly discussed. While images with s-curves often possess a graceful elegance, photographers should avoid assuming they have some special compositional power. The presence of an s-curve will not necessarily make an otherwise bland image more interesting.

Compositional guidelines exist in many other forms. Examples include the incorporation of patterns, vertical and horizontal orientations, angle of view, textures, and backgrounds. None of these guidelines are inherently bad, and many photographers find them useful. However, placing too much emphasis on guidelines can limit the ability to perceive a scene by shifting the cognitive processing away from perception to analytical processing. It is worth noting that the formal study of composition receives much less emphasis in the traditional fine arts than it does in photography. While many art books refer to compositional guidelines, most discuss composition using terms such as balance, movement, emphasis, and unity. The unstated assumption seems to be that once the sense of seeing is acquired, composition will take care of itself.

Viewing Other People's Photographs

Looking at the images made by other photographers is an excellent way to improve your ability to see photographically. Doing so will give you ideas about what the medium of photography is capable of doing and, when done critically, can provide insight into how other photographers go about making their images. To get the most benefit from viewing images, you should look at a variety of work by different photographers in different genres. Even though you will likely benefit the most from looking at the work of photographers you admire, be sure to review some work that does not appeal to you.

There are several ways to find photographs for viewing. Exhibitions of original prints in museums, galleries, and similar settings allow you to see photographs in the form of presentation most likely favored by the photographer. Although you should not pass up opportunities to see good exhibits, access to original work is not essential to glean good information from the works of other photographers. Books and magazines are a good source of photographs for viewing. Many monographs and collections have been printed with a quality that approaches that of display prints. Several books that feature the images of widely acclaimed photographers are listed in the bibliography.

When examining photographs for the purpose of enhancing your seeing, try to suspend critical judgment and assess your intuitive feelings about each image. Do you like or dislike the image? Do you think it works well for its intended purpose? Look carefully at the photographs you like and try to figure out why you like them. Conversely, look at photographs that do not appeal to you and determine why. Try to avoid judging photographs based on how closely they follow compositional guidelines. Instead, concentrate on aspects such as the appeal of the subject matter, your initial visual impression, and the role that technical aspects such as sharpness and shadow detail play in your reaction.

To develop your sense of discernment, speculate as to how the scene might have looked when the photographer first noticed it. Try to figure out what extraneous elements might lie outside the image. Also, assess why the photographer selected the particular viewpoint and how the image might appear if made from different positions. Since film does not record light in the same manner that the human eye perceives it, it is also useful to speculate how the light actually appeared when the photographer took the photograph.

Factors to consider are the intensity, diffuseness, and cast of the light.

An excellent way to evaluate a photograph and its composition is to make a sketch from it, taking care to depict the major visual elements exactly where they appear in the image. This kind of exercise can help you overcome the abstracting process of the brain and better assess where those elements appear on the two-dimensional surface of the image.

Another benefit of viewing a variety of photographs is that it develops an appreciation of style. There are no absolute rules as to what makes for a good photograph or a good style. When evaluating collective works of individual photographers, look at how they use lighting, color, composition, and graphic elements; then, try to determine which features dominate in making that photographer's style distinctive. For example, the street photography of Garry Winogrand is very different than the landscape photography of Bruce Barnbaum, although both photographers have worked extensively with monochrome films and have excellent reputations as fine art photographers. However, their approaches to subject matter and their use of different kinds of equipment have contributed to radically different styles.

Winogrand's images show his mastery of composing images in dynamic settings. Most were taken in urban areas and feature people as the main subject matter. The compositions are frequently dominated by various alignments of points (*e.g.*, heads) and lines (*e.g.*, bodies). Creating these kinds of images requires highly developed abilities to perceive elements in cluttered environments and to predict when, where, and how the composition will come together. Winogrand's choice of equipment and materials also influences his photographs. Exposing Tri-X at EI 1000 in a handheld Leica, he could capture mul-tiple scenes while working among streets and other public places. His images depend substantially on dynamism and subject matter for their substantive effect.

Bruce Barnbaum works mostly in large format. His images are typically of landscape and architectural subjects and involve contemplative consideration and careful analysis of exposure and filtration. In addition to his ability to envision how to get the most out of static scenes, his attention to the technical details of photography enables him to make prints with subtle tonalities and contrasts.

Another aspect related to style is the visual predilection of the photographer. Some photographers distinctly favor certain visual elements in how they perceive and render subject matter. For example, Robert Frank has made extensive use of point-like elements in his images whereas Alexander Rodchenko used lines extensively and Edward Weston used forms extensively. Photographers can show predilections towards using visual elements in other ways as well. Many of Margaret Bourke-White's images feature the repetition of identical or very similar objects.

Gaining an appreciation of predilections can be applied to your work as well. Knowing that you have a predilection gives you the option of working to further develop it or work around it, depending on your feelings about how it affects your work. Understanding your predilections can also help you to enhance your skills in various genres. For example, sports photography can be approached by concentrating on points, lines, forms, or spaces, but knowing that you are predisposed to perceiving certain elements can help you decide how best to approach a particular visual situation. Conversely, recognizing that you have a predilection may enable you to expand your visual approaches by working hard to overcome a dominant means of perception.

Although it can be beneficial to discern the elements that define the styles of various photographers, you generally should avoid trying to emulate them. Style depends on many factors but is ultimately determined by how the photographer sees objects and spaces in the visual environment. For the most part, style will develop without conscious attention, as the photographer becomes more proficient at seeing subjects and works more consciously at rendering them.

Likewise, you should not worry that looking at other photographers' work will somehow impair your creativity or impede the development of your individual style. Viewing and analyzing the work of others can influence a photographer's style but will not determine it. Even if a particular photographer's work inspires you to take on the same subject matter or to try a particular approach, differences in seeing will likely result in styles that are nonetheless distinct. In fact, it is very difficult to copy a particular style even if you are inclined to do so.

Looking at Art

Photography is one of many forms of visual art. As such, photographers can draw on the work of artists in other media as a source of insight. Looking at art from the perspective of learning takes more than glancing at a work and making superficial judgments. Each successful work encompasses one or more problems that the artist had to solve in order to depict the subject. Spending some time speculating about the problems that the artist faced and evaluating the potential solutions will be worth the effort when it comes to composing your images.

A good first step when looking at a work is to try and assess what motivated the artist to create a work of that particular subject. This is best done at an intuitive level without being overly judgmental or trying to fit the work within the framework of political or historical criticism. Irrespective of what critics and art historians often seem to imply, most art has not been created in furtherance of sociopolitical anger or with an intent to oppress the victimized social class *du jour*. What you should try to identify is the subject, concept, and basic approach to expression.

Next, assess the means by which the artist depicted the subject. There are many visual techniques that can be used or omitted in compositions, such as balance, contrast, harmony, movement, repetition, proportion, and depth. Consider the choices the artist made with respect to the composition and the effect it has on the organization and clarity of the work. Each artist favors certain approaches, and discerning them will help you understand the ways you might approach and solve visual problems.

As with photographs, you should not limit your viewing solely to works that appeal to you. However, when you do see something that registers strongly, try to deduce which elements make those works visually powerful. Many works that initially appear simple can be fairly complex upon further consideration. An example is *Birth of Venus*, by Sandro Botticelli. In addition to the varied poses of feet, arms, and heads, this work features common objects depicted in different ways. Conversely, some works that one might assume are complex can actually be very straightforward. For example, a realistic work depicting a restaurant on an urban street corner would be expected to show dozens, if not hundreds, of objects such as utility poles, hydrants, tableware, automobiles, wall hangings, window signs, newspaper racks, litter, and so forth. However, *Nighthawks*, by Edward Hopper, is quite sparse with regard to visual elements. If done properly, looking at masterworks, can show that the means of depiction is as important to visual communication as the subject matter.

2

The Camera as a Tool

One of the interesting dichotomies between photography and the other visual arts is that photographers tend to show a disproportionately high level of interest in equipment and a disproportionately low level towards the fundamentals of using it. None of the major art magazines concentrate on new models of materials. If anything, they tend to give more attention to ancient techniques than emerging ones. This is something that cannot be said of the most popular photography magazines. In fact, some camera companies offer a larger selection of lenses than most art supply manufacturers do of pencils or brushes. While equipment is important to photography, and many fine artists take more than a little interest in their tools, photographers seem to more readily succumb to the lure of technology. For example, an artist who acquires a new kind of conte crayon or brush is more likely to show others the work that he did with the tools than the tools themselves. The opposite tends to be true of photographers.

While there is nothing wrong with appreciating photographic equipment for its own sake or having equipment that is more sophisticated and expensive than you really need, expensive gear does not necessarily make for better images. Most of the features that add expense to photographic equipment tend to address issues such as reliability and durability, and have relatively small effects on the quality of the images produced. In most situations, the photographer's skill at using the equipment has far more influence on the final image than the quality of the equipment used to make it.

Considering the level of interest that photographers show in equipment, it is ironic that they do not work harder at achieving proficiency in the mechanical and technical aspects of using it. Perhaps this is because many photographers are able to become proficient at using their gear with little conscious effort, or maybe they do not realize the extent to which they could improve their images by operating their equipment better. Regardless, paying conscious attention to perfecting skills such as focusing and holding the camera steady can markedly improve the overall quality of your images. As is the case with the other visual arts, practicing the fundamental skills will pay off in the long run with better images.

The Basic Tool

To get the most from a camera, you need to understand its capabilities and become proficient at operating it. Most cameras are adequately designed for their intended purposes and are assembled with enough precision to serve as good photographic instruments. Although some cameras can perform better than others, most cameras can make excellent images when they are properly used. When selecting a camera for photography, it is important to consider how well you can work the controls and whether the camera is suitable for your intended applications.

Cameras and lenses can be designed for general or specific purposes. A 35mm single lens reflex camera with a 50mm lens is suitable for many applications. Conversely, the 172mm f/2.5 Kodak Aero Ektar was designed for aerial photography using five-inch-wide roll film. When mounted on a view camera, the Aero Ektar is suitable for some limited astrophotography purposes, but is too heavy and ungainly for general use.

The performance capabilities of cameras and lenses are largely determined by their design. Individual designs have strengths and weaknesses, and there is no camera that is ideal for every purpose. Some designs excel at specific applications but are unwieldy or impractical for others. For example, monorail view cameras are highly capable cameras when used in a studio setting but are impractical for sports photography.

Lenses can also be designed for either general use or for specific applications. The design of a lens encompasses various compromises in its performance. Lenses with large apertures are good for low-light situations but tend to be heavier and more expensive than lenses with moderate apertures. Similarly, a lens that is optimized for macrophotography may not perform as well as a conventional design when focused at infinity.

Problems such as manufacturing variations and damage caused by mishandling can cause cameras and lenses to perform less effectively than intended by their design. While it is important not to obsess over this issue, it should not be completely ignored. As tools, cameras are not perfect machines, although most are very precise. The question is whether the disparity between designed and actual performance is significant enough to affect the quality of your images. For example, the point of focus seen in the viewfinders of many cameras does not correspond exactly with the point of focus at the film plane, although the amount of deviation is usually insignificant. Nonetheless, the point of focus is a critical function, and it is a good idea to test your cameras by means such as the one shown in Exercise 1 at the end of the chapter.

When contemplating the acquisition of a camera or other photographic equipment, the first question you should logically ask is what you intend to do with it. Although factors other than logic drive many purchases, it is still important to consider what subjects you intend to photograph

and whether acquiring more equipment will add capabilities or increase the technical performance beyond what you already have.

Technical performance notwithstanding, you should give the most consideration to how well you can handle the equipment, because your dexterity at using it will have the greater influence on image quality. Some issues to consider when evaluating equipment are the focusing mechanism, aperture and shutter speed controls, ease of viewing, and how well it carries. These tend to be highly subjective, so determining your personal preference should be the dominant consideration. Many photographers justifiably base their decisions on their intuitive feelings about a particular camera or system.

Operating the Camera

Learning to use a camera as a tool is more important than the quality of the camera itself, because more can be accomplished by using a mediocre tool well than by using an excellent tool in a mediocre fashion. In addition to understanding technical aspects such as exposure and depth of field, you should strive to operate your equipment as proficiently as possible. Proficient operation means that you should be able to perform fundamental tasks such as setting apertures and shutter speeds without having to look at the controls. Although relatively few photographers do so, spending some time practicing at operating a particular camera can significantly improve proficiency. With sustained practice, near-perfect operation can become unconsciously embedded into your photographic technique.

Becoming proficient also means mastering the aspects of operation that are important to the application at hand. Genres such as sports photography require the ability to operate quickly to record complex and dynamic scenes. Unless you can focus and compose quickly, you are going to miss a lot of images. Even still-life photography requires the ability to operate the controls that will affect how objects will appear arranged in the image. Although the pace is slower than sports photography, doing still-life photography competently requires a contemplative approach that demands careful adjustments that affect position and perspective. Overlooking even small flaws can ruin an image.

Focusing is a skill common to all genres of photography and warrants particular consideration because, with the exception of pinhole photography, it affects every image made. Even becoming proficient at using autofocus requires knowing where the autofocusing sensors are located in the viewfinder and how the camera's autofocusing mechanism behaves under specific lighting and subject conditions. In addition, some cameras have autofocus modes for moving subjects that can take a bit of experience to use well. With conscious practice, you can become more aware of the qualities and quirks of your particular system and make adjustments accordingly.

Although autofocusing technology is at an advanced stage, it does not perform well in all situations. Therefore, being proficient at manual focusing is necessary. There are several ways to focus a camera manually. The most common is to move the focusing control back and forth until you settle onto the point of optimal focus. This approach is effective at achieving good focus because you judge the best point by making incremental adjustments until the focus can no longer be improved. However, this is not the fastest way to focus and is poorly suited for photographing dynamic subjects.

A faster method for cameras that focus on viewscreens, such as reflex and view cameras, is to develop an intuitive feel for what the best point of focus looks like and to stop focusing once you reach it. This can take some practice since

the viewscreens on most cameras do not show the optimum focus as a tack sharp rendition. This makes focusing a process of deciding on the "least worst" point of focus. However, achieving this skill is well worth the effort because it substantially reduces the time and effort required to focus the camera and allows you to keep moving objects continually in focus. With practice, you can achieve the same perfection in focus as you can with the back-and-forth method.

There is a related method that works well for cameras with rangefinder focusing. Such cameras have a small window in the center of the viewfinder that produces split images when out of focus. The key to fast focusing with such cameras is to be able to discern instantly where the window is placed and to recognize the unsplit image without having to hunt back and forth. It also helps to reset the focusing ring to infinity after each shot so that the ring need only be moved in one direction when focusing.

Zone focusing, also known as "hyperfocal focusing," is another approach that can work well

Many lenses have depth-of-field scales that indicate the range of distance in which objects will be rendered reasonably sharp. The range is somewhat subjective and also depends on the size to which the image will be enlarged. The scale on this lens works well for prints up to 5x7 inches.

when photographing subjects that change their distance from the camera rapidly. It is done by using the depth-of-field indicators on the lens to set the focus point so that a range of distances will be in acceptably sharp focus. This range will depend on the aperture setting, with the range increasing as the aperture is stopped down. For example, setting the f/stop at f/16 will produce significantly more depth of field than setting it at f/4. Also note that the point of best focus will be positioned somewhere about one-third back from the front of the zone of focus. For example, if you know that the subject is likely to be photographed at a distance between ten and forty feet, the point of optimal focus should be preset at twenty feet, and not twenty-five feet.

Another area where you might benefit from practice is the simple act of pushing the shutter button. The buttons on most cameras are placed so that the force used to depress the button tends to torque the camera a little bit. This movement can seriously affect the sharpness of images. Many photographers exacerbate this movement by pressing the button sharply when making an image. The best way to eliminate or minimize shutter button torque is to press the shutter button lightly with an easy squeezing motion.

To get a general idea of how much your camera moves when you push the shutter button, try experimenting when there is no film in the camera. Concentrate on a horizontal line in the scene and judge how much it shifts from level when you push the shutter button. With practice, you should be able to practically eliminate the shift. If you are using a single-lens reflex camera where the mirror interrupts the view at the moment of exposure, you can try pushing next to the shutter button to approximate the effect.

A related source of camera movement that can degrade image sharpness is the natural shaking that occurs when the camera is supported by

hand. The best way to avoid this problem is to use a tripod, but this is not always feasible. For example, tripods are prohibited in some places and do not work when used on unsteady platforms such as boats. In such cases, you need to know how to hold the camera steady.

The ability to hand-hold a camera depends on skill but is also influenced by equipment. For example, some photographers can hold cameras that have vertically-positioned shutter buttons steadier than cameras that have angled buttons. Camera shake is particularly important at slower shutter speeds. Exercise 2 will show how well you can hold a camera steady at slower shutter speeds.

The Tool's Effect on Composition

It is important that you not let the mechanical attributes of your equipment unduly influence your compositions. For example, most cameras have a rectangular format that is oriented horizontally when held in normal fashion. While there is nothing wrong with framing photographs horizontally, you should resist the tendency to compose most of your photographs in the horizontal position just because they most readily present themselves that way in the viewfinder.

Tripods pose a similar issue. Most have legs consisting of multiple sections that can be extended to adjust the camera height. Although such tripods are capable of supporting a camera at any level between their minimum and maximum heights, many photographers make the inadvertent mistake of selecting the height at which the camera is supported by pulling the legs out to their furthest stops and rotely using that level. This is not a good practice because camera height can have a substantial influence on the composition. Many photographers could improve their compositions by setting the camera height according to how they best assessed the scene, and not by using the tripod's default settings.

Ideally, compositions should be determined by how you think they best appear, and not by how your equipment lends itself to being operated. Unfortunately, some of the characteristics of the tool will place constraints on how the camera can be positioned and therefore preclude some kinds of compositions. For example, composing an image with the camera angled upwards from ground level is reasonably easy to do with a waist-level viewfinder, and almost impossible with a rangefinder, pentaprism viewfinder, or view camera back. On the other hand, waist-level finders are difficult to use when cameras are positioned at normal eye level. Many camera systems have means to get around this problem, such as right-angle attachments or interchangeable viewfinders. Furthermore, most subjects lend themselves to being depicted from a number of viewpoints. Nonetheless, photographers should be aware of the compositional constraints imposed by their equipment and make allowances when necessary.

Speaking of viewfinders, a common problem is the tendency of many photographers to use them more like aiming devices than as aids to composition. Instead of ascertaining what the image will look like, they make images by placing the subject more or less in the center of the viewfinder and releasing the shutter. Common signs that a photographer may be aiming the camera at the subject instead of composing the image are tilted horizons, people and animals with their feet unintentionally cut out of the picture, and distracting elements in the foreground or background that could have been avoided by removing them from the scene or photographing from a different angle. While these kinds of problems most often are caused by insufficiently developed seeing skills, there is a tendency to use the viewfinder merely to aim the camera.

Viewfinders vary significantly among and within the various camera types and formats. The

The orientation of the image in a viewfinder will influence composition. The inverted and reversed image on the ground glass of a view camera invites deliberate contemplation but is not well suited for action photography. When first using view cameras, many photographers find looking at the screen to be a mentally uncomfortable experience. This is a sign that the analytical processes of the left hemisphere of the brain are playing an overly dominant role in composition. The brain has difficulty in abstracting information that is inverted and reversed, and the uncomfortable feeling that results is its way of protesting. By shifting into the perceiving mode mediated by the right hemisphere, the discomfort will disappear, and composing becomes a straightforward process. This is most easily done by looking at the shapes and lines depicted on the screen and by not trying to identify them as specific objects.

distinct differences between rangefinders, pentaprisms, waist-level finders, and view camera backs require photographers to apply the visual effort of composition in different ways. For example, the viewfinders in 35mm cameras do not produce the inverted and reversed images that show up on the ground glass of a view camera.

Similarly, although rangefinders and pentaprism viewfinders both present images in their normal orientation, they have a different feel to them. Even viewfinders associated with the same type of cameras will have different peripheries and levels of brightness, which affect the user's perception when looking into the viewfinder. Therefore, it is important to gain enough experi-

ence with a particular camera so that seeing the composition when looking through the viewfinder becomes second nature.

It is also important to develop a general sense of how a scene will appear in an image without evaluating it in a viewfinder. One way to become adept at this is to practice looking at scenes and imagining how they will appear in a photograph. When doing this, consider where you would position the frame lines and also how you would position the camera to make the most desirable images. Experience will probably suggest to you that using a viewfinder is not always necessary. Exercise 3 provides some practice at taking photographs without using a viewfinder.

Exercise 1

The Point of Focus

Most cameras focus light in two places—the film plane and viewfinder. While it is natural to assume that the image will be focused the same at both places, the reality is that the focus point in the viewfinders of most cameras will differ slightly from the focus point on the film plane. Typically the deviation amounts to less than half an inch or so when three feet from the subject, but larger deviations are possible. This amount of deviation is usually insignificant except in applications that are especially demanding, such as telescope astrophotography.

Assessing the point of focus of your camera is easy to do. Using a word processor or other graphics tool, create a document consisting of a series of vertical lines spaced at specific intervals (e.g., one inch). Add arrows or some other marking at

the top of the line in the center to distinguish it from the others. It is also helpful to place a line of text above and below the vertical lines. Tape the document to a door and open the door so that the document is set at a forty-five degree angle to the camera (a protractor can be set at the base of the door to measure the angle). Set the camera on a tripod about three feet away from the center line. With the lens aperture set at wide open, focus on the middle line and take a photograph.

Ideally, the focus point on the image will exactly match the one indicated by the viewfinder, but don't be surprised if it is somewhat off. To judge how far off it is, count the number of lines that the focus point is away from the line in the middle, and divide by two. This will give you distance between the points of focus.

In most cameras, the focus point on the image will differ slightly from the focus point seen in the viewfinder. The amount of deviation in a particular camera is easy to test by photographing a test target set forty-five

degrees to the camera. The cameras evaluated in the photographs above are a Canonet G-III rangefinder (left), with a 40mm lens set at f/1.7, and a Nikon N90 SLR, (right) with a 50mm lens set at f/1.8.

Exercise 2

Finding Your Slowest Acceptable Handheld Shutter Speed

A standard guideline in photography is that to avoid blurring caused by camera shake, you should not use a shutter speed slower than the approximate reciprocal of the focal length when hand-holding a camera. For example, according to the guideline, if you are using a 60mm lens, then the shutter speed should not be set at less than 1/60 of a second. Like many guidelines, this one can be a little dubious in practice.

Experimentation will likely show that this guideline does not hold true for you, particularly if you practice at holding the camera steady and consciously do so when exposing images. Many photographers will also find that probability is a factor when shooting handheld at slow shutter speeds. For example, a photographer who consistently gets sharp images at 1/125 of a second might get one image out of three with good sharpness when shooting at 1/15 of a second.

Congress shall make no law respecting an establishment of religion, or prohibiting the free exercise thereof; or abridging the freedom of speech, or of the press; or the right of the people peaceably to assemble, and to petition the government for a redress of grievances.

This is the test target I use to assess how well I can hold a particular camera at slow shutter speeds. The results, using a Nikon N90 with a 50mm lens, are shown as 6x enlargements on the opposite page.

Assessing your personal limit for handheld exposures can be done by comparing photographs taken with a tripod to those taken at various shutter speeds while hand-holding the camera. The first step is to make a target to photograph. Text works well for this purpose, but commercial lens testing charts are available for those who appreciate the aura of science associated with them. It is helpful to incorporate a table of shutter speeds and apertures onto the chart so you can record your settings as you take the photographs.

The next step is to mount the target on a wall or other support. Stand on a marked spot a few feet away from the target and take a series of photographs using shutter speeds ranging from 1/2 of a second to 1/125 of a second. In addition, take several exposures at the lower shutter speeds. Concentrate on holding the camera still.

Next, set up a tripod at the same spot and take another set of images. You can skip the full range of shutter speeds if you like, although doing so will allow you to compare images made at the same apertures. This can be helpful, since lenses do not perform as well at their widest apertures.

When finished, enlarge the target area to five to ten times its size on the negative or sensor. Compare the handheld images to the tripod mounted ones and determine at which speed the detail becomes noticeably degraded. At some of the slower speeds, you may notice that some of the images are sharp while others are blurred. What this shows is that camera shake is more likely to degrade images at slower speeds but there is no clear-cut limit at which you cannot hand-hold a camera and get sharp images.

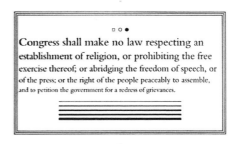

Tripod: 1/8 sec. at f/8

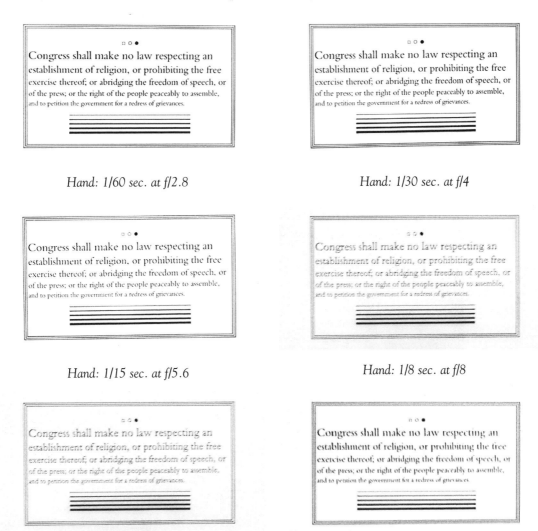

Hand: 1/60 sec. at f/2.8

Hand: 1/30 sec. at f/4

Hand: 1/15 sec. at f/5.6

Hand: 1/8 sec. at f/8

Hand: 1/4 sec. at f/11

Hand: 1/2 sec. at f/16

Exercise 3

Photographing without a Viewfinder

Ironically, one way to better appreciate the role of a viewfinder in composing images is to take photographs without using one. Working at visualizing what compositions will look like from the camera's perspective has the added benefit of exercising your seeing skills. Being able to work without a viewfinder is also useful when you don't want to call attention to yourself or when the camera must be positioned where you can't look into the viewfinder. A good example of work done without a viewfinder is Walker Evans' photographs of people on subway trains in New York, made with a camera concealed under his jacket.

The dominant considerations when composing without a viewfinder are the angle of view of the lens, the amount of tilt from the horizontal and vertical axes, and your mental image of how the photograph will look. Keep in mind that, when first starting out, most people tend to aim their cameras a little too high. If this happens, try angling the camera down a bit more, and you should improve with only a little more practice.

To do the exercise, select a subject that is not easily accessible from a normal viewpoint and visualize how it looks from different viewpoints, such as ground level, waist level, and above your head. Experiment with making images by placing the camera at the viewpoint you are visualizing. Concentrate on aligning the camera horizontally and vertically to capture the image and try to keep it level. It is also important to avoid taking "wild shots" during this exercise. Compose consciously to obtain the best composition you can under the circumstances. When done, compare how well the actual images match with how you thought they would appear.

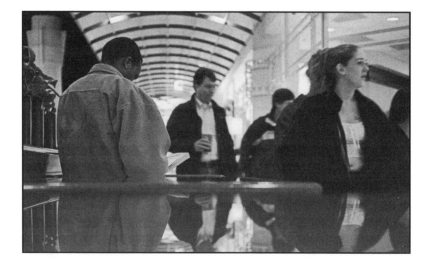

Tables and similar surfaces can make good supports when you can't use a tripod. Knowing how to evaluate visual relationships in your head is a useful skill when circumstances make using a viewfinder impractical.

Working from unaccustomed viewpoints is a good exercise for visualizing what an image will look like without looking into the viewfinder. This photograph was taken with the camera placed on a book, about one inch above ground level.

This image was made by extending the camera at arm's length from a bridge and timing the exposure to coincide with the drops of water descending from the bridge, hitting the stream below.

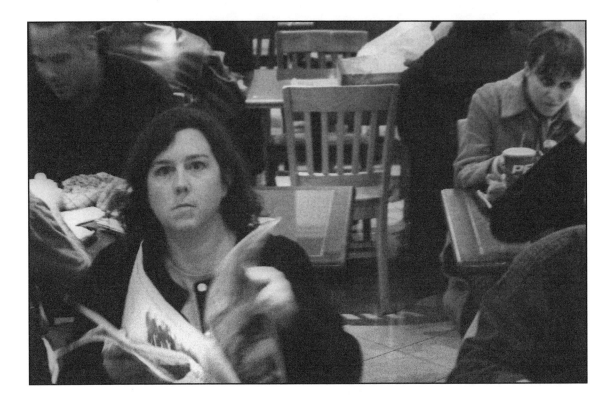

3

Doing the Exercises

The exercises in the three chapters that follow are designed to engage the brain in different situations that will help develop skills in perception and composition. Visualization is a process by which the brain processes information through the modes of perception and analysis. While in the perceiving mode, the brain recognizes the spatial content and arrangement of the visual data collected by the eyes. In the analytical mode, the brain organizes and abstracts this information based on what it considers important.

Most photographers work best when they are drawing on all the faculties of the brain that contribute to making images. To do this well, they need to engage both modes during the visualization process in ways that complement each other rather than conflict. While the analytical mode can play an important role in trying to express concepts or achieve a certain look, it can also work counterproductively when it causes a photographer to overlook elements that are visually important but not essential to the mental awareness of the primary subject. An example of how the analytical mode can work to the detriment of an image is the inadvertent placing of a subject in front of an unattractive background. In such cases, the analytical mode of the brain concentrates its attention on what it considers to be important (the subject) and edits out what it considers to be unrelated elements (the background), even though these elements may be critical to the overall visual effect of the image.

The perceiving mode can also express itself in ways that are counterproductive to making images. Typically this happens when photographers are so engrossed with the subject matter that they overlook important technical considerations. For example, O. Winston Link was one of the premier train photographers in the world and is best known for images of trains taken at night. He used a 4x5 view camera with a specially designed lighting system that could fire sixty flashbulbs at once. He had an excellent sense of visualization and would begin setting up his shots hours or even days before the train would pass by. On one occasion, after spending several hours setting up his equipment, he lost the image because he failed to remove the dark slide from the film holder before releasing the shutter

Although perception and analysis are essential elements in making photographs, it is critical that the brain engage its perceiving mode before engaging the analytical mode. In other words, the photographer needs to learn to work in a way that prevents the editing of important visual information from conscious awareness. Once this state is reached, compositions can be honed by engaging the perceiving and analytical modes in whatever proportion is needed to achieve the desired result. Traditionally, this has been the approach to teaching art skills such as drawing and painting. In most beginning art classes, students draw accurate renderings of objects and copy existing works of art. Those who succeed with this approach are

the ones who figure out they need to portray their subjects as they actually appear and not as they think they should appear. Budding artists who at first struggle with placement, perspective, and proportion almost always recognize that their skills need fine-tuning because their work clearly lets them know that improvement is needed.

Photographers in the same situation are not so fortunate. The most significant strength of a camera—its automatic and accurate depiction of perspective and proportion—makes it a poor tool for teaching these aspects of art. When using a camera to learn art, the results may not always be great, but they are rarely so terrible to suggest that perception is the fundamental problem. A common feeling among such photographers is that something is not quite right with their photography, but they do not really know what it is they need to address. The purpose of the exercises is to develop seeing and compositional skills by progressively working on the fundamental skill of perception and integrating it with the analytical abilities needed to understand the subject and address the technical aspects of making images.

Knowing the Subject

Each of the following exercises begins with a brief discussion about the subject matter. Given the space available, the information provided is not exhaustive but, rather, is intended to show how learning more about the subject can contribute to making better images.

Simply put, it is good to know about your subject matter. Sometimes, such knowledge is almost essential to making an image. For example, if you want to photograph meteors, you are unlikely to succeed unless you know the dates and times of meteor showers and where to point the camera. Otherwise, meteors occur so infrequently that capturing one on film becomes improbable.

More importantly, knowing about your subject is useful even if that knowledge does not seem to relate directly to the visual aspects of what you are trying to photograph. The reason is that the brain is an incredibly complex processor of information, which pieces together bits of seemingly unrelated information to form insights. It may be hard to imagine how knowing about plant hormones called gibberellins will contribute

The exercises are organized by point, line, and shape. This framework can be applied in many ways to many subjects. For example, looking at plants in these ways can help in registering their spatial characteristics.

Mount Hood, the highest peak in Oregon, is a frequent subject for landscape photography. Although it is impossible to predict exactly when meteors will pass over its summit, visualizing and planning made this image possible. The Leonid meteor storm in November 2001 was predicted to be very intense. Several viewpoints were assessed using astronomical software, and this one was selected because it was about thirty degrees from the constellation Leo, where the meteors radiate, and has an impressive view. About 150 exposures lasting ten to fifteen seconds each were taken over a two-hour period beginning at 1 AM.

to photographing a rose, but it contributes an awareness of the world around you and enhances your abilities to perceive, evaluate, and exercise judgments about your subjects.

Consider the Genre

Beginning in Paleolithic times, humans have always advanced their art based on the foundations established by the artists before them. The paradox is that originality and creativity are nearly impossible, unless they are set in the context of what has preceded them. Appreciation of how other artists and photographers have approached their subjects and what they accomplished will help you better understand what it is that you are trying to accomplish. Therefore, each exercise contains a brief discussion of the genre at hand, usually with specific references to artists and photographers who are known for working in it.

The other benefit of learning about genres is that it maintains a sense of connection with other artists and the field of art in general. For exam-

ple, it should be both comforting and inspiring for portrait photographers to realize that not only are they carrying on a tradition practiced by masters such as Sandro Botticelli and Albrecht Dürer, they are contributing their personal solutions to the same problems.

Framework of the Exercises

The exercises are organized according to the fundamental visual elements of points, lines, and shapes. This format is used because it encourages the conscious perception of objects in a scene as visual elements and thereby helps to engage the brain's perceptual mode. The first set of exercises is based on points because these are the simplest visual elements. In the exercises, a point can be considered to be any nonlinear element in a photograph whose area constitutes less than 3 percent of the image area.

The next set of exercises is based on lines. Lines are straight or curved elements that are relatively long and thin compared to the other ele-

Visual clutter and temporal change can make concepts difficult to express. An eight-year-old soccer player scoring from seventy feet out, against five defenders, is a considerable feat but the drama of the event is lost in these still images. In the first photograph the girl has *just kicked the ball, but the ball is difficult to discern because of the distance and surrounding clutter. In the second, it is easy to see that the ball is going into the goal, but the clutter of the players and spectators makes it unclear who has kicked the ball.*

ments in the image. They are more visually complex than points because they possess the inherent characteristic of directionality.

The last set of exercises is based on shapes. Shapes are visual elements that are neither point or line. They exist in two forms: (a) positive shapes which are delineated by the edges of solid objects; and (b) the negative space that exists between objects. Both forms are important in practicing the visual arts, although the natural tendency is to concentrate one's attention on positive shapes. However, understanding how to recognize and use negative spaces is a very effective skill in the visual arts and a significant objective of the exercises.

Within the framework of point, line, and shape, the exercises are further organized according to their degree of visual clutter and temporal change. Visual clutter is the measure of the complexity of a scene with regard to the number and variety of visual elements. Perception and composition are easier when the scene has fewer ele-

ments, and many images are strengthened by by isolating the subject from the surrounding clutter. In most forms of the visual arts, this is very easy to do. If a painter is working on a landscape and wants to leave out power lines, signs, and beer cans, he merely has to omit painting them in. Photographers do not have this option and therefore need to know how to recognize and deal with visual clutter.

Temporal change is the measure of how rapidly the scene changes over time, and can range from nil (e.g., still lifes) to extreme (e.g., sports photography). The most familiar aspect of temporal change is evinced in Henri Cartier-Bresson's concept of the decisive moment. When dealing with dynamic scenes, the decisive moment occurs at the point in time when the composition best comes together to express the concept that the photographer wants to record. It requires that the photographer be able to perceive the relationships between objects and predict their respective change over time. However,

applying the concept of the decisive moment can get very complicated, especially when a scene has several dynamic elements in which the decisive moments occur at different times.

Each of the following three chapters starts with simple static compositions that are designed to develop contemplative seeing in which details, elements, and unity are critical elements. From there, the exercises involve increasingly more complex and dynamic settings. Working in such a manner develops one's skill at perceiving details and at visually separating subject matter from the surrounding environment. Another aspect of the exercises is that the level of structure decreases as they progress. Each of the series starts with relatively tight constraints on the subject matter and settings, and then expands to settings where the subject matter is more variable and the photographer must exercise more personal discretion.

Practical Considerations

The exercises were designed with the specific objective of developing visual skills and should be approached from the perspective that intense concentration on the visual elements is the dominant consideration. Although the exercises provide substantial opportunities for self-expression, they are not directed at learning to express verbalized concepts or incorporate specific elements of graphic design. In other words, the exercises are not about making images that describe "happy" or "sad," nor are they directives to incorporate design concepts such as "dynamic diagonals" or "touchy textures." Instead, the exercises will prescribe things that you should see, evaluate visually, and then photograph.

While there is nothing wrong with thematic photography, becoming proficient at visual cognition and achieving a high level of control at photographic rendering is a more fundamental skill. Artists such as Botticelli, Michelangelo, and van Gogh are very much admired for how they depicted their subject matter. However, before they could execute their art at the high level for which they are known, they devoted the time working with basic materials and simple subjects that was needed to learn how to perceive the environment before them and render it into art. In much the same way, you should keep in mind that personal expression through photography depends largely on how well you can see and render subjects photographically.

It is recommended that you do the exercises in the order they are presented because they are designed to build skills progressively. Nonetheless, strict adherence may not always be feasible, so feel free to use your best judgment. In some instances, the exercises depend on events such as sports activities, which you must work into your schedule or on ephemeral objects, such as clouds, over which you have no control. In such cases, it is generally better to move on to other exercises than to postpone work pending the desired event. In some cases, it may be expedient to work on more than one exercise during photographic sessions. For example, there may be good opportunities for street photography incidental to attending a sporting event. However, it is recommended that you work on no more than two or three exercises at any given time.

You should keep working on an exercise until you are able to finish it successfully. Most exercises can be considered complete when you have made three to five images that genuinely satisfy you. Depending on the genre and the nature of the exercise, this may require taking a lot of photographs. For example, with careful attention, it is possible to depict a still life successfully with very few images. Nonetheless, if for any reason you are not pleased with the initial results of your still-life exercises, it is probably an indication that you need to keep working at them. Several of the

exercises involve genres in which a high proportion of unsuccessful images is to be reasonably expected. Street and sports photography are notable examples. If you get two to four good images per thirty-six exposure roll of film, you will be doing well. Keep in mind, however, that the high failure rate associated with these genres is due to their complexity, and that you should strive to take good photographs by applying your perceptual abilities. Using lots of film without engaging in seeing is rarely a fruitful approach.

Another aspect associated with the exercises is the role that luck should play. Some photographers would have you believe that luck never plays a serious role in their compositions, and that every image should be the result of profound and thoroughly considered visualization. In truth, luck factors into making images much more frequently that many photographers will admit. This is particularly true in photographing scenes with multiple dynamic elements because it is simply impossible to consider everything that is happening while composing the image.

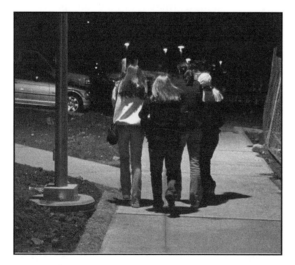

Another advantage of using normal lenses is that they work well in low-light situations.

You should not feel that your work is less worthy merely because an uncontrolled element was the factor that made an image work. Luck is something that all visual artists experience at one time or another, irrespective of the medium. Jackson Pollock likely had days when the paint splattered particularly nicely and Rembrandt no doubt happily used inadvertently-mixed flesh tones to great effect. Cultivated and encouraged luck is something to be respected. So long as it does not become your dominant approach to composition, the fruits of luck should not be discounted

Equipment

The exercises are designed so that they can be performed with simple and readily available equipment. Almost any handheld camera with adjustable focus and exposure controls can be used. Single lens reflex (SLR) cameras are the ideal choice but, with the possible exception of some exercises that entail close-ups, most rangefinder and twin lens reflex (TLR) cameras are suitable, as well. Point-and-shoot cameras are less suitable because the controls cannot be manually adjusted, and it is sometimes difficult to ensure they are focused on the proper spot. However, you can certainly get by with one if you have no better alternative.

Obtaining a suitable camera does not have to be expensive. For example, older 35mm SLR cameras equipped with 50mm lenses, such as the Nikon EM, Canon AE-1, and Pentax K-1000 models, can always be found for auction on eBay for less than $75.

It is strongly recommended that you perform the exercises using a normal lens, and avoid using wide-angle or telephoto lenses. In 35mm format, normal lenses have focal lengths in the range of 40 to 60mm. In medium format, the commercially available focal lengths typically range from 75 to 100mm for the 6x4.5 and 6x6 formats, and 90

to 127mm for the 6x7 and 6x9 formats. Digital cameras do not have a standard format, but many have sensors that are 60 to 70 percent smaller than the standard 24x36 mm frame of the 35mm format. For these cameras, the 35mm focal length is the best choice of lens.

The primary reason for using a normal lens is that this focal length renders perspective pretty much in the same way that the brain perceives it. One way to consider perspective is that it is the measure of the relative size of objects when viewed at different distances. For example, assume that you are taking a photograph of two fence posts that are two feet tall, with one positioned two feet in front of the other. If the camera is positioned one foot above the ground and two feet away from the closest fence post, the second post will be rendered as being half as tall as the first post. If you were to move back and take the photograph six feet away from the first post, the height of the second post would now be rendered three-fourths as tall as the first post. In other words, as you move away from objects that are a fixed distance apart, their relative heights become more similar.

Using lenses outside the normal range will distort the appearance of perspective. Wide angle lenses create the illusion of expanded perspective because the photographer is standing closer to the subject relative to what would be expected with a normal lens. Conversely, telephoto lenses create the illusion of compressed perspective because you are farther from the subject than would be expected with a normal lens. Learning to perceive subjects and evaluate the possible compositions is easier to do when you do not have to deal with the issue of distorted perspective introduced by wide angle and telephoto lenses.

Another important reason for using normal lenses is their speed. Speed refers to the ability of a lens to gather light, and depends on the size of the aperture. Lenses are generally categorized as fast, moderate, or slow. Fast lenses are better at collecting light and most commonly have apertures ranging from f/1.4 to f/2.8. Many of the exercises involve photographing dynamic subjects with handheld cameras where fast lenses provide a significant advantage. For example, the f/1.8 aperture of an inexpensive 50mm lens for a 35mm camera will allow you to photograph using shutter speeds that are four to eight times faster than speeds achievable with the zoom lenses typically found on entry-level cameras.

Some additional equipment will be needed for some of the exercises. When long exposures are required, as will be the case for many still lifes, the camera will need to be supported on a tripod. Depending on the camera, you may also need a cable release so you can depress the shutter button without jarring the camera. Some cameras with electronically controlled shutters will not accept cable releases, but you can take longer exposures by using the self timer to impose a delay between pushing the shutter button and the exposure. This cannot be done with cameras that have mechanical shutters, but in any case, cable releases for these cameras are inexpensive.

About 10 percent of the exercises require or favor the taking of close-up photographs. Unless your camera focuses down to eighteen inches or so, you will need a close-up diopter, which is a thin lens that screws onto the front threads of lens, in the same manner that filters do. Closeup diopters tend to be impractical for rangefinder, point-and-shoot, and TLR cameras. If you do not have access to an SLR camera, the alternatives are to select larger subjects or simply to do the best you can with the smaller ones.

The exercises are designed to be done by available light (i.e., without flash), but you may want or need to use additional lighting for some exercises. In such cases, a simple adjustable desk

Although cropping can be used to correct tilted horizons, the issue remains as to whether and when tilt should be considered a compositional fault. Tilt is sometimes deliberately used to change the vertical lines to diagonals and add tension to an image. In addition, many street photographers have traditionally tolerated tilt in images For most work, tilt is undesirable because it disrupts the overall harmony of the image.

lamp should suffice. None of the exercises require specialized photographic lighting.

Monochrome or Color?

It is recommended that the exercises be done in black and white. As discussed in the first chapter, the starting point in building perceptual skills is learning how to recognize elements such as edges, spaces, and the relationships between objects. Color introduces other issues into composition, several of which are more related to applied psychology than to the neuropsychology of perception. Issues such as balance, harmony, and the manipulation of hue, value, and intensity of color are important but complicated. By photographing in black and white, it will be easier to concentrate on the fundamental elements that affect basic perception.

Evaluating Your Images

Evaluating your images is an important part of the exercises. The first step is deciding whether to crop the image. Some photographers take the view that all composition needs to be done in the viewfinder, and that images should never be cropped. This approach has some merit with regard to learning about composition and, for some photographers, is an inherent part of their style. However, most photographers are pragmatic about the issue and freely crop when it improves an image.

One thing to keep in mind is that the purpose of cropping should be to refine the image. Cropping should not substitute for learning to compose well in the viewfinder. It is particularly useful for correcting compositional problems that inadvertently occur, such as tilted horizons.

Cropping is a mostly intuitive process, and you should experiment with an image until you find an arrangement that pleases you. The major consideration for most people is how well the visual elements balance each other within the frame. Many photographers find that they can often improve a composition by cropping out most of the foreground. If this happens frequently to you, consider whether you have a tendency

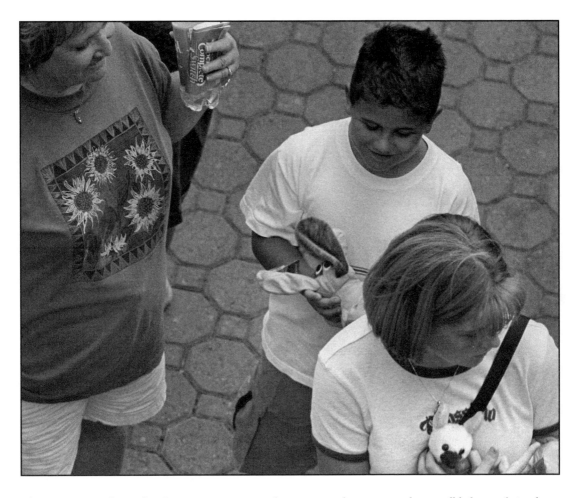

There are no inviolate rules about cropping images, but two considerations are the overall balance of visual mass and how the individual elements relate to the edges and corners.

to center the subject in the viewfinder. Unless due contemplation is given to all parts of a composition, centering the subject often results in incorporating too much foreground.

After you have finished any cropping, you should evaluate your images carefully and deliberately. It is important to be objective at this stage. Ruthless self-criticism is very productive when it is done with the constructive intention of discerning how you can improve future images. As you go over each image, try to remember what the scene looked liked when you saw it and how the composition appeared in the viewfinder. This process will help you manage visualization issues such as relationships, depth of field, and tonality. If the image did not turn out the way you expected, try to assess why. The deliberate comparison of results with the visualized perception is the surest way to improve your ability to visualize. However, remember that surprise is an element in all visual art, and that perfection in visualization is neither attainable nor always desirable.

4

Points

Points are the simplest of the visual elements, and make a good place to begin enhancing visual awareness. Two key issues that warrant attention when working with points are their size and the amount of space that separates them from other visual elements. Although the geometric point is invisible, when doing the exercises you can consider a point to be any object that occupies a small compact portion of an image. In simple images, it is possible for points to exist as independent elements. However, most photographs are complex enough that the points will typically coexist with other points, lines, and shapes. In such cases, points can exist either as dominant elements or subordinate ones.

A point is dominant if its importance to the subject matter and its position in the image determines the overall effect of the image. An example is the placement of a flower head in a floral arrangement. In such cases, the composition is constructed around the dominant point.

Subordinate points are those whose placement is determined secondarily to other visual elements. Nonetheless, subordinate points can be crucial to how well an image works. For example, the elements that most strongly influence the composition of a full-length portrait will often be the linear elements, such as the limbs and torso. Even though the placement of the head will be subordinate to these elements, it still warrants special attention because the face is an important area of interest in a portrait.

Single points are not directional, and the key to composing with them often lies in how well they are placed within the four edges of the image. The same largely holds true when multiple points are close to each other. On the other hand, as points become separated they tend to form implied lines and shapes. In such cases, points begin to take on a character of direction or form that also needs to be considered when evaluating possible compositions.

Points exist in static and dynamic forms. Static points provide good opportunities to thoroughly explore and methodically construct your compositions. Dynamic points are more challenging to work with, but learning to do so will help you take photographs under the kind of difficult conditions that don't allow for second chances. This is particularly true for fast-changing scenes with many dynamic elements. For example, the ball in sports such as basketball will be the element around which the other dynamic elements (*i.e.*, the players) organize themselves. Discerning how the players react to the motion of the ball will give you good insight into where and when the best compositions occur.

Another benefit of working with points is that it fosters a better awareness of small elements. This is particularly useful when small elements are important to an image (such as a model's eyes in a portrait). It is also important with respect to perceiving undesirable elements, such as litter in a landscape.

Exercise 1

Rocks

The prolific distribution of rocks throughout the environment makes them a common and sometimes inadvertent element of photographs depicting natural scenes. Rocks are formed through igneous, metamorphic, and sedimentary processes that occur within the crust and mantle of the Earth. Geologic processes can lift rocky material to the surface, where physical and chemical weathering causes rocks to fragment and wear into smaller pieces.

There are many ways that rocks are physically weathered. Repeated heating and cooling weakens rocks by causing them to expand and contract. This eventually breaks them into pieces. Ice and plant roots can lodge in cracks and push rocks apart as well as stresses caused by geologic movement.

Chemical weathering also affects the size and shapes of rocks. The most common cause of chemical weathering is water, which dissolves rocks through the action of carbonic acid. Other chemicals carried by water, such as humic and fulvic acids, can chemically remove portions of rocks through chelation and leaching.

Weathered rock fragments are transported throughout the environment by water, wind, and gravity. When moved about by these forces, rocks tend to accumulate at the bases of geological formations and around watercourses. Human activities also redistribute rocks. Their use as building materials, decorations, and manufacturing feedstocks causes rocks to be deposited throughout built-up areas. Construction activities such as excavation, blasting, and filling also tend to unearth, fragment, and redistribute rocks.

About the Genre

Considering their ubiquitous nature, it is surprising that rocks are not depicted more extensively as subject matter in art. Chinese art has a long established genre in which combinations of unusually shaped rocks. known as "scholar's rocks," and ornamental trees and plants are depicted in paintings. Otherwise, rocks serve mostly as incidental elements in genres such as landscapes and found still lifes.

Aaron Siskind and Paul Caponigro are photographers who are known for frequently depicting rocks in their photographs. Other photographers who have made notable images featuring rocks are Edward Weston, Bruce Barnbaum, and Ansel Adams.

About the Exercise

This exercise involves searching for rocks and photographing their relationships with other visual elements. Although rocks can have interesting forms, the main emphasis should be on assessing and depicting rocks in their surroundings and not their shapes. When looking for potential images, most of your attention should be directed toward how the rocks fit in with the other visual elements in the image.

One advantage to working with rocks as a subject is that they remain stationary irrespective of conditions such as wind. This allows the flexibility to study rocks from several viewpoints or even to return to a scene and evaluate it under different light conditions. Therefore, you should spend as much time as you need to find and evaluate scenes that you find appealing.

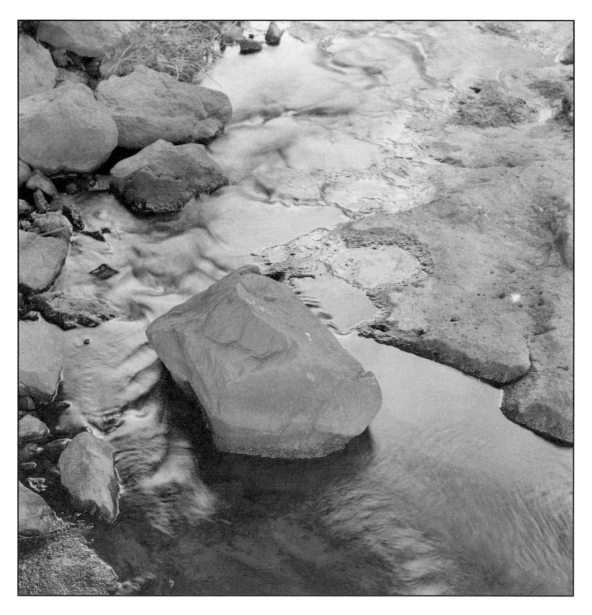

One approach to this exercise is to portray a single rock in its environmental setting. This rock is downstream from a spillway where the tailwater makes an angular jog. I saw the rock while walking toward the spillway, but did not think it looked particularly notable from that angle. When I was returning from the spillway, the rock attracted my attention because the glare coming from another angle made a background that set it off nicely. When searching for potential images, it is a good idea to be aware that previously viewed areas may present new opportunities when you view them from different angles or in different light.

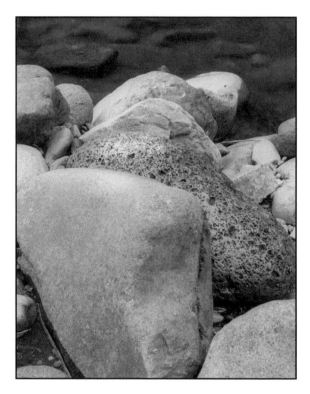

One approach to working with groups of rocks is to look for alignments that imply lines. The rocks on the bank of this freestone river tend to dominate the viewer's attention, but the submerged cobble in the upper right corner adds a subtle element that draws the continuation of the implied line into the corner.

Setting Up the Exercise

Interesting rocks are fairly easy to find. In natural environments, they tend to be deposited around geologic formations such as mountains, ridges, and cliffs, along shorelines, and in streambeds. In built-up areas, rocks can often be found near recent construction, unpaved roads, parks, and landscaped areas. For the purposes of this exercise, pebbles can work as well as boulders, so don't limit your search to rocks of a particular size.

Once you have found an interesting setting, carefully evaluate how to best compose the image. In situations where a single rock dominates the image, a primary consideration will likely be the arrangement of the rock with respect to nearby lines and shapes. In such cases, evaluate the composition from several directions and heights. Look specifically for patterns created by surrounding objects and seek to place the rock so that it

has a harmonious juxtaposition. It is also important to compose a way that isolates the rock from other point-like elements that would otherwise draw attention from the subject rock.

When working with several rocks, consider composing the image so that the points line up to form implied lines and shapes. As with single rocks, assess the implied lines and shapes from several directions and heights. Depending on the specific alignment, consider whether you want to isolate the implied lines or shapes, or integrate them with surrounding elements.

Technical Considerations

Lighting can make a big difference in how the rocks appear in photographs. Working in the early morning or late afternoon will likely produce more attractive images because the light is more even and less likely to cause blown-out

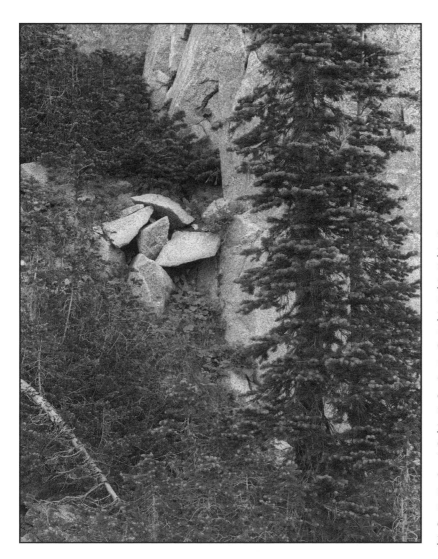

Groups of rocks can also be found in alignments that imply shapes. This cruciform assembly of granite boulders was found on the face of a cliff in the Wallowa Mountains of eastern Oregon. A key consideration in composing this image was how to place the boulders in a complex setting involving standing timber, fallen trees, brush, and the contours of the cliff itself. This particular viewpoint was selected after evaluating the scene from several positions, to the left and right and closer to and further from the boulders.

highlights or blocked-up shadows. In addition, the light is more directional, which can bring out the surface detail in rocks. Overcast skies also provide good light for photographing rocks because of the restricted brightness range and softer shadows. Shadows beneath rocks tend to be intense compared to cast shadows, and will block up as the brightness range of the scene increases. If you photograph under bright light, the shadows beneath the rocks are likely to block up into black masses without visible detail, so be sure to make allowances in the composition.

In most images, rocks will benefit by being depicted sharply and with lots of depth of field. This can be accomplished by using a tripod and stopping the lens down to a small aperture.

Exercise 2

Signs That Make a Point

Reactions toward signs tend to be as diverse as the types of messages they communicate. Most people give little thought to traffic signs because they provide useful information and generally utilize designs that are appropriate in size and content to the areas in which they are located. Billboards tend to be the most controversial kind of signs, especially in rural and scenic areas where many people feel their oversized stature and commercial content blight the landscape.

Congress started a trend in regulating billboards when it enacted the Highway Beautification Act in 1965. Since then, several states and many municipalities have enacted laws that limit the size and placement of billboards and other signs, or ban them altogether. Advertising companies and businesses have frequently objected to such laws, asserting that they unduly restrict the right to free expression.

Disputes over the balance between free expression and land use planning have resulted in many court cases challenging sign ordinances. Courts generally decide these cases based on whether the government's interest in promoting attractive communities outweighs the detrimental effect that banning billboards will have on people being able to communicate their messages. For example, courts have upheld ordinances that ban posting leaflets on utility poles because the clutter and cost of removing signs is excessive. However, governments face a very high level of judicial scrutiny when they try to regulate the content of signs. For example, the Constitution strongly favors the right of people to post political signs on their front lawns, and courts almost always hold that this activity is permissible.

About the Genre

Signs that espouse metaphor or comment on social conditions appear frequently in documentary photography. While working for *Life* in 1937, Margaret Bourke-White took a photograph showing African-American victims of a flood in Louisville, Kentucky, waiting in a bread line while standing beneath a billboard of a smiling white family in a car. The irony was that the headline on the sign proclaimed that the United States had the "World's Highest Standard of Living." Arthur Rothstein, a photographer with the Farm Security Administration (FSA) during the Great Depression, expressed a similar irony when he photographed another copy of the billboard situated next to a pair of squalid buildings near Birmingham, Alabama. Signs were frequent subjects of other FSA photographers, such as Marion Post Wolcott and Russell Lee. Over 160,000 photographs taken by FSA photographers can be viewed on the Library of Congress Web site at *memory.loc.gov/ammem/fsowhome.html*.

About the Exercise

This exercise is intended to provide experience at experimenting with metaphor by integrating objects with their visual settings. To address the metaphorical aspect, select a general theme conveyed by signs that interest you. Good examples include signs that prescribe behavior, warn about hazardous conditions, or advertise products or services.

After finding a sign that fits your theme, assess whether or not you can relate its meaning to other elements in the scene. From the visual perspective, the composition should place the

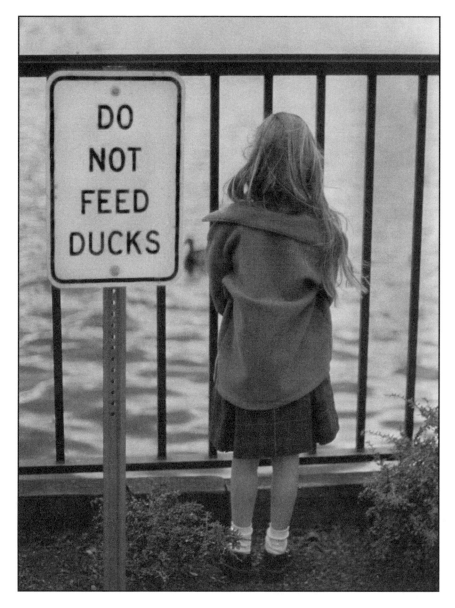

One consideration when trying to express metaphor is to place the elements so they are integrated. The three dominant subject elements in this image were integrated by taking the photograph when the duck was passing between the girl and the sign. Sometimes, you have to make compromises because of technical considerations such as low light. This photograph was exposed at 1/15 of a second and f/1.4, which resulted in a shallow depth of field. The focus was set on the girl, which rendered the sign slightly unsharp. In retrospect, this was a good compromise because the moving duck could not have been rendered sharply, and focusing on a middle-distance element resulted in the best overall zone of focus.

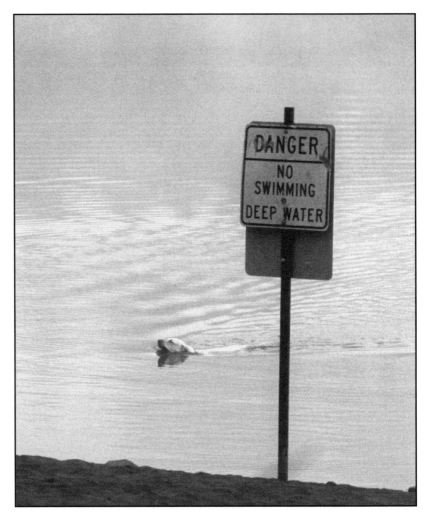

Look for different ways to express your metaphor. In a world where the authorities are constantly telling people not to do things, is it inappropriate to let a Labrador retriever fetch a stick thrown into a river? One dog owner apparently did not think so, and his dog seemed to agree. Compositionally, this photograph has two dominant subject elements that were integrated by aligning the dog and the sign with the corners. Including the piece of shoreline at the bottom shifts the visual balance toward the dog which, in turn, emphasizes the metaphor.

sign so that it shows its context with the surrounding environment. While the message conveyed by the sign is important, do not let the visual mass of the sign dominate the image. In other words, you are seeking to make more than a photograph of the sign, and need to incorporate at least one other subject element. The sign itself should occupy only a small portion of the image. Ideally, the composition should integrate the important visual elements so they neither detract nor psychologically separate from each other.

Setting Up the Exercise

Once a suitable sign is found, the major consideration in setting up the composition will be the distance and angle of the camera from the sign. The factors affecting whether the distance is appropriate are fairly straightforward; the sign should take up a small part of the image, yet be clearly readable. Similarly, the major concern in selecting the angle will be the readability of the sign. Both concerns can be easily addressed by consciously determining whether you can read

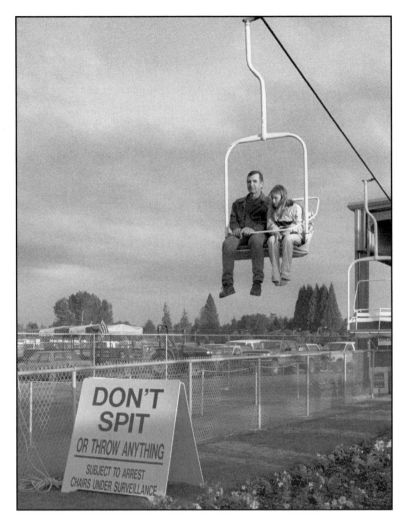

Well, perhaps some restrictions on behavior are entirely appropriate. People walking or standing beneath this tram would certainly think so. In this image, the sign and the chair are similar in shape and size, which contributes to the unity of the image. In addition, the girl looking down at the sign establishes a degree of psychological connection with its message. The expressions and actions of people in an image can be important in trying to express metaphor. As is the case with the preceding image, the dominant points are aligned with the corners.

the sign while you are assessing potential compositions in the viewfinder.

Technical Considerations

Signs can be photographed under a variety of conditions, so there are really no standard considerations that can be applied universally. Most signs have text set against a contrasting background which tends to emphasize deficiencies in lens sharpness and focusing. You can render the sign and the associated subject matter with better

overall focus by setting the lens aperture to achieve sufficient depth of field. If using a 50mm lens on a 35mm camera, this can usually be done by stopping the lens aperture down to between f/5.6 and f/11 and taking the photograph at least fifteen feet from the sign. However, limiting yourself to these parameters may cost you some nice images. Compromises in aperture, shutter speed, and distance will often be required in specific situations, so feel free to use this exercise to experiment with making these kinds of compromises.

Exercise 3

Still Lifes

The still life is the starting point in many art classes because of the simplicity of setting up or finding arrangements and the ability to render them at an unhurried pace. Still lifes are well suited to techniques such as drawing and painting because the static settings allow artists to work for extended periods of time without external factors interfering with the arrangement.

The primary approach in art classes is to work from still lifes that have been arranged in the classroom or studio. When the artist is the person who sets up the arrangement, a still life also provides an opportunity to develop skill at working with the spatial relationships of objects in three-dimensional space.

Another approach to still lifes is to find existing arrangements in their ordinary settings. For example, many of the Impressionist painters depicted still-life scenes they found in their kitchens and formal rooms. Although this approach is somewhat more demanding with respect to time, especially when someone wants to use the cutting board or eat the fruit being depicted, it avoids the need to determine the placement of objects where none existed previously and thus helps avoid the contrived appearance associated with less artful arrangements. Taking the approach of looking for "found still lifes" helps to develop the observational skills needed to isolate orderly arrangements in the midst of clutter and disorder.

While still lifes are a legitimate end in themselves, photographers who practice in any genre should appreciate their role in helping to develop skill at seeing and composition. Understanding the effect of an object's location in space is an essential skill that can be applied to genres as diverse as portraiture and sports photography. Similarly, the ability to discern and extract orderly scenes from complex visual settings is an essential skill that can be applied to genres such as nature and street photography.

About the Genre

The still life has a venerable history in the fine arts, and photography is no exception. One commonality among photographers who have widely recognized reputations for outstanding seeing abilities is that almost all of them have been proficient at working with still lifes. Some of the members of Group f/64, such as Imogen Cunningham, Edward Weston, and Ansel Adams, are classic examples of photographers who were masters at depicting still lifes.

Still lifes done as fine art generally have a different feel than those done for commercial work, such as product advertisements. It can be helpful to look at examples of both and evaluate what factors distinguish them. The distinctions are largely subjective, but tend to fall along the lines of lighting, subject matter, backgrounds, and the directness of presentation.

About the Exercise

Points have a way of being present without altering the dimensional feel of the space in which they are set. In a still life that features points, it is important to evaluate how the points relate to the other visual elements that define the setting. Points can exist as individual elements nestled among lines and shapes, in which case they usually serve as anchors of visual attention. They can

Points that are formed by different objects can still have the effect of implying lines, particularly if their sizes and shapes are similar. This is the kind of image that favors a deep depth of field that renders all the important elements sharply.

also form implied lines and shapes, in which case they can add a subtle complexity to an image.

The exercise consists of producing at least one still life from an existing arrangement found in an indoor or outdoor environment, and at least one still life of objects selected and arranged by the photographer. In both cases, it is important to try out various perspectives and visually assess their appearance before taking the photographs. It is also important to proceed patiently and methodically. Still lifes provide situations where you have all the time you need to examine visual relationships carefully and thoroughly. Make the best of these opportunities.

Setting up the Exercise

Because this exercise is structured around points, it is recommended that you limit your subjects to objects that are between one and six inches in diameter. Fruits, vegetables, small pieces of glassware, and shells are choices, but any compact object may be used. The other important consideration is the setting. Most still lifes work best when set against simple backgrounds. You can also use objects that are held by a person, provided the object is portrayed in such as way that it strongly dominates the image. Make sure that the person has sufficient patience to allow you to thoroughly assess the visual aspects of the scene before taking the photographs.

You should work at perceiving the objects as abstracted points and then evaluate how those points are arranged with respect to the adjacent elements. In some cases, the points will form implied lines and shapes. In other cases, the composition will depict the points in a relationship

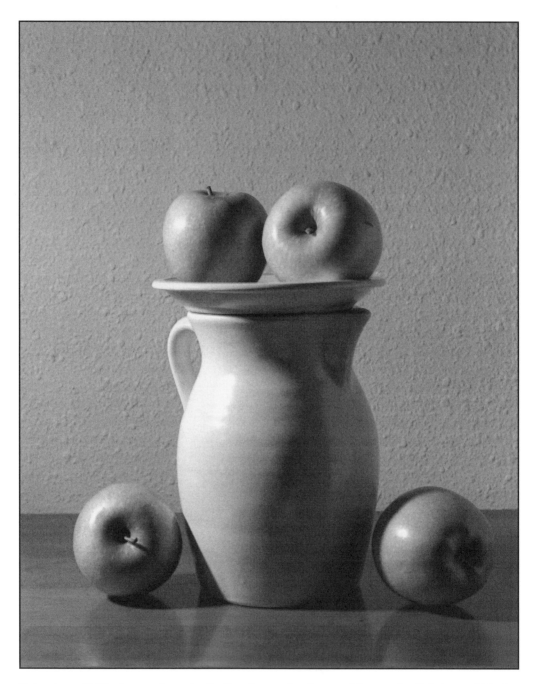

Points in a still-life photograph can be distributed around a shape and form an implied shape which, in turn, emphasizes an enclosed shape. This kind of arrangement initially appears straightforward, but its complexity becomes apparent upon further analysis. This photograph is also a good example of how you can use the works of master artists as a foundation for improving your skills. It is based on a painting that Pablo Picasso made in 1919.

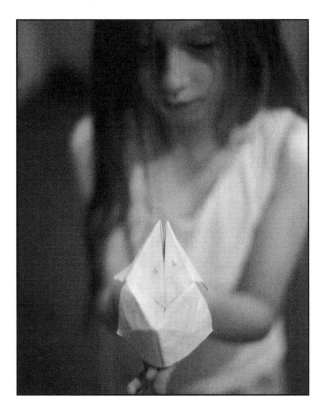

This is an example of a found still life where shallow depth of field serves to de-emphasize the matter in the background. Note how the "cootie catcher" is framed by the arms. The tones in the image get progressively darker as the edges are approached, which enhances the shapes and emphasizes the primary subject.

with other lines or shapes, such as superimposition, adjacency, or framing.

For the first part of the exercise, seek out objects in their ordinary settings that can be depicted as points. Evaluate various perspectives and determine which ones isolate the desirable visual elements from the detracting ones.

The second part of the exercise requires that you arrange objects into a still-life scene. Many people will find this to be more difficult than finding existing arrangements because arranging objects from scratch is a more substantial mental challenge. With persistence, this is a skill that almost anyone can develop. If you need inspiration, look in art books that feature still lifes. Copying the works of others is a time-honored art education technique that is very effective at teaching visual skills.

Technical Considerations

Still-life images are usually made using long exposures, so it is appropriate to use slower fine grain films or high resolution settings. In most cases, the camera should be mounted on a tripod.

You should also use still lifes as an opportunity to experiment with lighting. White paper or cardboard can be used to reflect light into dark areas and bring out more detail. Conversely, black sheets can be used to diminish the amount of reflected light and thus deepen shadows.

You can also experiment with using different depths of field. Using a deep depth of field will cause the objects to be well defined, which is often the best way to render a still life. However, using a shallow depth of field will render the background out of focus and thus isolate the primary subject and create a moody effect.

Exercise 4

Snooker

The two major cue sports are pool and snooker. Pool is more popular in the United States and snooker is more popular in the United Kingdom. Both games are played on a table with six pockets but use different numbers of balls and different size tables. There are many variations on the games, but the basic object is to hit the object balls into the pockets with the cue ball.

About the Genre

Snooker and pool have mostly been photographed within the context of sports photography, and have received little attention in other genres. Perhaps the most memorable artist depicting the game of snooker was Reg Smythe, creator of the comic strip *Andy Capp*. Snooker seemed to have a positive effect on the main character because it sometimes kept him out of the pubs or from spending the day drinking beer on the sofa.

About the Exercise

The object of the exercise is to find arrangements among the balls during the course of a game. Do not ask the players to pause while you are doing the exercise, since an important aspect of the exercise is to develop quickness in assessing compositions in somewhat dynamic settings. The height where the camera is set will have a major influence on the perception of implied lines and shapes formed by the balls. Lower camera angles tend to compress the arrangement of balls vertically, which tends to make arrangements appear more linear. Higher camera angles will favor the depiction of implied shapes.

Setting Up the Exercise

Setting up the exercise is fairly straightforward, provided you have access to a pool or snooker table. If you do not own a table or have friends

When objects that constitute points are grouped together on a common plane, they will assume the appearance of linearity as the camera moves closer to the edge of the plane. By holding the camera near the surface of the table, the balls are visually compressed into the lower quarter of the image. The implied line formed by the balls is juxtaposed with the horizontal line formed by the far edge of the table and the vertical line formed by the player.

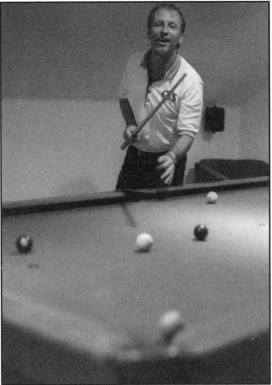

Both these compositions place the visual interest on the two balls that are hit by player and the near corner pocket. However, the image on the left relies on the line formed by the cue stick to emphasize the implied line between the balls and the pocket. Without this element, the alignments would be less apparent because

the cue ball and object ball are very close together. In the image on the right, the sense of an implied line is maintained because the distance between the cue ball and the object ball has increased. Note how the point of focus for the image on the right has shifted to just in front of the player's face to preserve his expression.

who do, one alternative is to visit a pool hall with a friend and play a few games. Some community centers also have tables. If there are no pool halls available in your locale, or if you would rather not visit one, another option is to photograph some other game or sport in which players alternate turns and play with multiple objects on a table or field. Possible alternatives include croquet, marbles, bocce, and shuffleboard.

Technical Considerations

The primary consideration will be the amount of light available. In most cases, a pool or snooker table will be sufficiently illuminated to allow you to take images at around 1/30 of a second at f/2.8, provided you use a film speed or digital equivalent of ISO 400 or higher. Flash is a good option in home settings, but might not be well received at a commercial establishment.

Exercise 5

Plants

Plants are a large, diverse group of organisms, and classifying them from the scientific perspective is a daunting task. Conversely, the diversity and ubiquitous nature of plants provides extensive creative opportunities from the artistic perspective. Although science and art may serve different functions in society, they share a common aspect when dealing with plants, in that their relevance is often tied to the perception of detail.

Modern classification systems are based on genetic patterns that represent lineages that share a common evolutionary history. The initial classifications are based on general characteristics, such as whether the plants have vascular systems or propagate through seeds or spores. As the subclassifications become more defined, the characteristics that distinguish them become more detailed and specific. For example, the various species of buttercups (*Ranunculus*) can be distinguished by whether they are aquatic or terrestrial and whether they have entire or lobed leaves, creeping or erect stems, seed fruits with or without spines, and stems that root or do not root at the lower nodes.

Botanists often use hierarchical lists of characteristics called keys to identify species of plants. Using keys successfully depends on the ability to read carefully and to perceive details in the parts of the plant being identified. Taking successful photographs of plants can also depend on perceiving details in flowers, leaves, and berries.

About the Genre

There is an established tradition of using plants as subjects in fine art and photography. Historically, artists have used plants as symbols to communicate various concepts. In the East, the Japanese use the chrysanthemum as a symbol of long life, and the Chinese use the carnation as a symbol of marriage. Symbolic plants constitute an established and complex tradition in Western art, as well. Medieval art, such as the Unicorn Tapestries, contains an abundance of sacred and secular symbolism based on plants.

While symbolism has received less emphasis in modern times, plants continue to serve as accents and points of interest in art and photography. During the early days of photography, most plants were photographed in either their cut form or in cultivated settings. Julia Margaret Cameron used flowers in a variety of ways to accent her photographs of women taken between 1864 and 1874. Over time, many photographers have depicted plants as the primary subject.

Most of the fine art photographers who have established reputations for working with plants seem more attracted to their lines and forms and have concentrated on making images in which the plants are highly isolated. However, an increased interest in nature photography has resulted in photographers expanding their subject matter to the depiction of plants in their natural settings. In this application, perceiving plants as points can be an effective means of portraying them in complex environments.

About the Exercise

Plants are more structurally complex than many people realize, and make an excellent subject for developing visual skills. For some reason, the abstracting function of the brain seems particularly adroit at dominating the processing of visual

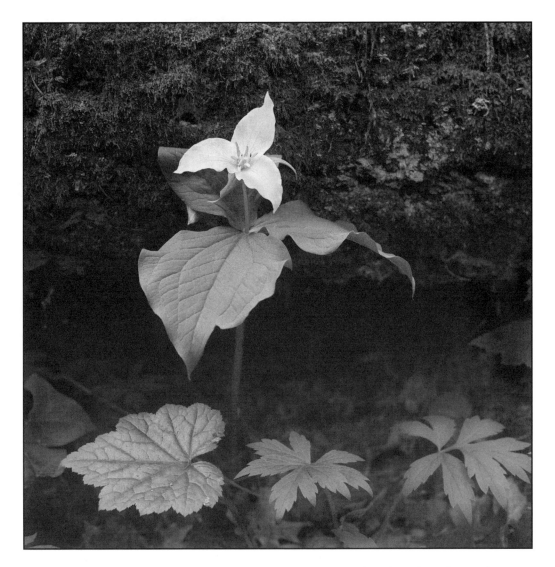

Being able to use parts such as leaves and flowers to compose images is a useful skill in trying to compose images of plants in vegetated settings. Because plants are commonly found in complex settings, it is often necessary to move in close and compose tightly in order to isolate the plants from their surroundings. The three species in this photograph illustrate the diverse structural characteristics of plants. The Western trillium (Trillium ovatum) has three white petals surrounded by three green sepals and set above three oval entire (unlobed) leaves. The leaf of a piggyback plant (Tolmiea menziesii) to the lower left is roughly heart-shaped, palmately lobed, and coarsely toothed. The leaves in the lower center and right, which belong to a Pacific waterleaf (Hydrophyllum tenuipes), are deeply lobed and sharply toothed. These species are native to the Pacific Northwest. The leaves share the common feature of having drip tips that shed rain.

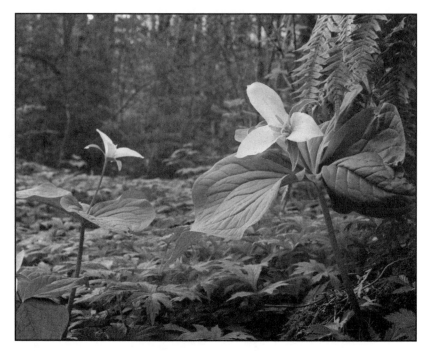

Composing plants in their natural settings can be challenging. The camera was placed a few inches off the ground so the trillium flowers would contrast with the darker background of the trees. Enough of the leaves of the front trillium extend into this part of the background to keep them from being lost against the similar tones of the ground cover. The stamens of the front trillium provide the visual detail needed to maintain the viewer's perception of the object as a flower.

information when looking at plants. This can cause you to overlook obvious visual elements unless they consciously work at perceiving the details of the plant and the surrounding scene.

The parts of plants that form points typically have subparts that can have a substantial effect on the image. Failing to depict the stamens and pistils in a flower is not always an error, but doing so can deprive the image of visual fullness. When doing the exercise, make an effort to consciously perceive the petals, stamens, pistils, and sepals of the flowers, and the edges, veins, and profiles of leaves. Also, look for defects and extraneous matter that may adversely affect the image, such as insects, damaged parts, spiderwebs, and detritus (e.g., needles, pollen, and lint). The presence of such elements will not always detract from a photograph, but their inclusion should not be inadvertent, either.

When evaluating compositions, the background warrants as much attention as the subject. Because the brain readily distinguishes the subject from more distant objects when looking at plants, it is easy to forget that distance will not necessarily separate plants from their backgrounds in a photograph. Furthermore, plants tend to have similar colors and tonalities, which means you need to examine how the edges of the subject plants mesh with forms and lines in the background before taking photographs.

Setting Up the Exercise

The exercise consists of photographing plants in outdoor settings in which they are surrounded by other vegetation. The goal is to depict plants and their parts as points in the environment while at the same time presenting the plant in an aesthetic manner. Plants can be photographed from any

Another way to isolate plants is to use vantage points that face almost directly above or below the plants. The photograph on the right shows the lighter-toned leaves of a vine maple (Acer circinatum) set out over a creek bed and surrounded by the darker-toned leaves of indian plum (Oemlaria cerasifomis). A similar approach

is taken with the photograph on the left, where the mid-toned leaves of a rhododendron seedling (Rhododendron macrophyllum) are set out beneath the sky and the canopy of a Western hemlock (Tsuga heterophylla). Both compositions required extensive evaluation to place the subjects amid very cluttered surroundings.

camera height, but the most productive level will often be found at or slightly above the main point of interest, such as the flowers or fruit.

In some cases, a little bit of gardening may enhance the scene by removing or relocating distracting elements. However, the ethics of nature photography generally prohibit the destruction of native vegetation, so in natural settings, you should avoid anything more disruptive than temporarily holding stems or branches outside the frame. Of course, alterations to private settings such as gardens should never be done without the owner's permission.

Technical Considerations

Plants are generally photographed close up and, therefore, require good depth of field. This usually makes it necessary to use long exposures, so be sure to bring a tripod when doing the exercise. Most plants are easily moved by wind and, therefore, need to be photographed under calm conditions. Fortunately, the best times for calm air tend to coincide with the best light—i.e., just after sunrise and just before sunset. Some areas experience calms at other times of the day. Patience is a virtue in waiting for the wind to die down, as it tends to fluctuate over a cycle of a few minutes.

Keep in mind that background elements such as stems and leaves will become better defined when the lens aperture is stopped down. Using depth-of-field preview in those cameras that have it is highly recommended when photographing plants. If your camera does not have this feature, make allowance for the fact that a stem that appears broad and diffuse at f/1.8 will appear significantly narrower and sharper at f/22.

Exercise 6

Eyes in Portraits

The level of attention to the appearance of the eyes is a factor that can distinguish one photographer's portrait style from another's. Understanding the factors that affect how the eyes will appear in a photograph can help concentrate one's attention on the eyes when taking portraits.

The exterior shape of the eye as seen from the camera's vantage is determined by the orientation of the head. The head is controlled by muscles that are anchored to the skull and upper body. Movement in aid of vision can thus affect the position of the shoulders and upper body, as well as the head and the neck.

The appearance of the inner portion of the eye is determined by the location of the iris and the size of the pupil. The pupils are controlled by tiny muscles within the iris that cause them to constrict or dilate, depending on the ambient light intensity. Research in the field of pupillometrics has shown that the size of the pupils has a subliminal effect on a viewer's emotional reaction to an image. People tend to be attracted to dilated pupils and wary of constricted pupils.

About the Genre

Artists have taken various approaches to depicting eyes, and some are well known for their individual styles and skills in this area. Sandro Botticelli (1445–1510) used a simple construction to obtain an elegant soulful effect, whereas Pierre-Auguste Renoir (1841–1919) used a different simple construction to get a bright expressive effect. Artists such as Albrecht Dürer (1471–1528) and Vincent van Gogh (1853–1890) sometimes used very complex constructions to depict the eyes in their portraits.

Reviewing how portraitists have rendered eyes can help develop skill at recognizing the characteristics that make eyes appear special in two-dimensional works. This can be important in photography where eyes are rendered much as they appear and not according to artistic technique. Many photographers have demonstrated their facility at capturing expressive eyes. William Klein and Diane Arbus are noted for environmental portraits in which the eyes tend to dominate. Photographers who have made images in more formal settings that emphasize the eyes include Yousef Karsch and Richard Corman.

About the Exercise

This exercise is intended to provide experience at observing the eyes and their effect on other parts of the body. Eyes are always changing their shapes and positions, and portraitists need to be able to concentrate on the eyes and judge their appearance. Becoming proficient at this skill can be a major step in making the transformation from "shoot and hope" to "compose and shoot."

The two parts of the eyes that frequently go unnoticed are the size of the pupils and the position of the irises. Pay particular attention to both and do not release the shutter until you have consciously assessed their size and position. Also, pay attention to how the shape of the eyes change depending on which direction the head faces.

While the exercise can be done in formal settings, it can also be done while people are engaged in reasonably sedentary activities, provided the purpose is to make a portrait, as opposed to documenting the activity. Examples of suitable activities are reading, watching an

Because the pupils take a few seconds to adjust to sudden changes in light, you can emphasize the effect of dilated or constricted pupils by having the model look into an area that has a markedly different light intensity than the light on the model and the background.

event, interacting with a pet, and listening to a friend. Make sure to perform the exercise in a situation where the eyes are engaged but the head does not move about much.

Setting Up the Exercise

Find a reasonably well lighted location with a good background where the model can sit or stand comfortably. It can be helpful if the model is engaged in an activity that does not require active watching, such as listening to someone on the telephone or smelling flowers. Otherwise, have the model look at near and far objects in various directions. Consciously note the shape of the eyes and position of the irises before you release the shutter. Also, check whether shadows or hair are falling in front of the eyes.

When finished, review the photographs and ascertain how well you photographed the eyes, as

they appeared to you. Pay particular attention to how the eyes appear differently depending on whether they are viewed from the front, at an angle, or in profile.

Technical Considerations

The predominant technical consideration is to focus on the eyes. While portraits do not always require much depth of field, the eyes have to be rendered sharply to appear expressive. Depending on the background, you may want to use a shallow depth of field to isolate the model. Some backgrounds, such as bodies of water, can work well even when rendered sharply. Complex backgrounds, such as urban scenes, are usually better rendered blurry. One reason why fast lenses are well suited for portrait photography is that they can be used at or near wide open to produce very shallow depths of field.

Exercise 7

Constellations

Astronomers have used photography since its inception. In fact, the first astrophotograph was a daguerreotype made in 1850 using a fifteen-inch refracting telescope. By the end of the nineteenth century, the entire sky had been surveyed with astrographic instruments, and the positions of over 500,000 stars had been charted.

Imaging continues to be a major astronomical tool, although almost all the research at the university level relies on images made with charge-coupled devices (CCDs), which are similar to cooled digital cameras. However, the significant advances over the last twenty years in film and astronomical instruments have made amateur astrophotographers fully capable of making quality images of celestial bodies equal to those formerly made by research observatories.

About the Genre

Even though films that are more sensitive than the human eye have been available for decades, a relatively small percentage of photographers have dabbled in photography of the night sky. For that matter, relatively few artists have depicted the heavens. Two paintings that evoke the feeling of a scene filled with stars are *The Starry Night* by Vincent van Gogh (1889) and *The Lawrence Tree* by Georgia O'Keeffe (1929). Some of the work of well known landscape photographers such as Galen Rowell also features stars as elements in landscapes. However, much of the best work is produced by amateurs that are mostly unheralded. *Sky and Telescope* magazine publishes some excellent work by its readers in its Gallery section, and many amateur astrophotographers display their work on the Internet.

About the Exercise

It is a shame that people tend to forego looking at objects in the sky, especially at night, because there is a lot to be seen. One purpose of the exercise is to show that directing one's perception to unconventional places at unconventional times can significantly expand creative opportunities and open up new experiences. For example, well known and frequently photographed landmarks can be given a fresh depiction by photographing them against a celestial background.

Setting Up the Exercise

This exercise requires that you go out on a clear night and photograph several terrestrial scenes with the sky set in the background. If possible, try to photograph specific constellations. Most people can recognize the Big Dipper, which is visible year round in the Northern Hemisphere. Other easily recognized constellations are the hourglass-shaped Orion, which can be seen towards the south in winter, and the hooked curve of Scorpius, which appears above the southern horizon during summer.

Film is more efficient at recording stars than the human eyes, and you can image dense fields of stars by photographing under dark sky conditions. The darkest skies can be found in rural areas, and occur between ninety minutes after sunset and ninety minutes before sunrise. The moon can significantly brighten the sky, so it is best to take photographs prior to the quarter moon phase, before the moon rises, or after it sets.

If you want to emphasize the patterns of constellations, try photographing them in brighter skies or by using shorter exposures. While pho-

Stars are most abundant around the Milky Way. During the summer, the southern end of the Milky Way is marked by Sagittarius, which is seen rising in the photograph on the left. Cassiopeia, seen in the photograph on the right, marks the northern end. The constella- *tions are difficult to discern in the dense star fields in these images, but are more easily recognized in urban skies, where light pollution washes out the Milky Way. Both images were made using fifteen-second exposures and a 50mm lens set at f/2.*

tographers are often tempted to maximize the numbers of stars in their images, sparse fields can be very attractive.

Technical Considerations

A basic 50mm lens on a 35mm film camera is a very effective tool for imaging stars, particularly when combined with fast film. Such films are recommended because they record dimmer stars, which will increase the density of the stars that appear in the images. Tabular grain emulsions, such as Kodak's TMAX and Ilford's Delta films have good reciprocity characteristics and are good monochrome films for the exercise. However, any fast film may be used.

Stars are points of light and thus are very demanding on optics. To avoid rendering the stars as distorted blobs, it will be necessary to control spherical aberrations by setting the lens aperture at one to two stops back from wide open.

Stars appear to slowly move across the sky because of the Earth's rotation, and will show up in photographs as trails if the exposure is too long. Limiting the exposure to ten to fifteen seconds will allow you to render the stars as points. Wide-field astrophotography is fairly easy to do and a good to get started in photographing celestial objects. (More information can be found in my book *Heavenly Bodies: The Photographer's Guide to Astrophotography* [Amherst Media 2003].)

Exercise 8

People at a Distance

Humans perceive distance using their vision, hearing, sense of smell, and kinesthesia. However, when judging distances in images, they can rely only on visual cues. Some of the more obvious cues are: (1) objects that partially block others are perceived as closer; (2) objects known to be the same size appear further away if they are smaller on the retina; and (3) hazy objects are judged to be further away than less hazy objects. Research into the perception of distance of real objects indicates that while binocular cues such as stereopsis (the disparity of the details seen by right and left eyes) and half-occlusion (surfaces visible to only one eye) are important sources of spatial information, perspective is the most powerful cue for determining relative distances.

The tendency to rely heavily on perspective to determine distance is one reason why wide angle and telephoto lenses distort the appearance of distance. True perspective depends only on the relative distances between the viewer and the objects being observed. In other words, the heights of the objects relative to each other will be the same, regardless of focal length. However, using lenses with angles of view that differ from that of the normal zone of dominant vision alters the relative amounts of foreground information that the brain relies on to judge distance. The altered reference base creates the illusion that objects are further apart when photographed with wide angle lenses and closer together when photographed with telephoto lenses.

The sense of space in this photograph is emphasized by the placement of the figures on opposite sides. Depicting people at a distance also tends to evoke emotions regarding their relationships to other people and their surroundings. Even though the people are far apart in this image, the fact that one is running toward the other provides a sense that they are a couple.

Placement of distant individuals at the edges of a composition can be an effective way to show their relationship to the environment. The boy looking out at the ocean evokes a sense of its vastness. Also, note how lining up the boy with the surf line contributes to the visual harmony of the image. This composition would not work as well if the boy were standing in the sandy portion in the lower right of the image.

About the Genre

While street photography is the genre in which people are most frequently depicted at a distance, this is also done in genres such as landscape photography. Reviewing photographs that depict faraway people can give you ideas on how distant points can strongly affect the emotional impact of images. For example, images that show only a few people tend to emphasize the smallness of humans in comparison to their surrounding space, and often suggest social isolation. Conversely, images that show many people from a distant viewpoint tend to suggest human activity or social cohesion. Berenice Abbott and Harry Callahan are good examples of photographers who have made good images of distant figures.

About the Exercise

The purpose of this exercise is to portray something about an environment by showing the people in it. Try to compose images so the presence of the people either emphasizes the vast spaces surrounding them or shows how people distribute themselves within open spaces. In either case, ensure that people are the dominant elements and not just incidental figures.

Setting Up the Exercise

Find a situation where you can photograph people from distances of at least 100 feet, while ensuring that they are not so far away that they cannot be identified as human figures. With a normal lens, this starts to be a concern when people are more than 250 feet away. Open areas such as parks and beaches are good settings for the exercise. Large interior spaces such as gymnasiums and auditoriums can also work. Avoid taking images in which the people form crowds that are sufficiently massed to lose the effect of points.

Take several photographs and experiment with compositions by placing the people in different parts of the image. In some cases, placing people in the center portion of the image will be effective, but placing them at the edges can also result in powerful compositions.

Technical Considerations

You will generally want to render people as sharply as possible. If feasible, set the lens at its sharpest aperture. Most normal lenses for digital, 35mm, and medium format cameras are sharpest when set at f/5.6 or f/8.

Exercise 9

Clouds

Clouds are formed by the cooling of moist air when it rises. Once the air achieves an altitude that matches its dew point, the moisture condenses and becomes a visible cloud. Clouds are classified by their altitude and whether they are heaped or layered. Small independent clouds surrounded by lots of clear sky are known as cumulus humilis. These clouds are associated with fair weather and mostly form at altitudes lower than 6,000 feet. They move over the landscape as the wind pushes them and change shape when sheared by gusts or evaporated by warmer air.

About the Genre

Clouds can be striking elements in the landscape although, like celestial bodies, they seem to be ignored by many photographers. Clouds seem to be held in more esteem by painters, possibly because the brush is able to conjure up clouds where none existed before. The English landscape painter John Constable (1776–1837) is renowned for his knowledge of skies and dramatic depictions of clouds. The French Impressionist Claude Monet also used clouds as important but subtle elements in many of his paintings.

 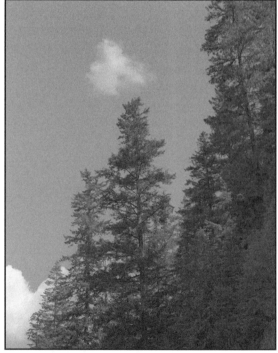

Clouds can move and change form quickly. These photographs of a cumulus humilis were taken about ten seconds apart. The cloud completely dissipated about thirty seconds after the second photograph was taken.

Among photographers of clouds, Alfred Stieglitz is probably the most recognized. His series titled *Equivalents* reflected his view that photographs can be a metaphor for life. Linda McCartney, best known for her marriage to Paul McCartney, was an excellent photographer who also created interesting cloud studies.

About the Exercise

This exercise involves honing your skills at perceiving the entire environment (including looking up) and introduces the concept of change and prediction. Clouds rarely maintain the same position and shape for extended periods of time, and at times, can be quite dynamic in their movement and form. Make it a point to observe clouds over the course of several days and note how quickly they move in relation to terrestrial objects and, how their shapes evolve. The objective is to get a sense for how much time you have to align clouds in a composition and to get a feel for predicting where clouds are headed and what they will look like when they get there.

Setting Up the Exercise

Select a day when cumulus humilis or smallish clouds are present and incorporate them into photographs in a way that establishes the cloud as an important element. While the clouds do not have to be the dominant element in the composition, they should be more than incidental. Pay particular attention to how clouds align with the other visual elements in the photographs. Feel free to be creative with respect to genres. In addition to conventional landscapes, clouds can be incorporated into almost any kind of outdoor photograph, including portraits.

Technical Considerations

Pointing the camera toward the sky can throw off the exposure metering because the sky tends to be brighter than the rest of the scene. To avoid underexposure, meter on the terrestrial portion of the scene and use those exposure settings. For monochrome images, the contrast between the clouds and sky can be increased by using a yellow, orange, or red filter.

One usually thinks about looking up to see clouds, but you can look down on them when flying in an airplane. Cloud photography is one way to pass the time during long flights. It helps to monitor the approaching landscape and predict where the clouds will be placed among the terrestrial elements.

Exercise 10

Moon and Sun

Physically speaking, the sun is much larger than the moon, but when viewed from Earth, they have the same angular diameter of about 0.5 degrees. Both objects travel along the ecliptic, which is the path that the planets follow through the constellations of the Zodiac.

The orbit of the moon is measured in two ways. Its orbit as viewed from Earth takes 27.3 days and is called the sidereal month. When viewed from the sun, the moon takes 29.5 days to reach the same point. This period is called the synodic month, and correlates to the lunar phases observed from Earth. The phases depend on the angle of the moon to the Earth and sun, and are not caused by the Earth's shadow, as some of us were erroneously taught in elementary school. The times for moonrise and moonset vary depending on the phase and time of year, but the full moon rises at sunset and sets at sunrise.

Light from the sun is very high in the ultraviolet and infrared wavelengths, and can damage your retinas if intensified by optics such as telescopes, binoculars, and telephoto lenses. However, the sun is not the notorious cause of eye damage that some have asserted. This is because the discomfort of normal viewing causes squinting and tears, which normally force people to divert their vision before damage occurs. The major exceptions occur when the sun is partly obscured during a partial solar eclipse or when inappropriate eye protection, such as sunglasses or exposed film, are used to reduce the intensity of the visible portion of the spectrum. It is safe to look at the sun during the eight-minute period before sunset and after sunrise because its light is amply filtered by a thicker layer of atmosphere.

About the Genre

Practically every culture and religion has attributed some degree of symbolism to the moon and sun in its art. Depending on the culture, the sun has served as a symbol for life, rebirth, and power. The moon has symbolized things such as intelligence, adversity, and the rhythms of the womb. Photographers, for the most part, have treated the moon and sun more literally than artists working in other media.

Except for sunsets, the moon seems to be the more popular subject for photographers. One reason is that the sun tends to produce flare in images. Another is that lack of visible detail within the sun tends to create the unpleasant impression that a hole punch was used to create a void in the image (this is also a problem with overexposed moons). *Moonrise, Hernandez, New Mexico,* is Ansel Adams' most popular photograph and is a testament to the visual power that a small point can exert in an image.

About the Exercise

One purpose of the exercise is to demonstrate that very small objects can be the most prominent elements in an image. As stated previously, the sun and moon are only one-half of a degree wide, which constitutes about one percent of the width of an image taken with a normal lens. Despite their small size in images, the brightness of the sun and moon tend to attract attention when they are incorporated into compositions.

The other purpose is to gain experience at composing images that feature large and small objects. The images need to show something more than a beautiful sunrise or sunset.

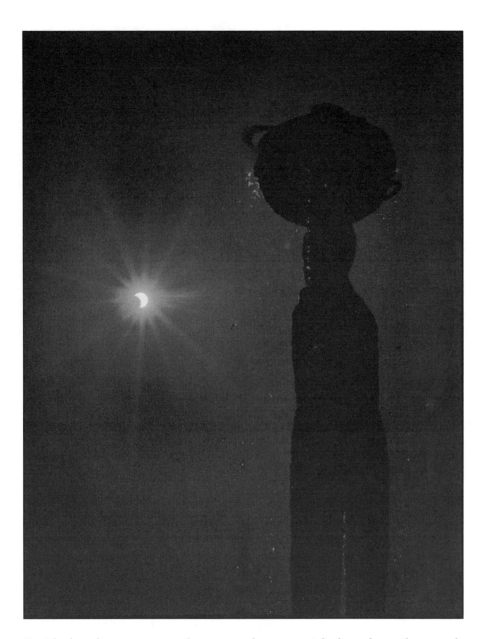

Partial solar eclipses occur every few years in most locales and can be challenging events for photographers. Information about forthcoming eclipses can be found by following astronomical magazines or Web sites dedicated to amateur astronomy. It is important to plan the shot well in advance, because partial eclipses do not always result in noticeably diminished light intensity and may last less than an hour. The range of brightness between the sun and terrestrial elements will be extreme except during sunrise and sunset, so you will likely need to underexpose the image by a few stops.

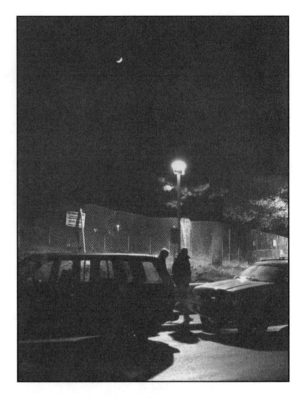

The moon in its crescent phase is easy to photograph because it does not need to show surface detail to look good. The moon in the quarter, gibbous, or full phases is difficult to photograph at night because its brightness causes gross overexposure, and the resulting absence of detail makes the moon look artificial. This photograph was taken using Kodak TMAX 3200 exposed at 1/90 of a second and f/4. Since overexposure does not adversely affect a crescent moon, exposing the image using the available light worked well.

Setting Up the Exercise

Look for situations where either the sun or moon can be photographed in conjunction with other dominant visual elements. Although landscapes are an obvious subject, the sun and moon can be incorporated into almost any photographic genre.

Depending on the phase, the moon is visible during the day and easily photographed. For the reasons discussed below, the moon will be overexposed by long exposures, and therefore, can be difficult to photograph well at night. However, it is possible to get good photographs of the crescent moon at handheld speeds.

Technical Considerations

The sun is very bright and depicting it can be challenging because, at best. it will appear as a featureless disc when properly exposed. Gross overexposure causes it to blossom into an indis-tinct orb with rays. Photographing the sun in a slightly hazy sky is often the best compromise, because the diminished intensity allows the disc to be rendered distinctly and the surrounding aura gives a more pleasing visual effect than the disc alone. The sun is very prone to causing lens flare, but this in itself does not necessarily preclude making a good image. Flare can be eliminated or minimized by photographing the sun when it is close to the horizon or partially obscured by haze.

Negative films can capture a broader range of brightness than slide films or digital sensors, and conventional black-and-white films tend to have the highest exposure latitude. Being able to record an broad range of brightness can be important when photographing the sun. It can be difficult to express the full range of brightness by printing on photographic paper and scanning film

The moon follows the path of the ecliptic and thus forms several conjunctions with planets over the course of a year. This image shows the moon in its crescent phase a few degrees below Venus.

and processing it digitally is a very efficient tool for making images when you want to render the sun distinctly while at the same time preserving some degree of detail in other parts of the scene.

During its full phase, the moon is best exposed by setting the aperture at f/16 and the shutter speed at the reciprocal of the ISO setting of the film or the camera sensor. For example, if you are using a film rated at ISO 125, the appropriate shutter speed will be about 1/125 of a second. You need to increase the exposure for the smaller phases. Reducing by one stop to f/11 works well for the gibbous phase, and reducing an additional stop to f/8 works well for the quarter phase. The surface detail of the moon is lost when it is overexposed, which creates a disconcerting impression that a hole was punched out of the image. This is less of a problem with the crescent phases, because surface detail is not needed to create a pleasing depiction.

Exercise 11

Mirrors

People have always been concerned with their appearance, and have used mirrors since ancient times to assess how they look. The first mirrors were most likely the smooth surface of water, but mirrors fabricated from polished metals were used by the Egyptians as early as 2500 B.C. Due to the difficulty of their construction, most mirrors were small until the nineteenth century, when the practice of coating plate glass with silver made the manufacture of wardrobe-length mirrors more feasible and economical. Prior to that time, mirrors were mostly used to evaluate facial appearance. In modern times, wall-sized mirrors are widely used in dance studios and fitness centers to allow self-viewing during physical activities.

About the Genre

Reflections, particularly of faces in mirrors, are frequent subjects in art. An interesting characteristic of works featuring mirrors is that while the subjects are almost always women, they are rarely depicted as vain. This likely reflects a cultural distinction between the sexes. Societies generally expect women to maintain their appearance and do not look down on reasonable efforts to do so. Conversely, looking at oneself in mirrors is not considered a masculine activity, and men who spend a lot of time doing so are typically perceived as foppish.

This predilection is related in the Greek myth of Narcissus, an attractive but self-centered youth. In Ovid's version, the seer Tiresias predicted that Narcissus would live to an old age if he never looked at himself. After spurning several nymphs (one of whom was Echo, who pined away to a plaintive whisper), the goddess Nemesis arranged for Narcissus to see his reflection in a spring. Enthralled by the image, he remained transfixed until he died. An interesting aspect of the myth is that although Narcissus fell in love with his image, he did not recognize it as himself. Narcissus has been depicted in many ways by many artists, including Nicolas Poussin (1594–1665), John W. Waterhouse (1849–1917), and Salvador Dalí (1904–1989).

About the Exercise

Reflections are one of the visual phenomena that are very common but usually overlooked during the normal course of events. Some typical surfaces that reflect objects include plate glass, shiny metal, wet sand, and water surfaces. From the perspective of making images, it is important to learn how to perceive reflections, since they can be important to compositions. For example, in some images, cutting off someone's reflection can disrupt a full-length portrait in much the same way as failing to include their feet. A similar effect can occur in landscapes, where omitting significant parts of reflected objects can adversely affect how the visual masses are balanced.

This exercise is intended to enhance the awareness of reflections by taking photographs of objects reflected in mirrors. Although mirrors are very efficient at transmitting reflections and therefore call attention to themselves, working with images reflected in mirrors is a good way to become attuned to more subtle reflections that are often present in scenes. Even though reflections from other kinds of objects may not be as intense as those from mirrors, they will behave optically in a similar manner.

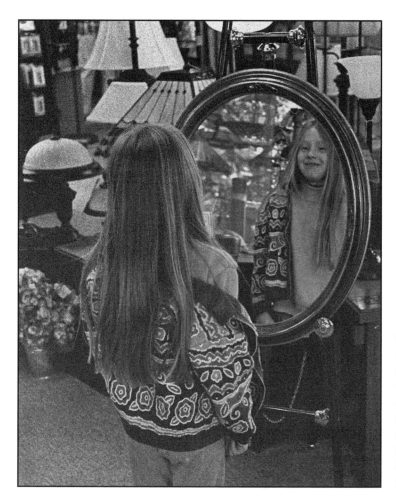

One of the goals of the exercise is to show the object in the mirror against a background that gives the image a sense of place. The reflection produced by a flat mirror is a virtual image, because it does not focus the image on or in front of the mirror. Objects reflected from mirrors will have a focusing distance that is further than the distance to the mirror.

Setting Up the Exercise

Look for situations in which mirrors are (1) reflecting point-like elements such as faces and (2) are set against an environmental background. Take several photographs which show the objects in the mirror while simultaneously providing a sense of place by using the background to show the general setting of the photograph. Mirrors tend to be more commonplace than many people assume. They are often incorporated as decorative elements in public places, such as restaurants. They also are used to facilitate viewing in motor vehicles, display cabinets, and aisleways.

Technical Considerations

In the case of common flat mirrors, the distance of the image from the mirror is the same as the distance of the object from the mirror. This means that in focusing an image that is reflected from the mirror, the lens has to be set to focus at the sum of the distance from the camera to the mirror and the distance of the mirror to the object. Since the image, mirror, and background need to be in focus, this exercise often requires a reasonably deep depth of field. In most cases, the distribution of the depth of field is best done by focusing on the image in the mirror.

Exercise 12

People's Soles

Posture is basically a matter of how people support their weight while standing, sitting, or reclining. The musculoskeletal system is the primary physiological system responsible for maintaining posture. It consists of many joints and muscles and can therefore support the body in many configurations, with varying degrees of stress on the body. The ankle and foot are particularly complex structures, consisting of over thirty-eight bones along with many muscles, tendons, ligaments, nerves, and blood vessels.

Although standing is typically associated with a state of rest, in some respects it can be more tiring than walking. Standing for long periods stresses the feet, neck, and lower back, which can lead to the formation of varicose veins and cause chronic pain in the arches and heels. One of the ways that people who spend a lot of time standing attempt to reduce stress on their bones and muscles is by shifting around to avoid maintaining the same joint positions for extended periods. By partially or completely lifting part of the opposite foot off the ground, they shift their body weight from one leg to the other and thus limit the stresses experienced by any one joint.

About the Genre
The soles of shoes and feet do not form the basis of any particular genre, but the ability to perceive nuance and body gestures distinguishes the work of many of the great portraitists and street photographers. Arnold Newman is a good example of a portrait photographer whose work is notable for depicting subtle but powerful nuances associated with the posture of the subjects. Among street photographers, Harold Feinstein's work often shows people in interesting but natural looking postural positions.

About the Exercise
The ability to notice subtle aspects of posture and gesture can be very important when photographing scenes that include people. This exercise is intended to enhance the ability to perceive subtle aspects of posture and how they affect a person's appearance. Although the specific goal is to take images where the soles of feet are visible, the experience of learning through observation is an important aspect of the exercise.

You should pay attention to how people hold their feet up, for how long, the kind of footwear they are wearing, and how often they shift their feet. You may notice that there is a lot of individual variation in how people hold their feet off the ground. For example, some people favor rotating their feet over their toes and others rotate over the side of the foot.

Setting Up the Exercise
The basic objective of the exercise is to develop perceptual skills, so do not be concerned if you are not producing great works of art. What is important is that you (1) are able to spot situations in which standing people are likely to shift their feet, (2) actually see people with the soles of their footwear visible, and (3) are able to get at least a few images. This exercise requires that you look for a specific and typically fleeting event, so it is helpful to find a setting in which a lot of people will be standing. Good candidates include places where people are shopping and events such as fairs and festivals.

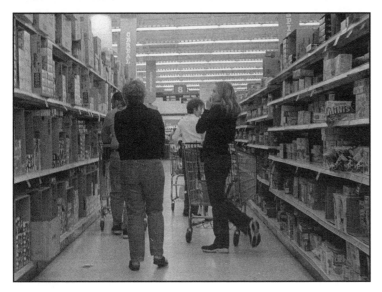

Lifting the feet so that soles are exposed is a common but generally unnoticed activity that people do mostly to relieve stress on their joints. People lift their feet in a variety of ways. The images on this page show feet being lifted high onto the ball of the foot, rotated onto the side, lifted onto the toes, and lifted slightly onto the ball of the foot. Such nuances are subtle but have significant effects on posture and the perception of attitude.

Technical Considerations

This is the kind of exercise that will most likely be conducted with a handheld camera, and although the subjects will be stationary, the shutter speed should be set sufficiently fast to get a sharp image. Since you may not be able to predict exactly which subjects will shift their feet, good focusing skills can be important. Autofocusing can help, but sometimes the environment will be too cluttered for the camera to focus accurately on the targeted foot. Zone focusing or presetting the focus in the vicinity of the most probable distance from the subject can be good approaches in such situations.

Exercise 13

Birds on the Ground

People tend to associate birds with flight, but most species spend the majority of their time at ground level or perched in high places. Although the major survival activities, such as feeding, courtship, and nesting, generally occur while at rest, the manner and degree vary significantly among the species of birds. You can learn a lot about how a particular species has adapted to its environment by observing how its members engage in activities when not in flight.

One survival activity, avoiding predation, reflects a strong association of the body type of a species with its environment. Waterfowl, for instance, tend to float on water bodies or stand close to shorelines where they can make themselves inaccessible to many kinds of predators. Chickadees, which are small and unable to swim, rely on their active temperaments and avoid resting in any one place for more than a few seconds when they are foraging for food. American robins, perhaps the most adaptable species of bird in North America, favor foraging in open areas such as lawns where they have time to flee from approaching predators.

About the Genre

Many people feel a special attraction toward birds, and avian art dates back to Paleolithic times. The attraction of art featuring birds is sufficiently strong that the paintings by John James Audubon were an important factor in the development of the conservation movement during the nineteenth century. Roger Tory Peterson is another artist whose illustrated field guides have been used by birders for decades and has influenced the public's affection for birds.

The demand for illustrations that can be used to identify species has strongly influenced the development of bird photography. Most bird photographers seem to favor taking close-ups of their subjects that typically show little habitat or survival activity. Nonetheless, many of the best examples of bird photographs show birds set in the surrounding environment engaged in activities such as feeding or courtship. As noted above, relating species to their habitats is an excellent way to learn more about birds, and making images that show birds in such contexts can help you understand them better.

About the Exercise

Birds, even at rest, rarely remain still. This exercise is intended to give you experience at observing and depicting subjects that are constantly changing their position and orientation. It also involves assessing where birds are located with respect to other elements in the composition, as well as monitoring their profile and overall appearance.

To do this exercise well requires that you analyze the settings around the birds and not just depict the birds themselves. Pay particular attention to the lines and shapes that surround the birds and their orientation to the camera. Birds are constantly moving their heads, and photographs generally work better when the subjects are not facing away from the camera. In addition, you should observe how birds that are in groups position themselves with respect to each other. As they move about within the group, they should present you with opportunities to photograph arrangements of implied lines and shapes.

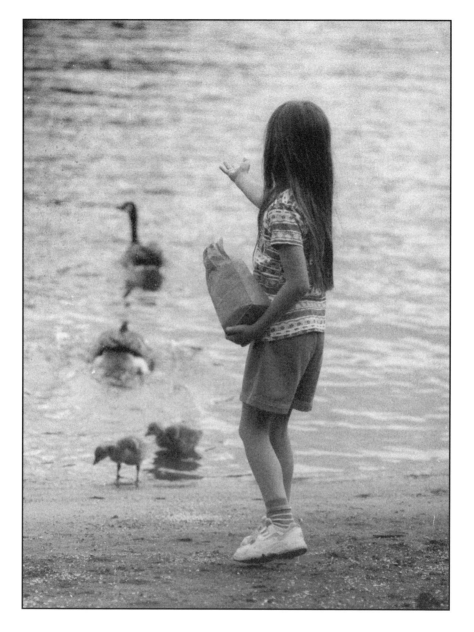

The implied lines and shapes formed by birds on the ground or in water can be very fleeting, and capturing them on film requires patience and vigilance. The four geese in this photograph are members of the flock shown on page 75. The isolation of the four geese in the image and the implied line that they form lasted only a moment.

Birds tend to move about in their environments and will usually position themselves in ways that provide good compositions if you are patient. The mallard was milling about this stretch of a small forested stream and was watched for about ten minutes before this photograph was taken.

Setting Up the Exercise

Even though larger birds are easier to photograph with normal lenses, feel free to photograph any species. Irrespective of focal length, a major challenge of bird photography is getting close to the subjects. Birds in the wild are often wary, but will tend to ignore you if you stay still or move very slowly. As a general rule, it is considered ethical to attract birds with food, but approaching nests or harassing birds is unacceptable behavior.

Most species tend to be constantly moving their heads and will frequently shift their bodies, as well. Getting good images thus requires a combination of vigilance, patience, and rapid action. Although this can make for some difficult photography, once you find a good situation, you should get a lot of opportunities to make images. Pay particular attention to the eyes.

Some good places to find wild birds are parks, bodies of water, and open spaces. Domestic and captive birds can be found in places such as zoos and farms. You do not have to limit yourself strictly to birds on the ground. Birds floating on water or perched in trees or similar places fall within the scope of the exercise.

Technical Considerations

Because they tend to be constantly moving, birds are usually best photographed using fast shutter speeds, even when they are resting. Many bird photographers shoot almost exclusively with their lenses set at the maximum aperture to obtain the fastest shutter speeds possible. This may not be the preferred strategy when you are trying to depict an environmental setting, so be prepared to make compromises regarding depth of field.

One way to get a group of objects on a common plane to assume the character of an implied line is to place the camera near the edge of the plane.

Individual birds within groups tend to move around and provide opportunities to depict them as implied shapes, such as the semicircle formed by the geese in this image.

Exercise 14

People Eating

The sharing of meals is a universal cultural tradition with deep social and religious roots. During biblical times, meals in Jewish and Christian communities were characterized by a formal breaking of bread and honored as a time for prayer and fellowship. It was during the Last Supper that Christ described the sacrament of Communion and provided final guidance to his disciples prior to the Crucifixion.

Eating meals together is also an established secular custom that pervades all kinds of social functions. At the personal level, eating at restaurants is one of the most popular dating activities, and at the family level, psychologists have established that sharing meals is beneficial to family harmony. Food is an important element of most social functions, including sporting events, wedding receptions, and neighborhood cookouts.

Sharing meals is also important in the commercial context. The business lunch is a preferred means of establishing commercial relationships among professionals and businessmen. In addition, many businesses hold office parties and celebrate employee birthdays to foster morale and organizational cohesiveness.

About the Genre

Restaurants, cafes, and nightclubs have featured prominently in the works of several photographers, especially those based in Europe, such as Andre Kertesz and Robert Doisneau. The sharing of meals has also been an important theme in other visual arts. In his series the *Four Freedoms*, the painter Norman Rockwell chose the setting of a family gathered at a Thanksgiving dinner to illustrate the concept of freedom from want.

About the Exercise

Meals are shared at just about every level of society and in a wide variety of social contexts among friends, couples, adults, and children. Meals also occur in many settings, including restaurants, homes, and public spaces. This exercise is intended to provide experience at observing social interactions in a cultural context.

The most important element in most photographs involving meals are people's heads, because people tend to maintain psychological connection through speech and eye contact during meals. Although the nominal purpose of meals is nourishment, you will likely find that the food itself does not have to be visible in the image to convey the nature of the event. Most of your attention during the exercise should be directed toward the social aspects, because depicting the interaction between the participants is what makes these kinds of images compelling.

Setting Up the Exercise

This is an exercise in candid street photography, which will depend in large part on finding a suitable setting. Food courts and informal restaurants can be good places, as can large events and neighborhood gatherings. This kind of photography is often unwelcome at establishments that cater to fine dining unless you are a member of the group you are photographing.

Try not to draw attention to yourself while taking photographs, but do not act furtive, either. Generally, try to avoid photographing people while they are putting food in their mouths, because this usually comes across as unflattering. Also, try to be respectful of the patrons by being

Mealtimes are common yet culturally important events. Although food is not visible in the images above, the social significance of shared meals is evident. Taking such images requires skill at being unobtrusive. You can tell by the profiles of the tables in these images that the camera was supported by resting on an adjoining tabletop.

unobtrusive and limiting yourself to only a few photographs of any particular person.

Technical Considerations

This is definitely the kind of exercise that needs to be done by available light if you want to avoid coming across as a paparazzo. Compact rangefinders are a good choice for this exercise, if you have access to one, because they are quieter and less obtrusive than single lens reflex and bulky medium format cameras.

In many settings, fairly slow shutter speeds will be required even if you use fast film and lenses. You may want to use ambient camera supports, such as counters and tabletops. If you need to raise the camera a bit to keep the surface out of the image, try resting it on an object such as a book. In this kind of photography, the ability to compose and time an image without using the viewfinder is useful.

Ambiance can add something to an image. The character of this restaurant, expressed by its inexpensive and quirky decor, makes it a good setting for showing a meal between friends.

Exercise 15

Heads in the Street

The position of the head is a major visual clue regarding how people are behaving toward each other. For example, the position of a person's head can tell us where their attention is directed, their priorities, and their place in a social hierarchy. The orientation of heads relative to members of a group also provides information about what is happening in a given scene and its collective importance.

Head orientation is not always as important an indicator in other species of animals. Although many species have their eyes set on the front of the skull, as do humans, they are typically predators or tree dwellers whose survival depends on depth perception. Most species have eyes placed on the sides of the skull. These tend to be herbivores whose survival depends on using peripheral vision to detect distant motion and provide warning of predators. While the orientation of the head can provide information about an animal's emotional state, other clues are often more revealing, such as the placement of a horse's ears or the motion of a dog's tail.

About the Genre

Heads are a natural subject of human attention and have been depicted in most art genres. Many of the best known masters have shown great skill in depicting emotion through head position, and variations in their approaches often characterize their style. For example, many of Édouard Manet's paintings show the dominant models with their heads facing slightly away from the plane of the work but with their eyes gazing directly at the viewer. Unlike portraits by other artists who have portrayed models with similar poses, Manet's works give the strong impression that the model's attention is intensely interested in the viewer.

Heads have also been featured prominently in the works of street photographers who have shown a predilection for composing images with prominent points. Two notable examples are Garry Winogrand and Robert Frank.

About the Exercise

This is an exercise in street photography in which you depict heads in terms of their compositional and psychological aspects. The two requirements are that the photographs be candid and feature two or more heads.

At the compositional level, you should think of the heads as points that need to be placed in the images with some deliberation. Since you cannot control the location of the points in the environment, you will frequently need to compose by placing the frame of the image over the points, as opposed to waiting for the points to align themselves within the frame.

At the psychological level, the exercise requires you to consider how the heads convey information about either the subjects' behavior or an event happening in their environment. What is important is that the image give some sort of feeling about what the subjects are doing. In doing so, you should discover that the orientation of heads is a very powerful visual clue regarding what is on a person's mind.

This exercise also requires you to distinguish between suitable and unsuitable backgrounds. This can be difficult to do under the often hectic conditions associated with street photography but

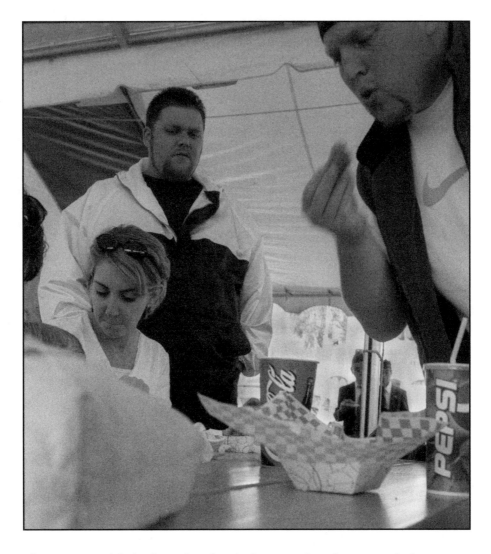

*The orientation of the head provides a lot of information about the matters which are con-
cerning people. The man in the foreground is concentrating on taking sustenance, the
woman is concentrating on a baby, and the man in the background is taking it all in. Their
heads form an implied triangle that visually balances the masses at the bottom of the image.*

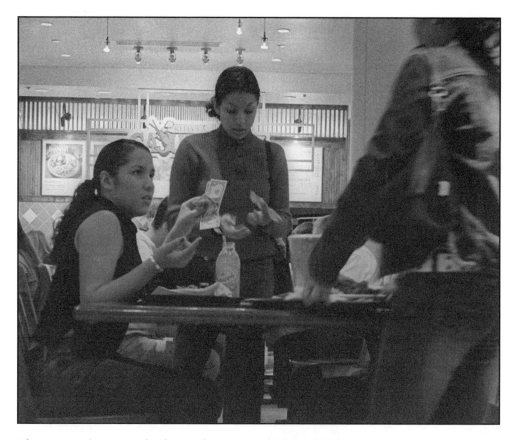

The position of a person's head can indicate to whom or what that person's attention is directed. In this photograph, the fact that one woman is counting money while the woman on the left is holding money and looking at the face of a third suggests that some sort of cost allocation is in progress. At the compositional level, the heads of the three women form a shallow triangle, which draws attention to the social nature of the group.

is nonetheless important. Once you get a sense of the speed required to discern a scene and obtain an image that depicts it, it should become easier to concurrently assess the subject and the background. With practice, it is possible to evaluate, compose, and take these kinds of images even though the scene may last only a few seconds.

Setting Up the Exercise
Apply your imagination in finding suitable settings. Good opportunities can likely be found during your daily routine but can also be sought at any place where lots of people aggregate. Situations in which people are sitting or standing in one place can make it easier to discern good ways to compose the heads in images.

Technical Considerations
Hand-holding the camera is the normal mode for street photography, but makeshift camera supports such as tables and trash receptacles can often be used. Becoming proficient at holding a camera at slow shutter speeds is helpful when photographing under street conditions.

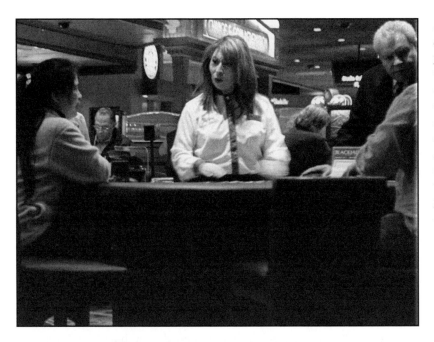

Positions of the head can be a major visual clue that people are in engaged in conversation. The dealer at a blackjack table is talking to one patron while the pit boss is talking to another in a separate conversation. Note the Gestalt effect of closure; although you cannot see the head of the patron on the right, you can sense his presence.

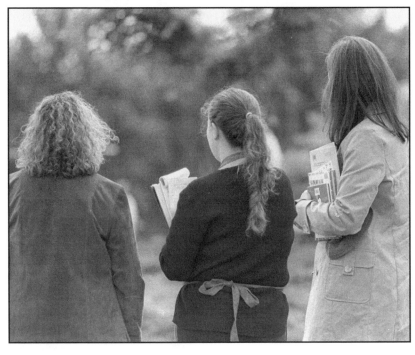

Even though the object that the people in this image are looking at is not visible in the frame, the position of their heads makes it clear that it is a subject of common interest. The variation in the positions of the heads also provides a clue as to distance between the object and the group.

Exercise 16

Similar Objects

Louis Henry Sullivan (1856–1924), a major innovator in modern architectural design, coined the phrase that "form follows function." The basis of his approach to architecture was the rejection of historic styles in favor of designs that expressed their nature through structural function. Ironically, his pioneering work with tall steel frame office buildings eventually led to criticism that such structures were looking too much alike.

The concept of form follows function is seen in disciplines other than architecture, and accounts for the similarity of shape seen in many kinds of objects. In some cases, functionality is so dominant that common objects have maintained similar shapes over the course of centuries. Two examples are metallic coins, which date back to China during the second millennium B.C., and bound books, which have existed since the fourth century A.D. Even recent innovations such as cellular telephones and portable CD players seem to have settled on similar shapes.

Sometimes, the development of new materials can introduce modern designs that address functional needs, but in most cases, they do not supplant the traditional design. For example, plastics have enabled the development of new drinking containers such as bottles with push-pull caps. Although these designs have largely usurped specialized containers such as canteens, they have not replaced traditional wares such as the cup.

People handling similar objects do not have to be engaged in exactly the same action for the image to effectively convey the sense of similarity.

The use of identical or similar objects that are repeated in a pattern is a standard graphic design concept. When applied in practice, it frequently relies on the geometric formality of the arrangement for its visual effect. However, it can also be effective when used informally, as *shown in the photograph on the left. However, incorporating such elements in an unpatterned way can also work well because the similarity of the objects helps to unify the image (as shown by the reading material in the photograph on the right).*

About the Genre

The repetition of elements is a well known graphic design concept that has been widely used and advocated in photography. It is a prominent compositional feature in many of the photographs by Margaret Bourke-White.

About the Exercise

Although the theme of repetition is a standard topic in the literature about photographic composition, this exercise goes beyond looking for similar or identical objects arranged in a pattern. Instead, it requires that you find and photograph people who are holding and using similar objects as they go about their ordinary activities. The exercise is specifically intended to extend seeing skills beyond perception of patterns so that you will be able to associate functional activities with their spatial relationships. It will also help you develop skill at perceiving objects in settings where their presence cannot be anticipated with a high degree of certainty.

Setting Up the Exercise

The exercise should be done in some sort of public setting, and requires you to photograph at least two people who are independently engaged in the same activity using similar objects. Examples include reading, talking on telephones, and exchanging money. It is also important that the object be functional, rather than decorative. It can be helpful to explore places where these kinds activities are likely to happen. For example, people tend to read while on public transportation or in waiting areas, and drink from cups in areas where food and beverages are served. The popularity of cellular phones has broadened the number of places where people talk on the telephone. Common places for this activity now include sidewalks and automobiles.

Technical Considerations

This exercise involves street photography and has the same technical considerations as the previous two exercises.

Exercise 17

Bowling

Although bowling is played on a standard sixty-foot lane, its popularity among players at all levels of skill results in a variety of individual approaches to the anatomical problem of delivering a heavy ball to a cluster of pins. While the consensus among experts is that a four-step approach using a natural unforced arm swing is the best technique overall, even professionals at the hall-of-fame level have succeeded with radically different methods. At the recreational level, there seem to be hundreds of individual variations. These deliveries range from the barely perceptible progress of six-pound balls lightly pushed at the foul line by small children to sixteen-pound rockets heaved by macho amateurs seeking to impress their girlfriends.

About the Genre

For the most part, the photography of bowling is a specialized area of sports photography. Although bowling alleys are frequented by various and interesting kinds of people, for some reason, they have never been popular settings for street photography despite the reasonably good lighting and casual ambiance that facilitates this kind of photography. Most photographs depicting bowling show bowlers approaching the foul lines, and rarely depict the pins being knocked over. One likely reason is that it is difficult to get sufficient depth of field to bring the pins and bowler in focus. Another reason is that there is normally a three-to-four second lag between when the ball is released and when it hits the pins, and by this

Most right-handed bowlers aim for the right-hand strike pocket between the headpin and the three-pin.

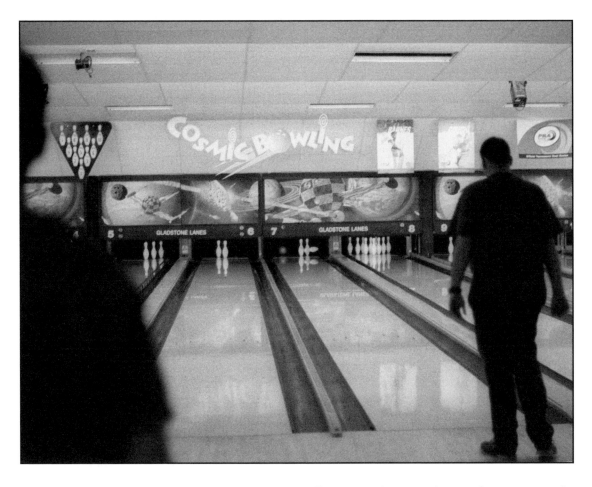

Another way to work on your seeing abilities while doing the bowling exercise is to watch how the pins fly after they are hit by the ball. Many people assume that the fall of the pins is too fast and complicated to observe, but in most instances, it is not that difficult to follow. As can be seen in this missed spare attempt, the ball is capable of propelling pins with considerable force and distance. During a strike, the ball itself may only hit four pins, so success depends on the remaining pins being carried by the pins moving off the ball.

Children tend to bowl at slower speeds and are more likely to remain at the foul line until the ball reaches the pins. Note how lighter colored balls show up better in images than dark ones, which blend in with the pit.

time, the bowler's posture often no longer suggests the action of bowling.

About the Exercise

This is the first of the exercises that really require split-second timing to capture the action. Bowling is used to introduce this skill because the action is largely confined to a single dimension, and bowling alleys are widely accessible. Unlike conventional bowling coverage, the object of the exercise is to photograph the pins as they are being struck by the ball.

Setting Up the Exercise

Go to a bowling alley and set yourself up at the sitting area in front of a lane. From this position,

you should be able to take good photographs of the lane in front of you and the ones to either side. It is helpful to know the people being photographed because some bowlers do not like being watched while they bowl. Keep in mind that you can avoid disturbing other bowlers and the establishment by renting a lane and taking turns with a friend. If you have to rent shoes, do not forgo the opportunity to have your portrait taken while wearing that great-looking footwear.

Watch several bowlers, and you should notice that the speeds and angles of the delivery vary considerably. Before actually taking photographs, you may want to practice some by looking through the viewfinder and predicting when you should release the shutter. This exercise will

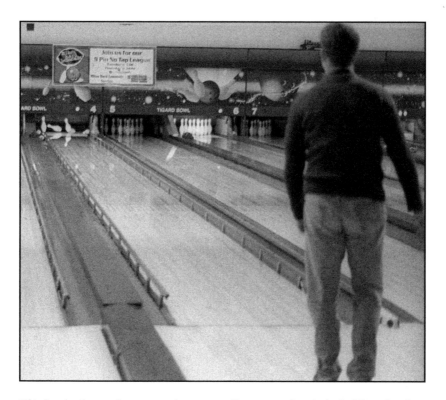

This bowler favors throwing rockets, which are difficult to photograph because of their speed. Nonetheless, they are impressive because they hit the pins with explosive force and make a lot of noise. Notice how the pins are still flying even though the ball has already passed into the pit behind the lane. This style is not always favored at the upper level of the sport because it tends to make the arm swing less consistent. However, it is fun to watch.

likely not be as easy as you may think. One way to approach the problem is to abstract the ball as a small circle and the base where the pins are set as a horizontal line. Abstracting this further to a two-dimensional plane, the circular point will appear to rise slowly up to the line, and then overlap it. The shutter should be released when the bottom of the circle reaches the level of the horizontal line. With practice, you should be able to determine intuitively the moment at which to release the shutter. Your percentage of successful images should increase, as well.

Technical Considerations

The light in the typical bowling alley should be sufficient to shoot at 1/60 second at f/2 when using an ISO 400 film. If your lens cannot be set at f/2, use film with a higher speed. In some centers, the lighting will be brighter during daylight hours at the lanes closest to the entrance.

The typical seating area is about seventy-five feet from the pins. If shooting at a wide aperture, which will generally be the case, the point of best focus will be just short of infinity. You can use the text at the end of the lanes to help set the focus.

Exercise 18

Mouths in Motion

The mouth is used universally in the animal kingdom as a structure for the intake of food. In most species, it also serves other functions, such as respiration, defense, and communication. In humans, the mouth is an important means of expressing emotions and is one of the significant characteristics by which appearance is judged.

Smiling is an example of an expression that depends on the mouth. This gesture is understood in every culture and is generally associated with happiness. Several muscles are involved in making facial expressions, and the mechanics of smiling can be quite complex. The adage that it takes more muscles to frown than smile is not entirely true. While it takes only two muscles to produce the contrived "beauty contestant" smile, many more are used to produce the kinds of smiles that are associated with genuinely happy expressions.

About the Genre

Depicting mouths has been a long-standing concern of photographers. During the nineteenth century, persons being photographed generally adopted austere expressions. One reason was to avoid moving during exposures that could last several seconds, but mostly, it was due to social customs that favored solemnity in portraits over what otherwise would have been forced smiles.

Although mouths are undeniably important to a person's appearance, many photographers show little proclivity to considering how mouths can be used as visual elements. This is true even of photographers who are well known for their portrait work. Some photographers who seem particularly adept at depicting mouths in photographs are Richard Avedon, Edward Weston, and Weegee (Arthur Fellig).

Laughing is easy to capture in photographs, particularly in photographing groups. All that you have to do is release the shutter when you hear the subjects laugh. Although perceptive seeing is usually founded solely on sight, engaging the other senses can sometimes help. When photographing people who are singing or speaking, being able to associate specific sounds with how the mouth appears is an enormous advantage.

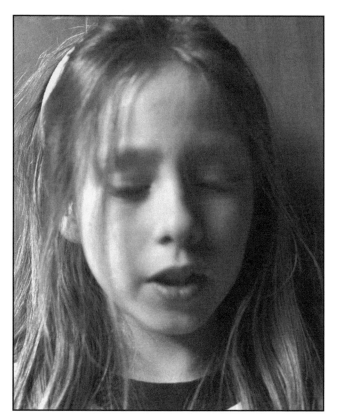

Recitation and singing are easier to depict if you can observe how the mouth changes during a poem or song. Capturing recitation in an image is much more difficult than capturing singing because the mouth movements are more subtle and less sustained. Learning how to associate sounds with visual elements can be helpful in other contexts, as well. One example is listening for the sound of the bat hitting the ball when photographing a baseball game.

About the Exercise

Taking photographs of smiling or frowning people is simple enough, but conveying the action of speech or singing is much more difficult. This exercise is intended to help you recognize and anticipate rapidly changing details, and also to introduce the concept of using senses other than sight when making images of dynamic scenes.

Setting Up the Exercise

Set up a situation in which at least one person is speaking, laughing, or singing. Reciting poetry and singing are particularly good because you can associate the appearance of the mouth with specific words and time your shots accordingly. Before taking photographs, watch the person for a period of time and observe how they alter their mouths depending on what is being said. Singing is easier to depict than speaking because the mouth tends to open wide during sustained notes, and standard lyrics make the voicing more predictable. Reciting poetry can be done to like effect but is more difficult because of the decreased vocal range relative to singing. Laughter is fairly easy to depict, because all you have to do is release the shutter when you hear people begin to laugh.

Technical Considerations

The shutter speed should be at least 1/60 of a second to stop the action. If the image does not encompass a group of people, the depth of field generally needs only to be sufficiently deep to render the mouth and eyes in focus.

Exercise 19

Birds in Flight

Birds exist in an immense variety of forms and exhibit an equally broad diversity of flight behaviors. The way that a species flies will depend on a number of factors, including the means by which it obtains food. For example, hummingbirds zip from flower to flower when feeding on nectar, whereas raptors search for prey by soaring in large graceful circles at lofty altitudes.

Some species tend to fly in flocks, while others are mostly solitary. Even species that fly in flocks show broad differences in spacing, geometry, and coordination. Songbirds tend to form loose random aggregations, while seabirds such as pelicans tend to fly in tight structured formations. Other kinds of flock behavior exhibited by flying birds are the aggregation of pigeons and crows prior to roosting and the V-shaped flocks that geese form during migration. Ornithologists have posed various theories for the varied flight behavior among birds, such as protection from predators, communication, and navigation. Whatever the reasons, the complexity of flight among birds is something that most people do not notice unless they intentionally look for it.

About the Genre

Bird photography, a standard subgenre of nature photography, places some of the most demanding requirements on equipment. Most serious bird photographers use long telephoto lenses, finely machined tripod heads, and highly automated camera bodies to deal with the challenge of photographing small and fleeting objects. Nonetheless, it is entirely feasible to use normal and wide-angle focal lengths to make photographs that show birds in their environments. Although equipment is important, success in bird photography usually depends on how well the photographer understands and observes bird behavior.

Eliot Porter, Tom Mangelsen, and Arthur Morris are just a few examples of well-known bird photographers. Most of their works are used to illustrate books and periodicals about birds and nature. Birds in flight have not been featured very often in fine art photography, although a few photographers seem to have enjoyed dabbling in images of dead ones on the ground. For those photographers who prefer their action live, birds make good subjects for interesting images, provided that sufficient time is spent observing where and how they fly.

About the Exercise

This exercise can be approached in several ways. For example, you can photograph birds to document the variations of flight behavior among several species, or concentrate on documenting the flight behaviors of a single species. The important thing is to develop skill at observing how birds behave at the environmental level, and learn to see the compositional aspects of how birds arrange themselves with respect to each other and their environments.

When planning images, pay attention to how the birds are positioned with respect to each other and within the scene. Some elements to consider are alignment, distance from the horizon, and the direction of flight. Birds are not the most predictable creatures, and it pays to be alert to sudden actions and unexpected compositions.

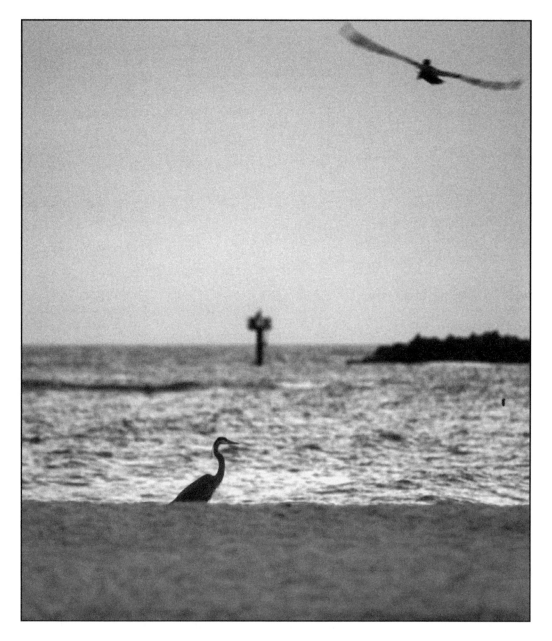

One of the things that makes birds in flight an intriguing subject is that they sometimes pass through scenes when you least expect it. Taking advantage of these opportunities requires quick recognition and reflexes. However, it is important not to react too quickly, because precise composition is often critical to images with flying birds.

Quick reflexes and patient waiting may seem paradoxical when the time available to compose an image is typically a fraction of a second. However, it is reasonably easy to train yourself to make the image when the composition "feels" right and to resist the urge to trip the shutter in a rush to catch the bird in the frame.

If you watch flocks for any length of time, it becomes apparent that the behavior of their members is not as straightforward as might be assumed. Although pelicans tend to organize themselves in either linear or geometric patterns when flying, the fact that the middle bird in this image is turning suggests that pelican flight behavior is much more complex than the flock merely following the leading bird.

Setting Up the Exercise

The key to most photographs of birds (and an obsessive concern among devoted bird photographers) is to get sufficiently close to the bird to make it relevant to the image. One traditional means of doing this is to get optically close using telephoto lenses with very long focal lengths, but this method is beyond the scope of this exercise. The other means is to get physically closer. Careful observation of the birds of interest should provide good information on how to get close. For example, birds often use established flight paths and frequent specific feeding places. Songbirds often prefer to fly between specific trees and similar resting places. Seabirds tend to fly near specific land forms such as promontories. Feeding areas are another common destination.

Once you discern some suitable flight paths, select a vantage point from which to take photographs. If you remain in one spot and move slowly, flying birds will feel less threatened, come closer, and be less inclined to veer away.

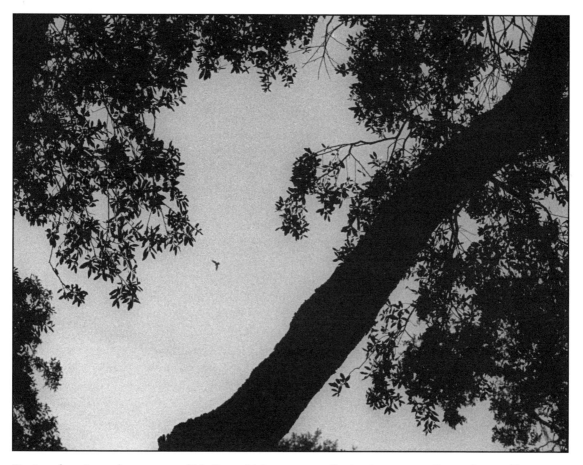

Don't underestimate the extent to which distant birds can form a dominant element of a photograph. Birds such as swifts, that feed on flying insects, often fly in generally circuitous routes. By watching and being patient, it is possible to photograph them against foreground elements such as trees.

Technical Considerations

Photographing birds in flight with a normal lens and reasonably fast film does not demand the steadiness required when using long telephoto lenses and slow films. Unless you want some blurring, the primary consideration is to use a shutter speed of at least 1/250 of a second to freeze the motion. Depth of field is generally not an issue when using normal lenses, because birds will usually be far enough away to focus at infinity.

Determining the proper exposure setting can be a bit tricky when birds are backlit against the sky. To avoid underexposure, it is a good idea to meter off a neutral-toned object such as foliage.

Remember to hold the camera still when exposing the film. Many photographers tend to keep the camera moving when following birds in flight. Shooting while panning the camera is generally an acceptable technique, but is not recommended for this particular exercise. You should also concentrate on keeping the camera level to avoid tilted horizons in the images.

Exercise 20

Moving Balls

Research into the collective behavior of groups such as flocks of birds suggests that the individuals within those groups determine the overall behavior of the group by independently following a small number of rules. One approach to the problem, developed by Craig Reynolds, who does research in interactive behavioral animation, is that the distribution of individuals within a group is based on action selection, steering behavior, and locomotion. Action selection reflects the objectives of the group, and steering reflects practical considerations such as maintaining the direction toward a destination and avoiding obstacles. Locomotion reflects the physical attributes of the individuals, such as speed and agility.

While the research into collective behavior has mostly been applied in the context of computer animation, it can lead you to a practical understanding of how the individual members of a team will behave during a sporting event. Most team sports are based around some sort of ball. Balls in sports are handled in many ways, including throwing, passing, carrying, kicking, and hitting. Nonetheless, the distribution and actions of the individual players seem to follow the general theories of collective behavior. The rules of the games strongly affect the action selection of the players and can also affect the steering behavior by setting guidelines such as the boundaries of the playing field and whether collisions between players are acceptable or unacceptable. The athletic abilities of the players and the physical characteristics of the ball are other important factors that affect locomotion. Because balls are the dominant objects of interest in most team sports, the movement and actions of athletes are influenced strongly by the position, direction, and speed of the ball.

It is usually possible to predict the intended target of a ball immediately after it is thrown. In sports where players make long throws, you will likely have a few seconds to shift the camera to the intended receiver.

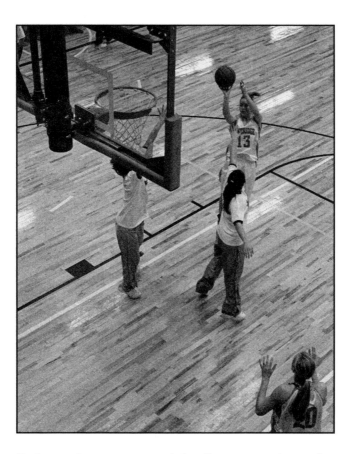

Finding good viewpoints is worth the effort in terms of seeing the action and having a good backdrop. Backgrounds can be especially important in team sports because the ball tends to get lost when it is superimposed in front of clutter.

About the Genre

The photography of team sports is a significant genre that is practiced mostly to illustrate stories in newspapers and magazines. Most sports photography is done with 35mm or digital cameras and telephoto lenses. The shallow depth of field associated with these lenses can be a real advantage in sports photography because in many cases, the only way to isolate the subject is to blur the background. Good sources for viewing images of team sports are the major sports magazines and the sports sections of newspapers.

About the Exercise

This exercise emphasizes how to observe a dynamic point, such as a ball, and connect it with other action. The key to performing this exercise well is to watch a sport for a substantial time before you start to take photographs, with the objective being to get a sense of how the location and movement of the ball influence the behavior of the athletes. With time, you should not only be able to discern how the players react to the ball in general, but also which players are especially talented at their positions.

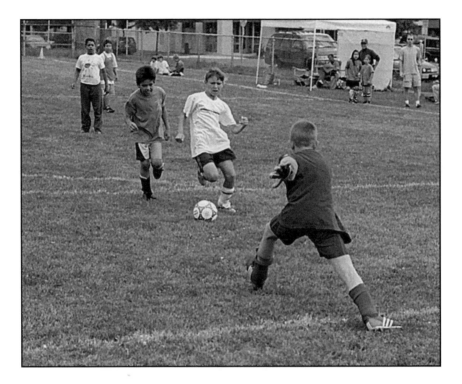

Players in sports that have defined positions tend to position themselves with respect to the ball. Knowing the positions and their responsibilities can help you follow the action and predict movement on the field.

Another part of the exercise is learning to isolate the action from the background. Many sports events are held in settings where good backgrounds are far from assured. This problem is exacerbated in shooting sports with a normal lens, since the distant players tend to merge with the spectators. In some sports, the lens will likely be focused at or near infinity, and the best way to deal with the background is to find viewpoints that do not encompass crowds in the distance, or that get you sufficiently close to the players so that they visually dominate the foreground.

Setting Up the Exercise

Amateur events are recommended because access is far less likely to be a problem than at profes-sional venues. Community sports leagues such as baseball, basketball, and soccer leagues are usual-ly fairly informal and place minimal restrictions on your presence at the sidelines. High school sports can also be good choices, especially at the freshman and junior varsity levels.

When choosing an event, you may want to consider factors such as time of day and populari-ty of the teams. For outdoor events, the light tends to be more flattering during the early morn-ing or late afternoon. Conversely, indoor events can be difficult to photograph during daylight hours if you are facing windows that will result in blown-out highlights. When popular teams are playing each other, it can become more difficult to find good viewpoints.

Selecting good backgrounds in sports photography will keep important subject matter from getting obscured in clutter. The closeness of the players near the foreground, and taking the photograph as the ball is passing in front of the shadowed area near the ceiling, keeps them from getting lost among the cluttered background presented by the fans.

Try to arrive early, if possible, to get a good viewpoint. If you have to sit in the stands, either try to be at floor level so you can photograph the nearby action, or sit higher up in the bleachers if doing so lets you use the field or court as a background. If you are free to move about the sidelines, select viewpoints that allow you to get close to the action and have a reasonably good background. However, make sure such locations are sufficiently safe so that you can avoid being injured by players or balls coming out of bounds.

Technical Considerations

Some sports are more suited than others for photography with a normal lens. Soccer, basketball, and volleyball are good choices if you can be near the sidelines. Football is more difficult because the field is so large and the action does not approach the sidelines often enough to enable very many shots close to the players.

Single-lens reflex and rangefinder cameras tend to be the best suited for this kind of photography. Although I personally covered football for my high school yearbook using a twin-lens reflex camera, it took considerable experience to adjust to the reversed image.

For safety reasons, do not use tripods where players may run into them. Hand-holding is usually adequate for this exercise, but a monopod may be used to increase stability, if needed. Fast film is good for this exercise because you will want to use fast shutter speeds to stop the action.

5

Lines

Lines constitute the second of the three fundamental visual elements in composition. In classical geometry, lines are the tracks formed by moving points. This characteristic also holds true in nuclear physics, where inferences about subatomic particles are made possible by the tracks they make when passing through bubble chambers and solid state detectors. Although the lines in the following set of exercises won't help you infer much about physics, they will help you learn about seeing and composition.

An important compositional aspect of lines is that they form edges, the perception of which is a critical part of seeing. Lines also define the boundaries of the composition, since they constitute the edges of the frame. Interior lines, which reside within the spaces bounded by edges, are important parts of most images. Sometimes, these lines are readily noticeable, such as the lines that form the text of a sign. At other times, they can be almost imperceptible, as is the case much of the time for the fine lines in skin. With practice, such lines become easier to discern and can be fully considered when composing images.

Static lines provide a lot of information about what is being depicted in an image. Features such as converging lines provide the brain with cues about physical characteristics like depth. Other lines, such as those formed by an arm pointing at an object, provide psychological information that indicates the object of interest.

Static lines also provide a framework against which other visual elements such as points and shapes interact. The relationships between static lines and the visual elements that cross, follow, or rest on them provide the brain with different kinds of information about the subject matter that is depicted in images.

Lines can be vital elements in images that depict movement. Solitary lines such as arrows can indicate movement by their placement away from other elements. Connected lines can indicate power and movement by suggesting levered action through hinges and fulcrums. Other ways that lines suggest movement and force are through sagging, arcing, and unfolding. Even when the visual element in motion is a point or a shape, lines often constitute the elements that provide the sense of movement. For example, a viewer will infer the speed and direction of a baseball by the information derived from the position of a pitcher's arm or a batter's bat.

Another important role of lines is their ability to suggest a sense of visual bulk, especially when they are curved into spirals and arcs. Depending on their width, length, and placement, lines can add visual balance to images in ways that range from suggesting the subtle presence of points to forming massed elements that imply shapes. The exercises are intended to give you opportunities to explore the myriad ways that lines can be used to serve expression.

Exercise 1

Fork

Knives were first used as flatware back in prehistoric times and spoons were used in ancient times. It is not entirely clear when dining forks were developed, but it is generally acknowledged that they first achieved widespread use in Italy during the sixteenth century. Forks were not particularly well received outside of that country; the English felt that they were an unnecessary alternative to eating with one's hands. Gradually, the fork gained acceptance among the wealthy classes for eating foods that were sticky or stained the hands.

Dining forks initially consisted of two straight tines, but the French developed a version with four curved tines that enabled diners to scoop their food. The scooped design became popular in Germany, England, and the United States during the nineteenth century and remains popular to this day.

About the Genre

Forks started appearing in art during the sixteenth century in the works of Italian artists. They are not particularly popular subject but are sometimes featured prominently in still lifes. Andre Kertesz's still life of an inverted fork resting on the edge of a plate is probably the best known photograph of a fork.

About the Exercise

The exercise is a specialized still life and consists of making several images of a fork. Although forks appear to be simple objects, the curved profiles and edges can create interesting shapes and associated lines. Some aspects to examine are foreshortening and how the lines and shapes change when viewed from different angles. Another is the interaction between the fork and its shadow.

Depending on the viewpoint, the slightly curved shapes of the tines and handle, combined with the direction of the lighting, substantially affect the visual mass of the fork. In the image on the left, the fork is facing up,

perpendicular to the camera and aligned with the light. These factors minimize the mass of the fork and its shadow. By aligning the fork at forty-five degrees from the camera, the opposite effect is achieved.

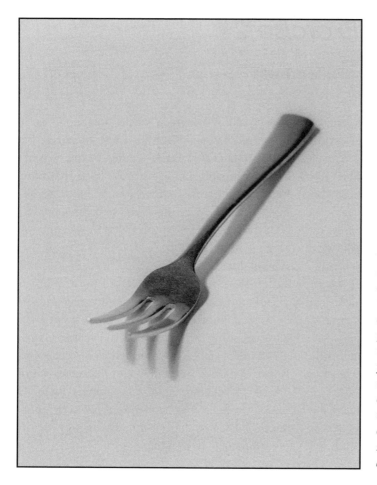

Forks make a good choice for experimenting with still-life compositions because they are simple objects that produce complex shadows. Although the tines in this image are angled only a few degrees from horizontal, the shadows point vertically downward. The distribution of the visual mass is quite different from the image of the inverted fork on the opposite page. Notice the foreshortening effect produced by positioning the tines closer to the camera than the end of the handle. Showing the fork at a slant enhances the feeling of three-dimensionality.

The shadow will connect with both ends of the fork, but whether or not it overlaps with the middle of the fork will depend on the direction of the light and the angle between the fork and camera.

Setting Up the Exercise

Place a dining fork on a plain surface with simple overhead lighting set slightly above and to the side. Take several photographs of the fork in different positions relative to the camera and the light. Prior to making each image, assess the nature of the space beneath the fork, whether the spaces between the tines are visible, and the relationship of the shadow to the fork. Also, con-

sciously determine whether the composition works better in vertical or horizontal orientation.

Technical Considerations

This is a still-life exercise, so shutter speed is unimportant. Stop the lens down enough to achieve sufficient depth of field to bring at least most of the fork into focus. Apertures ranging from f/11 to f/22 generally work well.

To get the most benefit from the exercise, use lighting equipment that allows you to raise and lower the light source. Desk lamps with adjustable arms work nicely for this purpose. A solid background will show the shadows better.

Exercise 2

Fallen Trees

The abundance and long life spans of trees are a testament to their resilience, but under certain circumstances, trees will fall over. Trees manage to keep themselves upright by the rigid fibers that stiffen their trunks and root systems that anchor them to the ground. For most species of trees, the roots extend no deeper than three feet into soil and anchor the tree mostly by spreading outward. If the soil becomes saturated and loses its retaining strength, or if its root system loses its integrity through trauma or disease, tree trunks can exert enough pressure against the roots to to lever them from the soil and uproot the tree.

One of the common causes of tree fall is the accumulation of large amounts of ice or snow in the branches of the upper portions of trees. Trees that have abundant leaves are at greater risk of falling, which is one explanation for why deciduous trees shed their leaves during autumn and why broadleaf evergreen species are found mostly in warm climates. Another cause of tree fall is severe trauma to the trunk caused by rot, beavers, errant cars, and similar hazards. Trees that have highly rigid fibers are more susceptible to breaking, which is why conifers tend to break more frequently than flexible species such as sweet gum.

About the Genre

Fallen trees tend to be depicted most often in nature and landscape photography, particularly by artistic photographers who have spent time photographing forests. Most of the artistic images are of trees befallen from natural causes, although Robert Adams is well known for taking images of clear-cuts. Fallen trees are photographed for other reasons, as well. The photographs taken by insurance adjusters and environmentalists are examples that come to mind.

One approach to composing with fallen trees is to look for other lines in the image that enhance the lines of the subject tree. The most obvious lines in this photograph are the inclined fallen tree and the bank of the steep mountain stream. Although the lines formed by the horizontal fallen tree and the standing trees are more subtle, they still are important to the composition.

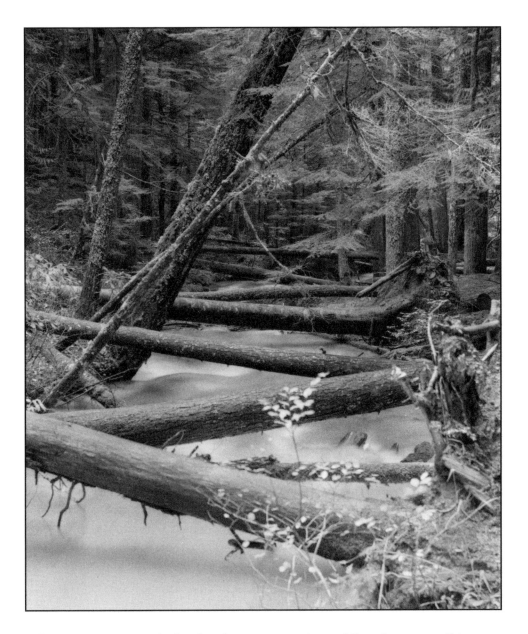

Fallen trees can sometimes be found in abundance around bodies of water that experience high snowfall because the soils become severely saturated when the snow melts. While scenes such as this one provide good opportunities for composition, it is important to slow down and consciously evaluate the linear elements. Placing angles carefully and ensuring sufficient space between the lines is important in composing images that feature several strong lines because of the risk that the lines may merge and create the impression of groups and massed shapes instead of retaining their individual character.

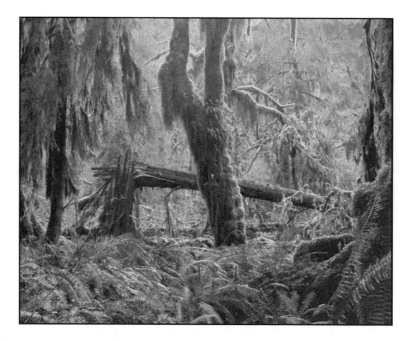

One way to isolate a fallen tree from its background is to rely on light. In this image, the shadowed underside and darker tones of the tree set it apart from the lighter tones and reflected glare of the surrounding wet foliage.

About the Exercise

Although fallen trees tend to form strong lines, they also tend to be found in settings with a lot of clutter that can obscure their linear character. When doing this exercise, concentrate on integrating the lines of the trees so they maintain their visual dominance. An effective way of doing this is to examine how the tree integrates with other visual elements in the image, particularly the other lines. Specific factors to consider are angles, foreshortening, and intersections. Sometimes, the best way to photograph a fallen tree will seem obvious. However, exploring different viewpoints and compositional placements almost always results in better compositions.

Setting Up the Exercise

For many people, the hardest part of this exercise will be finding a fallen tree. Fallen trees are most often found in wooded areas and forests but can also be present in other environments, such as parks and riparian areas frequented by beavers. You also may be able to locate fallen trees by calling tree services, municipal public works departments, and park managers. Small trees tend to fall over as frequently as large ones, so do not limit your search by size. If you cannot find a fallen tree, do the exercise by photographing surrogate objects such as pipes, posts, or garden tools.

Technical Considerations

Although fallen trees are stationary, they are often surrounded by foliage and other vegetative material that is easily moved by wind. In many cases, you will either want to use a shutter speed sufficiently fast to stop the movement of the surrounding vegetation or take photographs when the wind is calm.

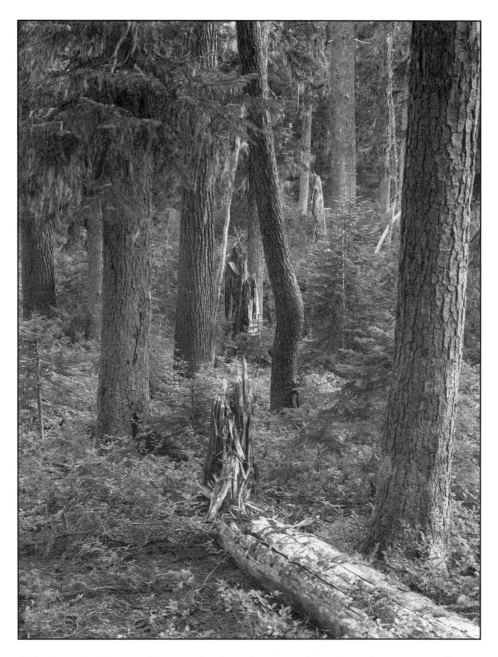

A dominant line does not always need to be at the center of attention to have a strong effect on the composition of an image. The fallen tree in this image anchors the lower right corner of the image. It also forms the lower part of an implied angle. (The upper part is formed by two stumps.) These trees are located in a part of a forest that is exposed to strong winds, which accounts for why they were broken at their bases and not uprooted.

Exercise 3

Corners

There are several ways to depict three-dimensional scenes on two-dimensional planes. A means commonly used in computer graphics, orthogonal projection, is based on objects not diminishing in size as they become more distant. It works well in this application because it eliminates the effect of distance from the viewpoint, and therefore provides a useful means of locating points in space.

Because photography is based on optics and uses a single viewpoint, it depicts three dimensions in accordance with linear perspective. The key feature of linear perspective is that sets of parallel lines are not depicted in parallel but, rather, converge to a location called a "vanishing point."

Depending on the orientation of the camera to the subject, an image can reflect one or more vanishing points. Assume that you are photographing a rectangular building in an open area. If the camera is kept on a level axis and the horizontal lines are perpendicular to the direction of view, the image will be rendered in a central perspective with a single vanishing point to which all the lines parallel to the direction of view converge. If the direction of view is angled to the side, the horizontal lines will converge to a second vanishing point. If the camera is shifted both to the side and vertically, the resulting image will exhibit three vanishing points.

About the Genre

The theory of linear perspective was one of the major breakthroughs in the visual arts. It was developed by European artists during the fifteenth century and refined by mathematicians

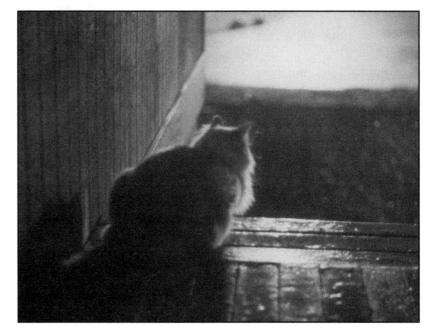

This is an example of an image with a nearly one-point perspective. Compositions with this kind of perspective have the effect of emphasizing the center portions of the image and emphasizing the feeling of depth.

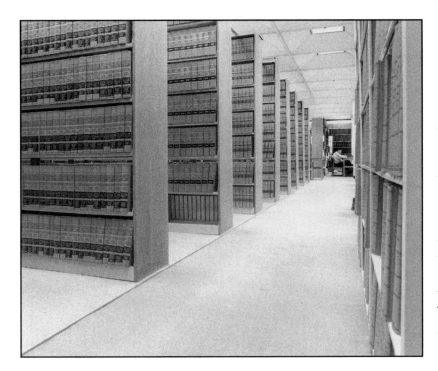

Here is an image in mostly two-point perspective. Note how the lines formed by the shelves on the right side of the image converge at the table, while the lines formed by the shelves on the left side converge to a point outside of the frame. Although the books in the image are physically the same size, foreshortening causes their size in the image to diminish rapidly as they approach the vanishing points.

shortly thereafter. Although linear perspective is one of the most realistic ways to depict three-dimensional space, even the earliest artists used techniques that took liberties with the literal depiction of linear perspective. For example, both Raphael and Leonardo da Vinci used viewpoints and angles of view that departed from reality in ways that produced effects very similar to those made photographically by wide-angle lenses and view camera movements.

About the Exercise

The exercise involves experimenting with one-point, two-point, and three-point perspectives by taking photographs of scenes with corners. Understanding linear perspective is a useful skill for photographers because it helps concentrate attention on linear aspects such as level horizons and upright vertical lines. It also enhances the ability to discern distorted perspectives when composing images and thus enables you to deal consciously with the opportunities and problems they present.

Setting Up the Exercise

Take several images of scenes that have one or more corners and feature parallel lines along the three coordinate axes. To obtain an image with a single vanishing point, you need to set the camera up on a tripod so that: (1) it is perfectly level with the direction of view, exactly parallel to the ground plane (assuming the ground is level); and (2) it faces an object that has horizontal lines that are perpendicular to the direction of view. A good choice for the exercise is to photograph the side of a conventional building from a viewpoint directly in front of its center. If you are doing this correctly, the horizontal lines should appear level and parallel and the vertical lines should appear vertical and parallel when you look through the

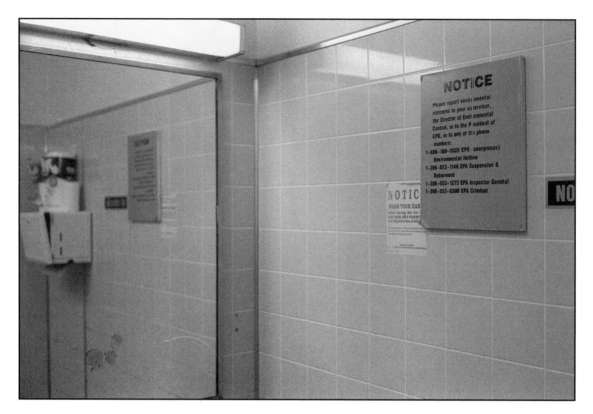

This image shows a two-point perspective with vanishing points located outside the frames on both sides. In this case, since the camera is pointed toward the corner, none of the horizontal lines on the walls are perpendicular to the direction of view. The lines on the wall to the right converge to the left, and the lines on the wall to the left converge to the right. With images that feature one- or two-point perspective, the vanishing points will be located on the horizon line, which will also be the level of the camera when movements are not used. View cameras which allow the photographer to tilt or shift the angle of the lens or the film plane enable adjustments to be made to how the perspective will appear in the image.

viewfinder. To obtain two vanishing points, pivot the camera to the side so that the horizontal lines are no longer perpendicular to the direction of view. Looking into the viewfinder, you should see that the horizontal lines no longer appear parallel but instead slope toward the side where the camera was rotated. Although the vertical lines will remain vertical, they will appear shorter on the side to which the horizontal lines are converging. If, instead of rotating the camera to the side, you tilt it up, the vertical lines will slope toward the upper end of the vertical centerline of the viewscreen and the horizontal lines will remain parallel. A downward tilt will cause the vertical lines to slope downward. If the camera is simultaneously rotated to the side and tilted, both the horizontal and vertical sets of lines will converge to their individual vanishing points. Explore finding vanishing points by making prints of the images and, using a ruler and pencil, extend the parallel lines outside the frames of the images. The vanishing points will be located where the lines converge.

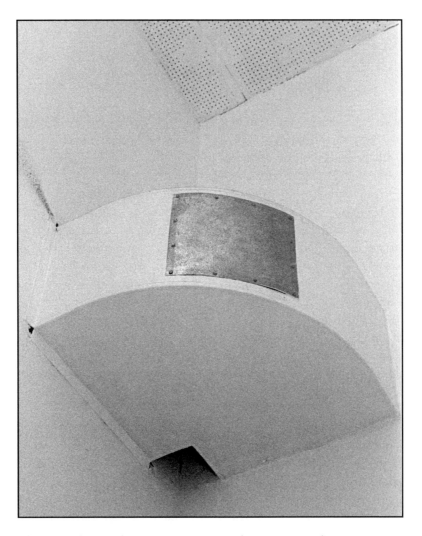

This image shows a three-point perspective. Convergence is an important visual cue regarding distance, and does not look out of place in images taken with normal lenses. However, wide-angle lenses exagger-ate the appearance of convergence and can produce exaggerated effects when the camera is tilted up or down. Being conscious of perspective and convergence is particularly important when using such lenses.

Technical Considerations

Some photographers struggle with achieving horizons that are perfectly level. If you fall into this category, you might want to try using a bubble level. These accessories can be mounted in the flash shoe of your camera and let you ascertain whether the camera is level. Over time, especially if you work at this exercise, you should develop a better appreciation of perspective and not have to rely on levels as frequently.

Exercise 4

Florals

Flower arrangements have been popular among many cultures, but the Japanese approach to the art is the most highly developed. In Japan, formal styles of flower arranging date back to the seventh century and have been strongly influenced by the Zen Buddhist predilections for simplicity, naturalness, and free, yet controlled, movement. Western cultures have also established a tradition of flower arrangements. Although Western styles were influenced by the Japanese schools during the twentieth century, they mostly favor the decorative aspects over the spiritual.

General guidelines have been developed for flower arranging that are somewhat analogous to the rules of composition in photography. One such guideline maintains that the longest stem in an arrangement should extend above the container at least one-and-one-half times the height when in a tall container, or one-and-one-half times the width when in a low container.

The orientation of lines is also believed to influence the emotional effect of arrangements. For example, arrangements with mostly vertical lines are supposed to suggest vitality, while those with mostly horizontal lines are supposed to suggest peace. As is the case with photography, diagonal lines are supposed to indicate dynamic movement.

About the Genre

Flower arrangements have been a stalwart subject for visual artists working in all types of media. Several of the best known Impressionist and Post-impressionist painters frequently painted still lifes of flower arrangements and often incorporated them into their portrait work, as well. Photogra-phers who have done significant work that shows the linear aspects of plants include Laura Gilpin and Imogen Cunningham.

About the Exercise

The linear aspects of plants with long stems may appear simple at first, but can be seen as quite complex upon further observation. This exercise involves using cut flowers to evaluate the inter-action of lines with negative spaces. The objec-tive is to learn how to portray the graceful nature of stemmed flowers while avoiding a massed effect, where the arrangement assumes the char-acter of a shape instead of an assemblage of lines. Success will depend on composing the lines to minimize or avoid overlapping.

Setting Up the Exercise

This exercise is generally best done with at least two flowers, but avoid using too many, or the spaces between them will block up and negate the linear characteristics of the stems. Set the flowers in a tall container so that the stems extend more or less vertically above the rim. Most flowers pho-tograph better if at least some of them face toward the camera and show interior parts, such as pistils and stamens. Some exceptions are rounded flow-ers, such as tulips and rosebuds. Be sure to place the flowers against a suitable background. Solid-colored paper or fabric set a few feet behind the arrangement should work well.

Evaluate several compositions either by mov-ing the camera or by rotating the container. With practice, you should be able to discern that some arrangements and viewpoints are distinctly better at emphasizing the graceful and attractive nature

When composing floral arrangements, take your time and carefully consider how the flowers as a whole relate to the space of the composition and how their parts relate to each other. The images above show how rounded flowers such as tulips are attractive when viewed in profile. However, most flowers are better presented with the interior portions at least partially visible. Note that despite the sparse nature of the arrange-

ment, the linear elements are complex. The dense black background was achieved by placing a black fabric backdrop about four feet behind the arrangements. When trying to produce low-key images, it is important that the backdrop be shaded from the illumination source. Conversely, adding illumination to white backgrounds can enhance a high-key effect, when this is desired.

of the forms. Good photographs of this kind of subject rarely come easily, and if you find the compositions come too readily, you are probably not working hard enough or paying sufficient attention to the negative spaces.

The key visual elements are the direction and isolation of the lines formed by the stems, the orientation of the flowers, and the quality of the negative space between the stems and flowers. Pay particular attention to whether the stems and flowers are occluding important visual elements. Some degree of overlapping is to be expected, but keep in mind that you are seeking to show the

linear characteristics. Also, feel free to adjust the arrangement if doing so will create better lines and more effective spaces.

Technical Considerations

You will generally want to stop down to a small lens aperture to maximize the depth of field. Simple flower arrangements tend to photograph well when illuminated from above and slightly in front. Placing a sheet of white paper at the base of the flowers just outside the frame will bounce the light from the main light source and softly illuminate the underside of the flowers.

Exercise 5

Rivers and Streams

There are many kinds and sizes of rivers, but they all share the common characteristic of being the path of least resistance for water flowing through the landscape. Most rivers are fed by runoff from precipitation and melting snow, and some are charged by groundwater. Depending on the source of water and the surrounding environment, river flows can vary significantly over the course of the seasons. Some river systems, such as the lower Nile, are known for seasonal flooding. Other rivers, such as the Santa Ana River in southern California, run dry for much of the year.

Topography and geologic processes play a major role in characterizing individual rivers. Rivers on coastal plains tend to be wide and low energy, while mountain streams tend to be narrow and fast flowing. Rivers are significantly affected by their riparian zones. Although the ideal vegetation for any particular river will depend on the surrounding ecosystem, the quality of the riparian area is a major indicator of the health of a river system.

Coastal rivers tend to have low energy flow characterized by a lack of riffles and standing waves. A good way to photograph these kinds of rivers is to emphasize their riparian vegetation. Note how the pine tree at the point where the river bends adds a small element of visual interest to an important area of the image. The lush vegetation is typical of the natural portions of rivers near the gulf coast of Alabama.

The reason that most images of waterfalls show blurred water is that they are taken with slow films that require slower shutter speeds that don't freeze the motion of the water. While such images can be very attractive, this is not the only way to photograph a waterfall. Using fast films will facilitate shutter speeds fast enough to avoid blurring under the conditions typical for most landscape photography. This image was made using Kodak Tri-X film rated at EI 400 and exposed at a shutter speed of 1/125 of a second.

When viewed in discrete parts, rivers and streams can be visually rich. These standing waves were found in a very high energy section of a small mountain stream.

About the Genre

Rivers have been depicted widely in art since ancient times. Two of the prominent pioneers of photography, Louis Daguerre and William Henry Fox Talbot, photographed rivers during the first half of the nineteenth century. The interest in rivers as a subject for landscape and environmental photography has continued to modern times. A good collection of this kind of work can be seen in Larry Olsen's book, *Oregon Rivers* (Westcliff, 1997), which shows and describes the fifty-five federally designated wild and scenic rivers in Oregon. He spent several years working on the project and made about 18,000 images.

About the Exercise

Rivers are a combination of static banks and moving water that can produce a variety of lines. The purpose of this exercise is to take a large subject and determine how it can be photographed at the grand scale and in discrete intimate parts.

Setting Up the Exercise

Find a river or stream in any kind of setting and evaluate it carefully from as many vantage points as possible. Specifically, look at the lines formed by banks, the dynamic character of the water, objects in the water, and the surrounding landscape features. Take several images that show the

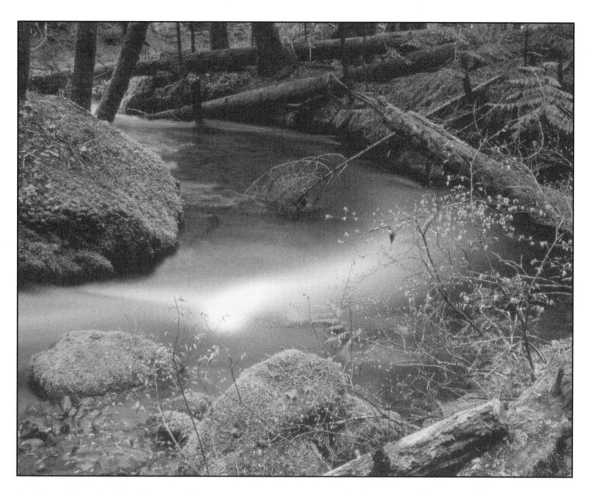

Bends are often visually pleasing and warrant particular attention when evaluating potential compositions. The Little Zig Zag River is a fast-running mountain stream in Mount Hood National Forest in Oregon. Set *in a conifer forest at an elevation of about 3,000 feet, it has a type of riparian vegetation that is very different from the coastal river in Alabama that is shown on page 112.*

river as part of the landscape and several more that show the more intimate characteristics of the river, such as waveforms, riffles, and the effect of human activities.

Technical Considerations

Depending on the velocity of the flow, water in rivers will blur if shutter speeds less than about 1/30 of a second are used. Blurred water typically produces a pleasant effect that is favored, or at least tolerated, by most photographers and viewers. Nonetheless, feel free to use a fast shutter speed if you want to stop the motion of the water.

Water is very reflective, and in many cases, rivers will photograph better if glare is reduced or eliminated by using a polarizing filter. However, glare is not necessarily bad. For example, it can enhance the sparkling appearance of streams and the texture of small riffles. When in doubt, try taking photographs with and without the filter.

Exercise 6

Still Lifes

In addition to their traditional role as a starting point in art education, still lifes have also served as a means of extending art into its modern forms. One of the most influential periods in the development of Western art occurred during 1919 through 1933, when the Bauhaus in Germany was an active participant in the movement to meld art and industrial technology. The avant-garde school was founded by the architect Walter Gropius, and encompassed practically all art and design disciplines. Photography was not formally taught at the Bauhaus until 1928, but was strongly encouraged and practiced by many of its students and teachers. The photographic work was often wildly experimental, and frequently incorporated techniques such as double exposures, montages, and photograms.

About the Genre

Academics often refer to the still life as a means of exploring form, texture, and composition, but even a cursory overview of still lifes shows that many artists and photographers have used them to express themselves through lines. Laszlo Moholy-Nagy was probably the best known of the Bauhaus photographers. Many of his still lifes are dominated by linear elements.

About the Exercise

One reason that lines tend to be dynamic elements is that they often overtly suggest their relationships with other objects. This exercise entails exploring the various ways that lines establish the viewer's attention, such as pointing to, closing off, and intersecting with other elements. Even

A few simple objects can make a visually complex still life. Note where the line between the backdrop and the cloth is placed in the image. This aspect can be an important consideration in composing still lifes because if done properly, it can emphasize the subject objects, and if done poorly, it will obscure them. The placement of this line will also affect the balance of visual masses in the image.

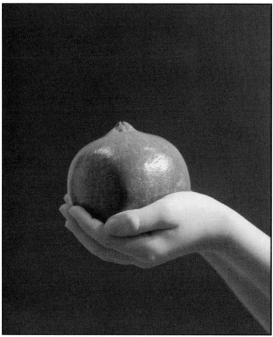

The corners and flow of the dominant lines are important considerations to keep in mind when arranging and composing still lifes. The image on the right uses the bottom right corner to good effect, while none of the

corners are engaged in the image on the left. In addition, the angles of the arms and hands in the image on the right emphasize the curvature of the hands as they cup the pomegranate.

those still-life scenes that appear to be simple arrangements can have complex linear elements that are discernible only with careful observation. One such aspect is the role that lines play with respect to the edges of the frame.

Setting Up the Exercise

Select a few objects to be arranged into a still life, ensuring that at least one of them will form a strong linear element. Examples of suitable objects include kitchen utensils, narrow fruits and vegetables, and clothing with linear features such as sleeves and legs. Arrange the objects in a way that the lines interact with the corners and edges of the frame and with the nonlinear subjects. If you have difficulty coming up with satisfactory subjects or arrangements, consider looking in art

books for ideas. Once you have set up the arrangement, thoroughly evaluate possible compositions while looking through the viewfinder. You should also experiment with rearranging the objects and evaluating the effect that changes have on the compositions. You do not need to make a lot of images, but you do need to spend a lot of time assessing them. If you are doing the exercise properly, you should feel that it was a lot of work once you are finished.

Technical Considerations

Most still lifes can be photographed using long exposures, which means you have options regarding the depth of field. You may want to consider experimenting by making images with different depths of field and comparing the results.

Exercise 7

Cracks in Rocks

Rocks typically have great compressive strength but are relatively poor at resisting tensile and shear forces. In other words, they resist being crushed but are not very good at withstanding forces that bend them or pull them apart. Cracks form in these materials when the stress applied to them exceeds their ability to resist cracking. In the simple situation where the force is applied along a single direction, cracks will appear and grow perpendicular to that direction. In natural environments, rocks are mostly subject to complex forces, which makes it difficult to predict where cracks will appear and how they will grow.

The ability to resist cracking is known as "fracture toughness." Once a crack is formed, it will continue to grow until the stressing forces no longer exceed the fracture toughness. Rocks vary significantly in their fracture toughness and have different susceptibilities to cracking. In general, porous rocks such as limestone have less resistance to cracking than dense ones such as granite.

About the Genre

The artists who are the most aware of the fracture properties of rocks and masonry are those who work directly with stone, tile, and similar materials. In the two-dimensional arts, the oldest works made with these materials are the Babylonian and Assyrian mosaics that date back to about 2500 B.C. Another well-known art form is stained glass, which became a dominant feature in the windows of medieval churches, beginning in the twelfth century. Although both art forms are intricately composed of interior lines formed by the gaps between their constituent pieces, they work effectively as images because of the human tendency to discount many kinds of interior lines as a source of primary visual information.

About the Exercise

Even though people tend to perceive interior lines less consciously than edges, they do not disregard them altogether. Interior lines can signifi-

One approach to the exercise is to look for interesting patterns to photograph. Cracks can form simple patterns (such as the one shown in the granite in the photograph on the left) and very complex patterns (such as the ones in the basalt in the photograph on the right). Crack patterns depend on the physical properties of the material and the nature of the forces on the formation or structure.

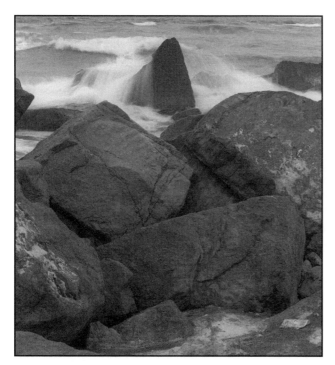

Although the boulders are covered with cracks, they go all but unnoticed during a casual view. Nonetheless, they contribute to the unity of the image. Note how the major cracks in the boulder in the lower foreground align with the light portion on the boulder to the upper right and the edge of the boulder to the upper left. Similarly, the major cracks of the boulder to the upper left align with the edges and cracks of adjacent boulders. Attention to this level of detail may seem trivial, but viewer's perceptions are often affected by subtle visual cues.

cantly affect compositions, and photographers benefit from being able to recognize them. This exercise provides a context which involves looking for interior lines where many people do not expect to find them and using them to compose photographs.

Setting Up the Exercise

Look for cracks in rocks and masonry structures and figure out ways to photograph them. While cracks can be found in rocks of all sizes, places such as cliffs and extrusions are good places to find large cracks that fit in with the landscape. If you cannot find satisfactory cracks in rocks, look for them in concrete structures. Because this material is prone to cracking, most pours are designed to crack in a controlled manner.

Look for hairline to medium-sized cracks in places such as walls, sidewalks, and building foundations. If you have trouble finding cracks, you

probably need to look harder. Select an area of a rock or concrete and visually scour it, looking for very small cracks. With persistence, you should be able to find a few.

When you find suitable cracks, carefully figure out how to place them in the composition. Cracks that align with the edges of other objects can contribute a subtle but significant unifying effect to an image. Also, look for cracks that form interesting designs.

Technical Considerations

Cracks in rocks are fairly straightforward to photograph, and you should use whatever camera settings are necessary to obtain the desired depth of field. Lighting can be important, since direct frontal light tends to minimize the visibility of cracks. Lighting from an oblique angle will intensify the shadows and make the crack contrast more against the surrounding rock.

Exercise 8

Lines of the Hand

Although most people associate hands with tactile functions such as grasping objects, they also provide important visual cues by which people communicate and draw inferences about each other. After the face, the hands are the most expressive part of the body. The most prominent visual aspect of hands is their ability to form complex shapes. However, hands have very complex patterns of interior lines that contribute significantly to their visual impact.

Lines form on the hands at the places where the joints flex. While the deepest furrows are found on the palms and at the knuckles, the entire hand is covered by finer lines. Because lines are affected by environmental factors such as age, use, and exposure to the elements, they can serve as visual indicators of a person's history. For example, smooth, soft hands are associated with feminine beauty and a pampered lifestyle. Conversely, calloused, furrowed hands are associated with hard, manual labor.

One reason you should consider the placement of interior lines when photographing a hand that is holding an object is that Gestalt effects can disrupt the intended impression of an image. The fishhook has been placed on the hand so that the ends touch the dominant line of the palm and form a closure. Although a viewer can discern that the object is a fishhook with a little effort, the closure lends itself to the impression that the hand is holding an annular object, such as a rubber band. In general, it is desirable to avoid such ambiguities in visual communication.

About the Genre

Many people associate figure photography with images of the torso or the entire body, but the genre also encompasses other parts of anatomy, such as the limbs. The expressiveness of hands makes them a good subject for exploring this genre. Although the complicated structure makes hands one of the most challenging parts of the human figure to render artistically, it also makes them one of the most interesting and expressive parts of the body.

The first works of art that depict hands as primary subjects were made about 20,000 to 35,000 years ago, when Paleolithic humans used earth pigments to outline their hands on the walls of caves. The depiction of hands has come a long way since that time, and they have been used to express many themes, such as work, religion, and emotion. Some photographers who have made notable works that feature hands include Alfred Stieglitz, Tina Modotti, and Irving Penn.

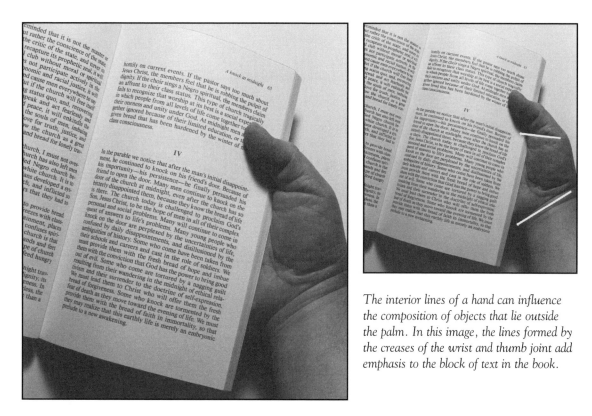

The interior lines of a hand can influence the composition of objects that lie outside the palm. In this image, the lines formed by the creases of the wrist and thumb joint add emphasis to the block of text in the book.

About the Exercise

The purpose of this exercise is to enhance the ability to perceive the interior lines that exist inside of the contours of shapes. To begin, take a few minutes (not moments) and look at the lines over the entire surface of your hands. Begin by perceiving the deep furrows on the palms and fingers, and keep looking until you perceive the medium, fine, and very fine lines that exist all over your hands. As you look longer and harder, you should become increasingly cognizant of the finer lines. Compare both hands, and determine whether their lines are similar or different.

When photographing hands, consider how the interior lines contribute to the image. One aspect is to ensure that the lines serve to reinforce the intent of the image. For example, the lines of the hand can provide emphasis to parts of the image by directing the eye to desired elements. Similarly, lines can detract from an image by directing the eye away from elements by forming inadvertent but distracting closures with other visual elements.

Another important aspect is to consider what the hands tell about the subject. Because the lines on hands are influenced by time and environment, they can reflect the occupation or avocation of the model. For example, the hands of an elderly ranch hand will appear different than those of a young ballet dancer.

Setting Up the Exercise

Have a model hold a small, round object such as a coin or stone in his or her hand. Compose and take several photographs, giving due consideration to where the object is placed on the hand.

When objects are placed on the palm, the interior lines will influence the composition by virtue of their convergence between the thumb and forefinger. In this image, the dime is placed over the point of convergence rather than the center of the palm, which is where people tend to place objects naturally.

Repeat the exercise using a small linear object, such as a nail. In both cases, pay attention to how the lines align with the objects, and make sure to avoid inadvertent closures. When you are finished taking the photographs, review the images and assess how well the lines interact with the objects. If the lines affect the images differently than you perceived while taking the photographs, try repeating the exercise until what you see in the viewfinder largely conforms to what you see in the image.

For the next part of the exercise, set up a composition where an object such as a tool is grasped by one or both hands. If possible, make images of two or more models holding the object ,and observe the differences in the features of their hands and how they hold objects.

Technical Considerations

Bright lighting is desirable for this exercise because it is difficult to keep the hands steady during long exposures. Off-camera flash is ideal, but the exercise can also be done with a bright incandescent light or can be performed outdoors in sunlight. You can increase or decrease the prominence of the lines on the hand by adjusting the angle of the light. When doing so, it is important to keep in mind that altering the lighting to effect a change in one line can change others. In general, lighting will accentuate the lines on surfaces that are parallel to the direction of the light and minimize those that are perpendicular.

Good depth of field is generally desirable for this exercise, so the lens should be stopped down to f/16 or smaller.

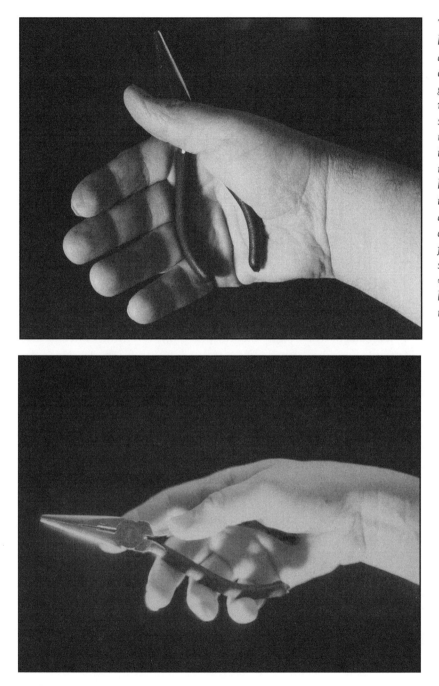

The interior lines of the hand also warrant consideration when composing with curved objects. The photograph on the left is illuminated from the front and shows a man's hand, while the photograph on the right is illuminated from the bottom and shows a woman's hand. Note that while each image encompasses a similar alignment between the handle of the pliers and the deep furrow of the palm, they show different alignments with the arced lines formed by the joint at the base of the thumb.

Exercise 9

Shadows

People tend to assume that shadows cast by the sun will always point in the same direction, but, as can be demonstrated in images, this is not always true. While shadows are parallel when cast over flat, level ground, they generally will not appear this way in photographs because of perspective effects, which cause lines that are not perpendicular to the optical axis of the camera to converge to a vanishing point. When uneven terrain is involved, shadows will deviate even more from the common expectation. Shadows change in length when cast on sloped terrain for the same reason that tilting the back of a view camera will alter the way the perspective is recorded on film. In addition, when viewed from the side, shadows on uneven terrain will be distorted in accordance with the topography.

Another widely held misconception about shadows is that they provide highly useful information when interpreting aerial photographs. The reality is that shadows can be used to calculate parameters such as the height of objects only when vertical objects are casting shadows over level ground. It is possible to accurately determine the heights of objects using aerial photographs, but the most commonly used method is based on measuring the parallax differences between pairs of stereo images.

About the Genre

Shadows have been used in many ways to express concepts in art. Even the concept that shadows are associated with fear and anxiety can be exploited in unusual ways. Edvard Munch painted *Spring Day on Karl Johan Street*, in which he depicts a peaceful daytime scene on a city street in 1891. The pleasantly diffuse shadows stand out in this painting and express the sunny

Note how the shadows cast from the plants are not parallel but instead recede toward the horizon. In theory, shadows that are created by the sun should converge to a vanishing point on the horizon directly beneath the sun. In practice, factors such as irregular objects and uneven terrain will preclude perfect convergence. Although this image shows mostly a one-point perspective, the lines of the shadows do not converge to a single vanishing point, although they do converge in the general vicinity of one. Note also that while the plants are perceived as the subject of the image, the shadows occupy about two-thirds of the area of the image.

Shadows can behave in visually complex ways. The shape next to the arrangement and vase is a combination of the shadow on the wall and its reflection. The portion of the shadow between the vase and the wall is lost in the glare of the table.

The lines formed by shadows can be used to isolate point-like subjects. The X-shape of the shadows was formed by the panes of a large window. Note that even though the shadows are quite dark, the image was exposed to preserve the detail in the chairs.

nature of the day. A year later, Munch painted *Evening on Karl Johan Street*, in which anxious, sallow-faced people are walking toward him. One of the aspects that gives the painting its eerie feeling is its substantial lack of shadows.

About the Exercise

The purpose of this exercise is to enhance the awareness of shadows and how they affect composition. Shadows are important for several reasons, but two of the most important are how they affect exposure and visual mass. Film cannot record the full range of brightness that humans perceive, and the result is that shadows appear darker in images than they do in the actual scenes. For example, outdoor portraits taken under the midday sun tend to show eyes as dark blobs because the film does not have the latitude needed to record the details within the shadow beneath the eyebrows. The visual masses of shadows are important because they will have the same effect on the composition as the other dark

visual masses. Photographers who ignore shadows will have significant problems in composing images of scenes with prominent cast shadows.

Setting Up the Exercise

To do the exercise, find scenes with reasonably strong cast shadows, and take several images in which the shadows occupy at least one-third of the image. Consider factors such as mass, direction, and length, and also make sure that the shadows are integrated with another subject. While the shadows should be prominent in the image, you are seeking to make more than just a photograph of an interesting shadow.

Technical Considerations

Try to expose the images so they retain at least some of the detail in the shadowed areas. As a general rule, the exposure should not be set more than two to three stops higher than an exposure reading taken in the shadowed portion, or the shadow detail will be lost altogether.

Exercise 10

Trees

Trees grow upwards because they can detect gravity and respond accordingly. This response, called "gravitropism," is believed to be controlled by hormones called "auxins." Although trees also respond to light, gravitropism has a greater effect on their vertical orientation. For example, if a tree is growing in an area where it gets light from only one side, its main trunk will grow vertically rather than toward the light.

The cellular and molecular mechanisms that underlie the gravitropic response are still poorly understood, despite decades of research. However, the specific mechanisms are known to vary among trees. When bent, trees seek to regain their vertical orientation by forming wood with different cellular characteristics called "reaction wood." In conifers, the reaction wood forms as a wide area on the lower side of the bend and is called "compression wood." As this wood grows, it has the effect of gradually pushing the tree back to an upright position. In hardwood trees, reaction wood forms on the upper side of the bend and is called "tension wood." It has the effect of pulling the tree back to an upright position.

One approach to isolating trees is to use the sky as a background, as shown in this image of a slash pine (Pinus elliottii). The exposure was set to preserve the tones in the sky as well the details in the trunk and limbs. An important compositional element is relating the lines to the corners of the frame.

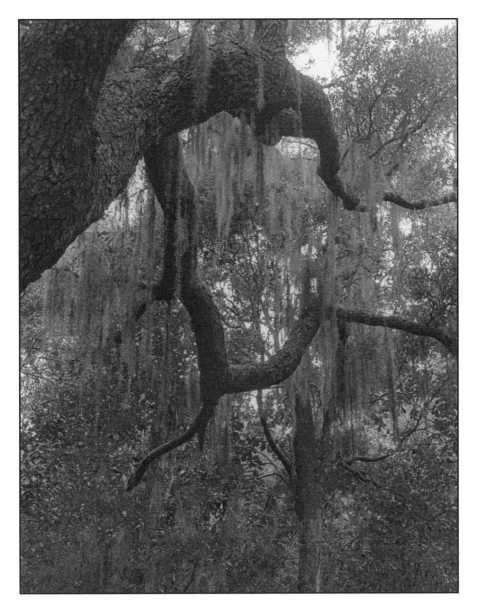

The most difficult situations for photographing trees are when they are situated among nearby trees and heavy with foliage, such as this live oak (Quercus virginiana) covered with Spanish moss (Tillandsia usneoides). One approach to the problem is to look for the strongest lines and position them to minimize the competition from the strong lines of other trees. By moving close to the tree, the foreshortening effect depicts the trunk and major limbs of the subject tree with significantly more visual mass than the adjacent trees. Gestalt effects can also be used to aid in the visual isolation. The lines of the two dominant lines converge near the left center of the image, and the implied closure attracts visual attention and de-emphasizes the background.

When working with trees, avail yourself of all the tools available to isolate lines from the clutter of the surroundings. The mass of licorice ferns (Polypodium glycyrrhiza) around the base of the big-leaf maple (Acer macrophyllum) blocks off about one-third of the background area while nicely complementing the trunk and the mass of ferns on the tree behind it. The other way that the tree is isolated is that its inclined angle differs markedly from the vertical orientation of the surrounding trees. This tree is inclined because it was partially uprooted sometime in the distant past. Note how tension wood has formed on the upper part of the crook and is drawing the trunk up to a more vertical position.

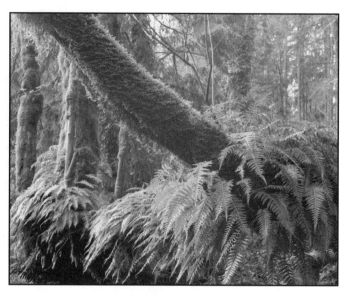

About the Genre

Although trees have appeared in art throughout history, they began to be more frequently depicted as a dominant subject during the nineteenth century. Artists who have produced many notable works encompassing trees include Claude Lorrain, Claude Monet, Vincent van Gogh, and Emily Carr. Examples of different ways that photographers have approached the subject of trees can be seen in the works of Josef Sudek, John Sexton, Robert Adams, and Lee Friedlander.

About the Exercise

Except for the fairly uncommon situation in which a solitary tree exists in an open field, trees tend to make difficult subjects because they exist in environments that are rich in linear elements. This exercise provides experience in exploring ways to isolate lines amid visual complexity through the use of background, perspective, and arrangement. It is also an exercise in persistence. In many cases, finding a composition that enables the lines of a tree to stand out will seem very difficult, if not impossible. With effort, you should find that in most cases, it is possible to find worthwhile compositions.

Setting Up the Exercise

To do the exercise, go to an environment with a lot of trees. Forests are an excellent choice, although they are very challenging. Spaces such as parks and orchards tend to be less daunting because of their lower densities or increased anthropogenic structure. Explore the selected area looking for potential images that appeal to you. In addition to the trees themselves, look for backgrounds that enable trees to be visually isolated, and also be alert for open spaces that will enable you to use perspective as an isolating tool.

Technical Considerations

Lighting is a significant factor affecting images of trees. In general, the best light occurs within thirty to sixty minutes of sunrise or sunset or when the sky is overcast. Fairly long exposure times can be required under these conditions, and you will likely need to use a tripod to obtain adequate depth of field.

Tonal differences can be used to isolate trees from their backgrounds. In the top image, the light-colored trunks of a grove of red alders (Alnus rubra) stand out against a darker conifer forest, which forms an inconspicuous background. In the bottom image, another grove of red alders is isolated by placing them against a river that forms a separate dominant subject.

Exercise 11

People from Overhead

Acrophobia is a common situational phobia in which the sufferer has an irrational fear of heights. Although clinical psychologists have treated phobias since the end of the nineteenth century, the profession is somewhat divided with respect to what causes acrophobia and the best way to treat it. Psychoanalysts believe that irrational behavior is caused by psychic conflict, and that acrophobia is the expression of repressed suicidal urges. The favored course of treatment is to assist patients in discovering which fears are embodied by their phobias, and use these insights to help them deal with the emotional conflicts more realistically. However, the behavioralist model has become the more popular approach to treating acrophobia. Behavioralists believe that the phobia is acquired by observational learning. They treat acrophobia by exposing patients to incrementally greater heights until they become acclimatized and are better able to cope with their fears

Fearlessness in high, exposed places is the opposite of acrophobia. In 1886, while constructing a bridge over the St. Lawrence Seaway, managers of a construction company noticed that Mohawk Indians hired to perform menial labor showed no apparent fear when climbing over the iron structure. The company hired several Mohawks as ironworkers and started a tradition that continues to the present day. Working on projects involving the assembly of steel frameworks on very tall structures has become part of the cultural identity of the Mohawk Nation, and is seen as proof of their courage. Some Mohawks maintain that they have the same inherent fear of heights as other people, but they have learned to deal with it better by drawing on the experience and leadership of the workers before them.

People tend to orient their activities according to the lines that make up their environment—particularly in urban settings. Note how the pedestrians are positioned well within the confines of the sidewalk and crosswalk. When abstracted as points, the arrangement of the people likewise suggests the lines of a cross. Can you see how the suggestiveness would have been even stronger if the shutter had been released one-half of a second later?

When photographing people from an elevated vantage point, the compositional issues often exist at two levels. The first is the placement of the environmental lines with respect to the frames of the image. Unless this is done properly, the images will look out of balance. The second issue is the placement of the persons within those lines. This aspect is equally important to maintaining the visual integrity of the image.

The dominant lines of a sidewalk are its edges, but the less obvious elements, such as joints and the spaces between masonry, can sometimes be more important. The woman was photographed as she was stepping on the joint between two segments of sidewalk. Note how the joint also aligns with the vertical line between the buildings, and almost aligns with the front cross member of the roof rack on the vehicle parked next to her.

About the Genre

Depictions among the visual arts of people observed from high vantage points has been dominated by photography. The reason is not entirely clear, but may be due in part to the difficulty of drawing and painting in high places. Although people have been photographed in mountainous settings in the landscape and adventure genres, most photographs of people seen from heights have been taken in urban settings. Photographers who have made notable works of this subject include Berenice Abbott and Paul Strand.

About the Exercise

Although people seen from heights tend to constitute points, they generally distribute themselves in spaces demarcated by lines such as sidewalks. The main purpose of this exercise is to work at perceiving subtle lines in broad landscapes. These kinds of lines, as is the case with hands and rocks, tend to exist at several levels. The most prominent lines, such as the curbs of streets and the edges of sidewalks, tend to dominate your attention and can cause you to overlook subtle lines, such as joints and cracks. When doing the exercise, look at the scene carefully and try to discern the subtle lines before you. Also, observe how people move about and come to rest within those lines. Once you discern the patterns of behavior within the lines, take photographs that depict those relationships in some sort of considered manner.

Don't ignore vertical elements. They can be as important as the horizontal lines that demarcate the boundaries in a scene. The foreshortening effect of the lamp in this photograph emphasizes the height because it has a larger visual mass than the person below. Note how the composition is arranged so the lamp is horizontally adjacent to the spot where the person is walking over the rails. When working from high places, the space available to place the camera is often constricted, but even relatively small changes such as raising or lowering the camera by a few inches can significantly affect the relationships between the objects in an image.

Setting Up the Exercise

The abundance of high vantage spots varies depending on the locale, but some can almost always be found with persistence. Extreme height is not necessary to do the exercise, and even two-story structures are usually adequate. Parking garages, shopping centers, and bridges can be good choices because they are usually easily accessible. In any case, be sure to use good judgment and avoid dangerous places. Risk rarely equates with better images. Furthermore, the exercise of prudent caution is a good thing irrespective of whether it derives from common sense, learned behavior, or repressed urges.

Technical Considerations

If the people below are far away, the images will look better if they are rendered sharply. When the available light allows it, setting the lens to a sharp aperture, such as f/8, is recommended.

Exercise 12

Strings

Strings, ropes, cables, and wires are used for many purposes and have come to be extremely common objects in the human environment. This has not always been the case. Cordage such as string and rope was first fashioned from hides, hair, sinew, and vines during neolithic times, and was used as straps and for binding the parts of tools together. Pre-Columbian peoples in the Western Hemisphere even made ropes from vines and used them to construct bridges over rivers.

As technology advanced, cords came to be mostly manufactured from plant fibers. Hard fibers from the leaves of plants such as abaca (manila hemp) and sisal were used to make ropes with very high strength, and soft fibers from plants such as jute, hemp, and cotton were used to make more supple cordage. Ropes were made solely by hand until 1793, when the first rope-making machine was invented. Mechanical methods for manufacturing rope advanced substantially during the nineteenth century. During the twentieth century, synthetic fibers such as nylon and polyester came to be the major materials for manufacturing rope, although natural fibers are still favored for some applications.

Wire is made by drawing metal through progressively narrower dies. It was first developed in the ancient civilizations, but its use was mostly limited to jewelry because it was difficult to make large quantities. By the Middle Ages, wire was still made by hand but was also used to make rivets and chain mail armor. The demand for wire increased dramatically during the nineteenth century because of the westward expansion in North America and the major technological advances affecting society. The development of

Hanging lines can take on a special appearance, perhaps because they are perfectly vertical. The lines in this image are enhanced by the irregular shapes created by the oranges. They also contribute to the composition by forming the main part of the visual mass in the right third of the image.

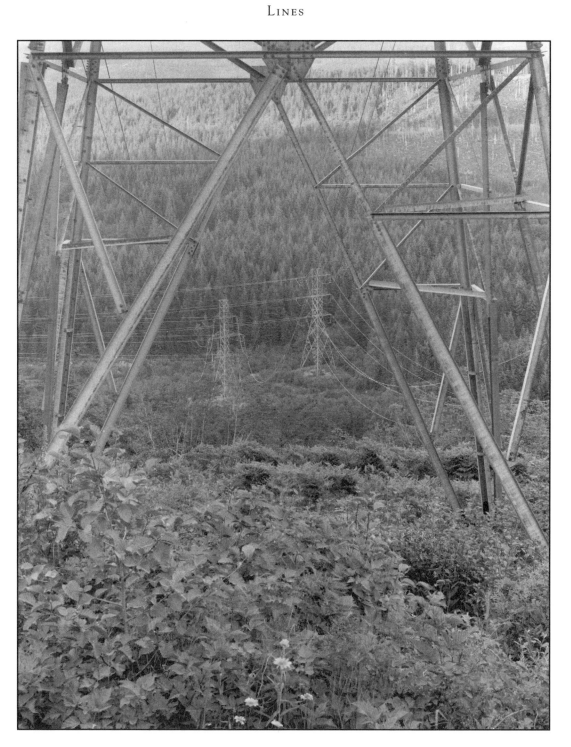

Power lines are generally considered to be undesirable incidental elements in landscape photography, but it is sometimes possible to make them the subject of an image.

One way to use the tendency of thin curved lines to become lost in the background is to hide unsightly power lines. In the image on the left, the upper power line appears prominently against the sky, and its prox-imity to the lower power line also makes it easy to discern. Moving the camera back lowers both lines into the trees in the distant background, where they are effectively concealed.

the telegraph, telephone, and electric industries required huge amounts of wire for the manufacturing of electric machinery and the laying of transmission lines. The passage of the Homestead Act created a large demand for barbed wire. In response, large wire mills were established to manufacture wire at the commodity level. Afterwards, wire became a common material and was put to widespread use in many applications.

About the Genre

The proliferation of wires throughout the environment has created problems for architectural and landscape photographers, since they are generally perceived as blemishes. Power lines and telephone wires, particularly those suspended from transmission towers, mar the appearance of natural places and are anathema to most landscape photographers. Some photographers, such as Robert Adams, have chosen to depict the landscape as they see it and do not avoid compositions with power lines and other wires. Even in interior spaces, electrical cords and outlets are similarly disfavored by architectural photographers, many of whom will spend considerable time hiding them or composing images so they are blocked from view.

About the Exercise

When ropes and wires are suspended from one or two points, they tend to form soft lines that are readily susceptible to the influence of gravity and external forces such as wind. The purpose of the exercise is to find lines formed by ropes, wires, and cords, and create photographs in which the "string" is a dominant visual element. It is important to observe how they actually appear because they rarely form straight lines unless they are

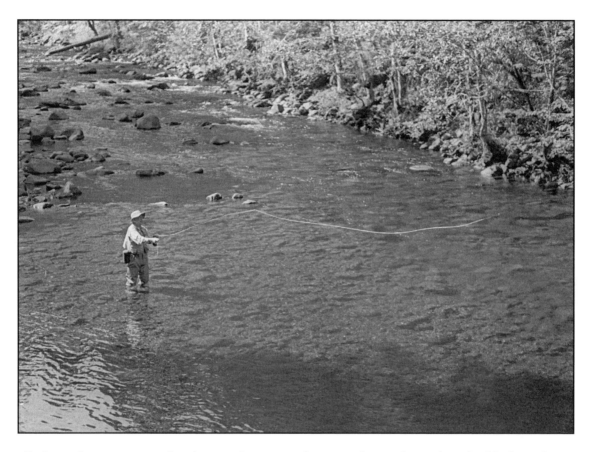

Backgrounds are important when the image features the thin curved lines formed by cordage. Flylines are highly flexible and dynamic when cast, but are actual-ly easy to photograph near the ends of the forward cast or back-cast, provided the angler has mastered the skills needed to throw out a pretty line.

under substantial tension. Likewise, most of these lines tend to be thin and curved, so it is important to avoid situations where they will be nearly invisible against an inappropriate background.

Setting Up the Exercise

Find a scene that features some type of string, rope, or wire that is suspended from at least one point. Situations where the string is substantially supported by resting on a surface, such as electrical cords on tables or people wearing necklaces, are to be avoided. Take several photographs while ensuring the object is visually aligned with the other elements in the composition and stands out prominently from the background. Pay particular attention to the background, because the fine lines formed by most strings show up best against contrasting backgrounds. Try to place dark strings against light backgrounds, and vice versa.

Technical Considerations

Fine-grained films are generally the best choice for recording fine lines. However, fast films will work well despite their coarser grain, provided there is sufficient contrast between the string and the background.

Exercise 13

Star Trails

The illusion that stars move through the night sky is created by the Earth spinning on its axis. When stars are photographed with long exposures, they will record as curved trails in the images. The positions of stars can be predicted with great precision because they follow paths according to their position on the equatorial coordinate system. This system is analogous to the system of longitude and latitude used to map the Earth's surface, but is instead applied to the celestial sphere. The grid used in this system rotates at the same rate as the Earth, which means that the coordinates are constantly moving with respect to the observer. In the Northern Hemisphere, the axis around which the celestial sphere rotates is very close to Polaris, which is more commonly known as the North Star.

Polaris is the nineteenth brightest star in the northern sky and forms the end of the tail of Ursa Minor (the Little Dipper). While the star is readily discernible, it does not particularly stand out in the night sky. To make matters worse, the light pollution that affects most urban skies makes it difficult (and sometimes almost impossible) to distinguish all the stars that are key to discerning the Little Dipper.

Fortunately, there is a fairly simple way to find Polaris. The Big Dipper asterism in Ursa Major is easy to see in most skies and is widely recognized. It can be seen to the northwest at mid-sky level after twilight during summer and to the northeast during winter. Once you find the Big Dipper, you can find Polaris by following the imaginary line formed by the two stars at the end of the bowl and continue out about five times as far as the distance between them.

About the Genre

Most nature and landscape photographers take at least a few photographs of star trails at some point in their careers. For example, Art Wolfe has produced some nice photographs in this area. Although the moving sky has fascinated humans for millennia, it is interesting to note that photography is the only conventional visual arts medium that has explored depicting this motion in substantive depth.

About the Exercise

Although stars form trails over long exposures, they are seen visually as points. This exercise is intended to exercise your faculties at imagining implied lines based on single points and the direction in which they are moving.

You can assess the paths that stars will follow by pointing your arm at Polaris and visualizing the arcs around Polaris. As you move your arm away from the celestial axis, the arcs will be along the line equidistant from Polaris and will form in a clockwise direction. Since the Earth rotates about its axis at fifteen degrees per hour, you can estimate the lengths of your star trails according to how long your exposure will be. When you have rotated your arm so that it is positioned ninety degrees from Polaris, you will have found the approximate location of the celestial equator. This is the region where star trails will show the most length per unit of exposure time.

Star trails will appear more curved the closer they are to the celestial pole, and will straighten out as they approach the celestial equator. If you include Polaris in the image, the trails will appear to revolve around a point very close to that star.

This photograph of star trails and cottonwood trees was made during a windstorm using ISO 400 film exposed for twenty minutes at f/8.

This can be useful to know when composing images because you can place the point around which the stars revolve against objects that will be complemented by the circular effect created by the imaged trails.

Setting Up the Exercise

Find a subject in the landscape that features strong visual elements with edges that you can juxtapose against the star trails. Examples include trees, buildings, and geologic formations such as hills or mountains. Find a spot where you can photograph the object in such a way that the star trails complement the object. Contrary to popular belief, exposures do not need to last for hours to show the star trail effect to good advantage. Experiment, and you may find that exposures lasting only a few minutes will suffice.

Technical Considerations

If possible, photograph star trails under dark skies because the ambient brightness of the sky will record on the film and wash out the background. This effect is known as sky fog and, eventually, it can reach the point where it will wash out the fainter trails. Sky fog can be reduced by stopping down the lens, which will reduce the amount of light from the sky proportionately more than the light from the points formed by the stars.

Selecting the proper aperture requires that you balance between washing out the trails by overexposing the sky and picking up sufficient detail in the foreground objects. Setting the aperture at f/5.6 usually works well for star trails lasting five to thirty minutes, because it will reduce sky fog while allowing you to record the trails made by the brighter stars.

Exercise 14

Portraits

There are dozens of guidelines and tips for taking portraits. These range from the long-since discredited advice that the sun should be over the photographer's shoulder to the old adage that people with big noses should point them directly at the camera lens when being photographed. Although few of these guidelines are universally followed, they can be helpful when photographers need a little help in setting up a portrait. Like the rules of composition, these guidelines should not be rigidly applied, and are best used as starting points.

The work of the elite portrait photographers shows that the best images are made without resorting to contrivances. These photographers universally agree that the most essential skill for portrait photography is getting to know something about their subjects and putting them at ease before taking the photographs.

Many guidelines are directed at helping photographers deal with lines in quarter- to full-length portraits. Some of these guidelines are meant to help subjects overcome the natural tendency to look straight into the camera. For instance, one guideline states that models should hold their heads away from the camera at one angle, while placing their bodies at another angle. Other guidelines are more directed at keeping models from hanging their arms down by their sides and standing with their feet square to the camera. These guidelines recommend that subjects keep their arms separated from their bodies, bend their wrists upward, raise their heels, and keep their back foot ninety degrees from the camera while pointing their front foot in a direction toward the camera.

About the Genre

Posing techniques were essential during the early days of photography, when slow emulsions required exposures that lasted several seconds. Some photographers even resorted to braces and clamps to keep their subjects still. Nonetheless, some photographers were able to gracefully pose their subjects despite these limitations. Julia Margaret Cameron is a good example.

Modern photographers use faster films and sophisticated lighting equipment, and are no longer technically restrained with respect to exposure time. Although they may choose to photograph different types of people in different contexts, the best portrait photographers manage to show a sense of naturalness even under studio conditions. For an example of how two photographers can take different approaches to portrait work while maintaining variety and distinctive styles, compare the photographs of Annie Leibovitz and Anne Geddes.

About the Exercise

The objective of the exercise is to make a portrait under circumstances where the person or persons know that you are photographing them. Start by asking the person to take some sort of pose while standing, sitting, or prone. Observe how the lines of the face, neck, head, torso, arms, and legs affect the appearance in the viewfinder. Ask the subject to change the pose slightly and evaluate the effect it has on the composition. Some suggestions you may want to try are angling the body away from the camera, tilting the head, lifting a heel slightly, and pointing the feet at different angles to the camera. Consciously note

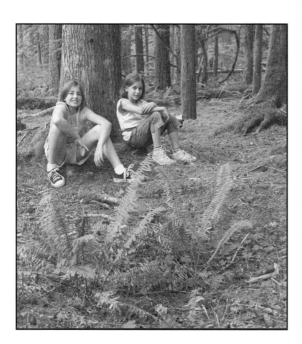

One way to get natural-looking portraits is to start by having the subjects select their own poses. Afterwards, while looking through the viewfinder, you can suggest refinements.

The setting can also be used to encourage good poses. Note how the curved bottom of the boat made it nearly impossible for the boys to sit square to the camera, and encouraged a unified pose.

how small changes such as repositioning the feet can substantially affect other parts of the pose.

Setting Up the Exercise

Portrait work can be done in many kinds of places so give this issue some consideration. You can use a plain wall to emulate a studio setting if you want to give a formal look to the portrait. Likewise, you can make a simple background by draping sheets and similar materials over a pole. These kinds of background tend to work better when you put some distance between the subject and the background. Environmental portraits tend to be appreciated by subjects, and if you want to take this approach, ask the subject for their personal preferences regarding the setting. When subjects participate in planning the session, they tend to be more cooperative, which usually results in a better portrait.

Technical Considerations

Lighting is very important in portrait photography. The most critical element is how the light falls on the subject's face. You want sufficient illumination to bring out the important details and, generally, some shadow to accentuate the features. Portrait lighting is a book-length subject in itself, but a very workable starting place is a single light located about forty-five degrees above and to the side of the subject.

Exercise 15

Fingers

Hands are the most complicated and versatile parts of the human musculoskeletal system. Much of human communication is mediated through the hands through various gestures. For example, people greet one another by shaking hands and waving. They also use hands to identify or designate objects by pointing at them. Hands are also used to express emotions such as anger when clenched into fists. The use of hands to communicate is so ingrained that people even gesture when they are talking to each other on the telephone.

Gestures vary among cultures. North Americans form the "OK" sign by holding the tips of the index finger and thumb together to make a circle. However, this is considered to be an obscene gesture in many Latin American countries, and in France, it is used to indicate that something is worthless. The thumbs-up sign, which is used in the United States to indicate that something is positive, is considered rude in Australia and obscene in Spain and Iran.

Of course, hands are also used for mechanical tasks, such as grasping, feeling, and pushing. Hands are anatomically complex, with twenty-seven bones, thirty-three muscles, and twenty joints. They are neurologically intricate, as well, and rarely stay completely still for extended periods. The extreme dexterity facilitated by hands has largely made possible the development of the high levels of culture among humans. Hands are essential to culturally significant tasks such as grooming, writing, cooking, eating, playing musical instruments, and dealing cards.

Viewpoint can be important when taking photographs that feature hands. In situations where people are handling objects in front of them, the best vantage will sometimes be behind the person. One way to emphasize the dexterity of hands is to photograph them when the fingers are wrapped around an object.

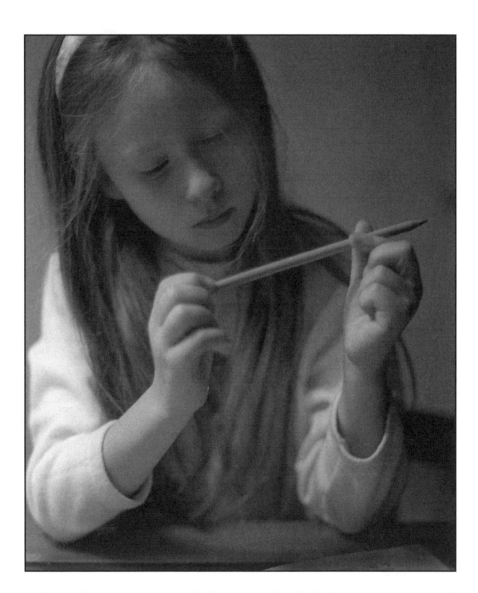

Enhancing the elegance of images by depicting hands with the fingers engaged in a specific task is a technique that dates back to the Renaissance. When subjects are engaged in dextrous activities, watch for these poses, because they typically last only a moment.

Performances with musical instruments are good subjects for this exercise because the hands are easy to see and assume a variety of positions.

About the Genre

Most artists consider hands to be one of the most difficult subjects to depict. The interest in anatomy shown by Renaissance artists such as Albrecht Dürer, Michelangelo, and Leonardo da Vinci evinced itself in the importance that hands played in their works. Hands became easy to depict with the advent of photography, since cameras automatically take care of issues such as foreshortening and perspective. Although hands are not technically difficult subjects for photographers, they still require a good eye to render well. Examples can be seen in Elliott Erwitt's *Handbook* (Quantuck Lane Press, 2002), a collection of images taken over a forty-year period in which the veteran Magnum photographer shows how people use their hands in a variety of ways.

About the Exercise

This exercise is intended to provide experience at looking for relatively short lines that can strongly influence compositions. Look for settings and situations where people will be using their hands. Gesturing is a good subject for street photography, and is common when two or more people are communicating. Public events such as concerts and auctions are good, as well, because people often rely on their hands for expression in such settings. Activities involving manual dexterity, such as writing, working on crafts, and unwrapping presents, are also good choices.

Setting Up the Exercise

You are looking to take essentially candid images, so it will be necessary to position yourself where

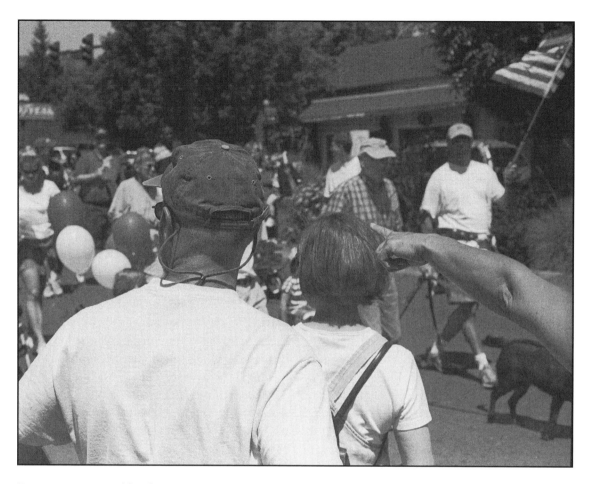

Pointing is a universal hand gesture. Gestures are a powerful means of communication and are highly useful to photographers, because their meanings are usual-ly apparent to the viewer. In situations where people are fairly inactive, capturing a gesture in an image can significantly enhance its appeal.

the hands and any associated activity are in plain view of your camera. The best position will vary according to the circumstances, and you need to be able to see most of the hand. In many cases, a front or side view will be best. Sometimes, such as when a person is handling a large object, the view from behind the person will work best. Watch the positions of the hands in general and the fingers in particular. Take several photographs in which the fingers are positioned in attractive, expressive, or interesting ways.

Technical Considerations

Fingers tend to move fast, so you will need to select an appropriate shutter speed if you want to stop the motion. In situations where the depth of field is limited, images of hands tend to look bet-ter if the nails are the points of sharpest focus.

Exercise 16

Stairs

Falls down stairs are a well-known cause of injury, and they present an opportunity to examine how society views issues of risk and responsibility. At the governmental level, building codes promote safety by addressing issues such as angle of inclination, width, riser height, and tread length. For the most part, government standards reflect the minimum levels considered appropriate.

Building owners vary in how they feel about stair safety. The responsible ones want stairs to be well designed and maintained, but they also want tenants to take reasonable safety precautions, such as watching where they are going and using handrails. Less responsible owners do not want to be burdened by problems such as uneven surfaces or bunched-up carpeting. Their approach to stair safety is that the tenants should be extra careful when they encounter risky conditions.

The attitudes of occupants tend to vary depending on the circumstances. Most willingly assume personal responsibility for safety within the spaces they control, such as their residences. However, they usually feel that owners should be responsible for maintaining safe conditions in common areas such as commercial spaces.

Lawyers often view the issue of stair safety depending on who they represent. To be legally liable for the injuries that a person suffers from falling down stairs, owners must either have caused the dangerous condition or failed to correct a known or reasonably detectable problem. Lawyers representing the injured party will look at whether or not the owner failed in their duty to maintain safe conditions. Lawyers representing owners will usually argue that the injured person was responsible for the fall.

Different interests result in different perspectives and different attitudes toward personal responsibility. Understanding the different ways that people feel about these kinds of issues can help photographers approach images in more insightful ways.

This exercise provides the opportunity to use lines as static references against which moving subjects can be photographed. Note how the primary visual clues that the image is of a stairwell are the handrail and the elevated vantage. Only a small portion of the stairs themselves are visible at the bottom of the image. Knowing that people are able to determine objects and contexts based upon small pieces of visual information can be useful when composing images.

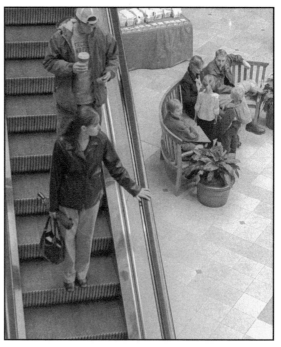

Note how the diagonal lines converge around a specific area (left) and bisect the entire frame (above).

About the Genre

Stairs appear fairly frequently as subjects in architectural and street photography, particularly among photographers who show an inclination to depict strong linear elements. Photographers who have made several good works that feature stairs include Andre Kertesz, Alexander Rodchenko, and Tina Modotti.

About the Exercise

Stairs feature strong diagonal lines, and are places where people tend to be in motion. The purpose of the exercise is to provide experience with composing with diagonals and also with placing moving people in compositions. Approach the exercise by selecting a spot that people will transit, and wait for them to come to you.

Setting Up the Exercise

Find a vantage at the head or bottom of a flight of stairs, where you will have a good view of the people using them. Plan your composition ahead of time, giving particular emphasis to the diagonal lines formed by the handrails and the steps. You should also evaluate where people should be placed in the composition before they enter the scene. Take several photographs of people as they approach or use the stairs.

Technical Considerations

Places with stairs are not always brightly illuminated, so you may need to compromise regarding depth of field and, point of focus. If so, most images work best when focused on the people rather than the architectural elements.

Exercise 17

Roads and Paths

During the middle of the nineteenth century, it is estimated that 250,000 to 650,000 people migrated to the western United States. Although it was possible to reach the Pacific coast by ship, most settlers traveled over land because it was less expensive and quicker. The Oregon Trail was the most popular route, and settlers used it and various cutoffs to travel to Oregon, California, Utah, Colorado, and Montana. Travel by wagon was the favored means of transportation until 1869, when the availability of railroad service reduced the trip from a few months to a few weeks.

Practical considerations dominated the concerns of the families that made the winding 2,000-mile journey across prairies, deserts, and mountains. Most of the space in their covered wagons was devoted to tools and food. Although most families brought a few heirlooms, the wagons were not used as mobile living spaces. Most of the settlers used oxen to pull their wagons.

Although slower than horses and mules, a yoke of oxen cost one-fourth as much as a horse and could sustain themselves on native prairie grasses, whereas horses could not. Some settlers used mules, which were faster than oxen, and could live off prairie grass, but most did not appreciate their cantankerous dispositions.

Political considerations were also important to the westward expansion. The United States government had acquired vast territories in western North America during the first half of the century, and wanted to encourage settlement to cement its hold on these lands. Through a series of acts, parcels of land ranging from 160 to 640 acres were made available to individuals and families for free or at low cost, provided they worked the land. During the 1850s and '60s, Congress granted several railroad companies titles to vast tracts of land which they were expected to sell off to finance the building of new rail lines. The

You can establish a mood by photographing activities on the street that are associated with specific times and emotions. Children riding their scooters in a community-wide Fourth of July parade evoke the feeling of summer and carefree childhoods. This photograph of an informal parade was taken while I stood in the street. I did this so that the children on the scooters could be isolated against the sloping pavement. Had I taken the image from the sidewalk, the children would have been lost against a very cluttered background formed by the crowd of onlookers. The street is not a dominant element, but this image demonstrates how working within the lines can be used to advantage when composing images.

A shabby single-lane road set in the gloom of approaching twilight produces a sense of loneliness. The lone rabbit adds to the feeling of isolation. Composing the image so that the near edges of the road are placed on the sides of the frame adds to the sense of depth by making the foreground appear more massive.

legacy of these grants is highly controversial, but they were important in establishing rail as the primary means of transcontinental travel until the development of the highway system during the first part of the twentieth century. When the time came for the westward migration during the Great Depression, most of the masses traveled by motor vehicle on paved roads.

About the Genre

Roads, streets, paths, and such appear frequently in street photography, since they are common fixtures of urban areas. A review of the work of almost any prominent street photographer will show the many ways that streets and walkways can be depicted photographically. One of the classic works of street photography, *The Americans*, by Robert Frank, was created during a road trip throughout the United States during 1955 and 1956. People have widely different interpretations of what the photographs in the book represent, but most agree that it reflects the complex vision of the country as seen by an outsider.

About the Exercise

Use this exercise to explore the placement of objects within or against the lines formed by streets and paths and to see whether you can establish a sense of mood by the context and composition of the images. Some possible approaches are to concentrate on depicting public events, the activities of solitary persons, or

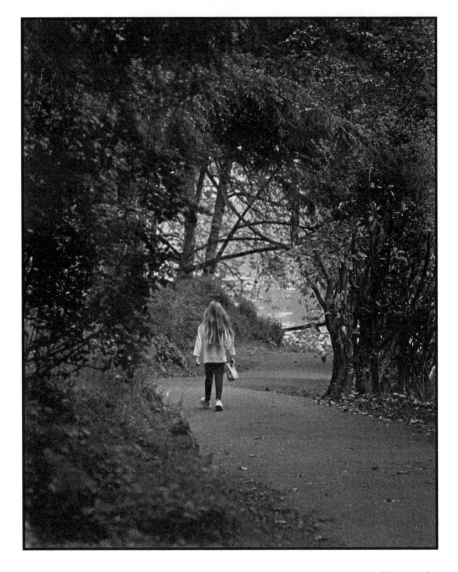

Paths are often surrounded by objects, such as trees and structures, that add vertical lines. These objects help define the edges. If the vantage is properly selected, such lines can be used to emphasize the subject.

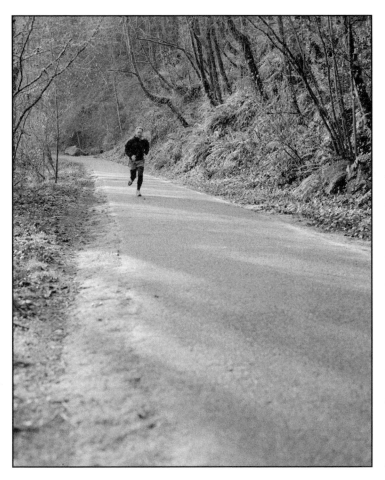

A sense of the loneliness of running is given to this image by placing the near edge of the path at the bottom. Here, it emphasizes the distance to the visible end of the path, and it also emphasizes the convergence with the opposite edge of the path. The placement of the runner is important to this composition. Any closer, and his visual mass would have dominated the image, to the extent that the path would have been strongly de-emphasized. Further back, the runner would have been relegated to a background element. This composition was an intuitive judgment, intended to show that the runner had come a long distance but still had much ground to cover.

small objects, such as the feet of people walking by. Once you have selected a general approach, survey the scene and evaluate your options regarding how you might depict the street or walkway. Depending on the direction you photograph, you may be able to emphasize the depth of a scene or capture a sense of fleeting motion. Experiment by taking several photographs, and assess which approaches work best for you.

Setting Up the Exercise

Take the photographs at or near normal street level so that you are working on a substantially horizontal plane. Look for some characteristic in the scene that can form the basis for a sense of mood. When you compose the images, be mindful of how the object is placed within the lines that form the edges of the road or pathway. These lines are part of the background, and need to be accounted for in the composition.

Technical Considerations

Photographs that feature roads and paths typically benefit from having a lot of depth of field, because sharpness throughout the image adds to the sense of distance. If you have to compromise between depth of field and shutter speed, the best solution will be to focus on the object of interest.

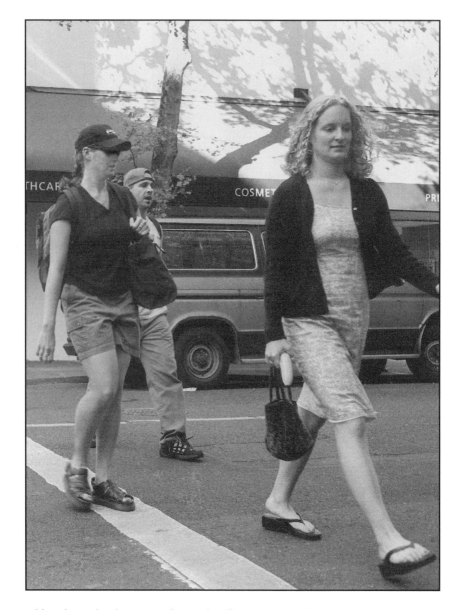

Although people who are standing and walking can generally be perceived as vertical lines, you should try to monitor other associated linear elements, such as arms and legs. Note how the extended leg in the foreground contributes to the composition of this image. Evaluate how the image would differ if the leg were not extended and how it would appear if all the right legs were extended at the same time.

Exercise 18

Street Lines

One characteristic that distinguishes urban settings from other landscapes is that the linear elements tend to form a greater proportion of their visual complexity. While perfectly straight lines do exist in nature, they are much more common in areas where development had been subjected to the human proclivity toward straight lines in construction, communication, and organization. Curved lines also take on a different character in urban areas, and they tend to be more regular and geometrically perfect.

Another characteristic of urban settings is the plethora of dynamic lines and their interaction with static ones. People are generally the most interesting of the dynamic lines and, naturally interact against common static lines, such as streets, walkways, trees, and columns. Understanding how static elements provide visual backdrops is helpful when planning compositions and evaluating dynamic scenes as they develop.

About the Genre

The works of all the highly regarded street photographers feature strong lines. Lines can be a blessing or a curse in street photography, depending on whether they add to or detract from a composition. Many of the best images show that street photographers frequently contend with lines by using dominant and subtle lines to good effect and minimizing the disruptive effects of extraneous dominant lines. When viewing works in this genre, it is highly recommended that you evaluate how dominant and subtle lines factor into the effectiveness of the image.

Looking at how other photographers have approached street scenes can also provide insight into the challenges of street photography. Although Raghubir Singh was inspired early in his career by Henri Cartier-Bresson's photographs of India, he approached street photography in the context of Indian esthetics. Singh favored portraying the vivid colors he found in his land over Cartier-Bresson's use of monochromatic film in a documentary style. Having grown up and been educated in India, his images show a markedly different attitude toward that country than is seen in the works of photographers who have visited such, as Margaret Bourke-White, William Gedney, and Sebastião Salgado.

About the Exercise

The purpose of this exercise is to develop a portfolio of street images while using your abilities to perceive lines in dynamic settings. The four basic objectives of the exercise are to recognize:

• dynamic lines as compositional elements in their own right.

• static lines as baselines for composition.

• dynamic lines as a tool to increase or diminish emphasis.

• the psychological aspects of linear elements (mostly arms and legs).

It is important to be able to perceive linear elements in both their obvious and subtle forms. Contours, such as the edges of sidewalks and corners of buildings, tend to be more obvious than elements such as cracks, traffic lines, and utility vault covers. Both kinds of lines can strongly affect images, although it is easy to overlook subtle lines unless you are looking at scenes in a seeing mode. Similarly, while standing and walking people can be perceived generally as vertical

Street scenes often feature strong vertical lines in forms such as the corners of buildings. Placing other vertical elements against them so that the lines are parallel can produce visually pleasing compositions. The vertical nature of the lines in this image is particularly emphasized because the woman has her arms behind her back, thus concealing her forearms. Even though this scene looks static, most images of this kind actually involve dynamic situations. Her gaze to the side, which is a major visual element, was fairly fleeting. Furthermore, as a practical matter, when you come across such scenes, you will normally be able to take only a single shot before the subject changes his or her stance.

lines, but appendages such as arms and legs are more subtle elements that can make an important difference in how well the image works.

Remember that street photography is not limited to large cities. Any place where appreciable numbers of people gather in constructed areas is suitable. For example, settings such as county fairs in remote areas can be as visually rich as downtown areas in the largest cities.

Setting Up the Exercise

This exercise can be done over the course of several days, and is well suited for those photographers who always carry a camera so they can take advantage of opportunities as they arise. During the first part of the exercise, observe people as they go about ordinary activities such as walking,

standing, and sitting. Pay particular attention to how people move their arms and legs when walking, and how they move their arms and tilt their bodies when talking with one another. While the pendulum motions that arms and legs make when people walk are easy to perceive, the very slight tilts of torsos and necks made when people talk can be just as important to a composition. Make several images that reflect your conscious perception of these dynamic elements.

The next part of the exercise is to look for situations where static lines form a backdrop over which to place dynamic elements. Some possibilities are to photograph people as they walk around corners, stand next to architectural columns, or navigate among obstacles such as tables. In many cases, you will have a few seconds

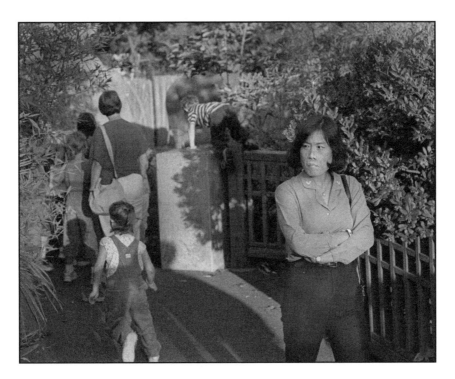

Dynamic lines can be used to monitor the distribution of the visual weight of elements in busy settings. To emphasize the standing woman, this photograph was taken as the lines formed by the passing family merged into a single vertical line.

in which to evaluate how a scene is going to develop. Practice watching dynamic elements approach the static backdrop and assessing the best time to make the image. Take several photographs which are based on a dynamic line moving in relationship to one or more static lines.

Following this, experiment with how the convergence and divergence of dynamic lines can add or reduce emphasis in an image. This is a technique that can be particularly useful in dealing with people in groups and crowds. Paradoxically, it is sometimes easier to emphasize that people are in an associated group by photographing them when they are apart. Conversely, you can de-emphasize a group by photographing them when they are close together.

Finally, maintain your emotional awareness when making the images. Linear elements, such as crossed arms, pointing fingers, and hand gestures, can sometimes add psychological elements that make images more effective.

Technical Considerations

When doing street photography, it will often work better to focus using the hyperfocal distance method of setting the depth-of-field scale to encompass a range of distances in which the subject will be in focus. You can usually get by with less depth of field when the composition is based on a static reference point. In such cases, settle into a suitable vantage point and prefocus on the spot where the action will happen.

Exercise 19

People at Play

Games and play activity are an important part of growing up. At the individual level, games are an important part of child development because they provide experience that enhances motor skills. As they grow older, participation in group activities teaches children how to coordinate and cooperate with other people.

Games and recreation have benefits that extend beyond childhood. For example, activities that require players to perform specific functions involve a sort of role playing that can lead to improvement of character. Other benefits include providing a sense of control over one's life and a means of garnering social kudos. Most people enjoy games and continue playing them throughout their adult years.

About the Genre

Recreational movement is an important part of most cultures, and is widely depicted in art. Activities such as motor sports and flight feature prominently in photographs by Jacques-Henri Lartigue. He made photographs of other forms of recreation, as well. Some of the more interesting images of this type come from the world of dance. Many of the works of Edward Degas feature strong lines in their compositions. Although he is well known for his paintings and pastels of ballet dancers, Degas also made a few photographs of dancers. Dance is also an important subject in modern photography. Lois Greenfield has made many notable photographs depicting creative forms of movement.

When composing images of dynamic scenes, listening for the sounds they make can help you determine when to release the shutter. Dance and musical activities involve rhythm and repetition, and observing how movements correlate with sound and time can help you capture peak moments that would be difficult to gauge solely by sight.

One technique that can be used to determine the best moment to release the shutter is to abstract visual elements and follow their spatial relationships as they change with time. One way to photograph limbo dancing is to abstract the head as a point, and release the shutter just before the anticipated moment when the point will touch the line formed by the stick.

About the Exercise

Many recreational activities involve strong linear elements in the form of implements or extended appendages. This exercise involves observing certain kinds of playful activities and discerning the action by finding and watching lines.

Setting Up the Exercise

Find a situation where people are engaged in games or similar activities. Outdoor parties, picnics, ethnic festivals, fairs, and group activities such as dancing can present good opportunities. Look for visual elements that have linear characteristics, and evaluate how their movement relates to the action at hand. Take several photographs while using a line or several lines to determine when to release the shutter to obtain the desired composition.

Technical Considerations

Many games and play activities involve fast movements, so use high shutter speeds when appropriate. If you cannot stop the action, many dynamic linear elements will form blurred arcs in which the object will define the edges. While the effect can be visually interesting, be sure to consider how those edges will fit in the composition before taking such photographs.

Exercise 20

Skating

Roller skates are believed to have originated in Holland during the eighteenth century, when wooden spools were nailed to strips of wood. Skates underwent further mechanical development in France and England. However, the Germans can take credit for what were most likely the most significant cultural advances for European roller skating during that period. In 1818, roller skating was incorporated into a German ballet, and in 1840, barmaids were put on roller skates to serve thirsty patrons in beer halls.

Despite the progress in Europe, the major developments that resulted in roller skating becoming a popular activity took place in the United States. In 1863, James Plimpton invented the modern style of roller skates, which have two parallel sets of wheels. These were the first kind of skates that could maneuver freely in a smooth curve. He also opened the first roller rink in the United States, which was a converted warehouse with smooth wooden floors. Until that time, skating was significantly constrained by the widespread use of cobbles in paved streets. It was also a somewhat elite activity, and the first rinks were patronized by the upper social classes.

The most important development in roller skating occurred at the turn of the twentieth century, when ball bearing wheels were introduced. This changed roller skating from a slow and fairly strenuous activity to one where the skaters could coast with ease and develop significant speed. Skating became popular, and roller rinks catering to the general public were opened throughout the country. Its popularity soared during the Great Depression because it was fun and affordable. In 1980, the introduction of roller blades, which allowed for greater agility, maneuverability, and speed than conventional skates, gave the activity another huge boost in popularity.

About the Genre

The skating sports, whether on land or ice, have mostly been the domain of sports photographers and are generally perceived as difficult to photograph because of the fast action. In some instances, the difficulties go beyond capturing the action. For example, one professional sports photographer advises paying careful attention to your camera bag when photographing professional ice hockey to prevent theft by fans.

About the Exercise

The exercise is intended to develop skills at using lines to judge dynamic relationships. It can involve almost any of the skating sports, so long as two or more persons are participating in the activity. Roller rinks are recommended as venues because they are easy to access and feature fast action. When doing the exercise, abstract the skaters as vertical lines and follow the action accordingly. With only a little observation, you will notice that at public rinks the skaters proceed at very different paces and converge, pass, and diverge at a rapid rate. Although skating at rinks is a form of visual chaos on wheels, if you watch the action over time, you should be able to get a feel for how it develops and unfolds.

Setting Up the Exercise

The objective is to isolate individual skaters or groups of skaters from the mass of activity. Once you have found a safe viewpoint, concentrate on

Roller rinks can be very difficult settings for photography because the elements in the foreground and background are moving at different speeds and in different directions.

One approach to photographing skaters is to simplify the scene by abstracting them as moving vertical lines and watching for convergences and divergences.

following the action, and release the shutter according to where the skaters are placed in the composition. To do this effectively, you need to judge how quickly the skaters are converging and estimate when they will sufficiently be separated to call attention to themselves. Also, remember to monitor the distant skaters, as well as those in the foreground, because they will affect the quality of the background. If you are photographing in a rink, the distant skaters will most likely be moving in a direction opposite to those in the foreground. This can make for difficult scenes, but provides excellent experience at judging dynamic relationships.

It is easier to time the images if you follow the action with a careful but relaxed vigilance and release the shutter when you intuitively sense that you have the appropriate amount of separation between skaters. Even though the environment at roller rinks can be chaotic and distracting, resist any tendency to become tense while you are taking photographs.

Technical Considerations

Roller rinks and other skating facilities tend to have dim lighting, and you may need to use very fast film or a high sensor setting in combination with a fast lens. Films that are designed to be pushed to ISO 3200 are good choices. If necessary, shoot with the lens set wide open to maximize your shutter speed. One way to contend with the resulting shallow depth of field is to prefocus on a particular spot and restrict your photographs to skaters passing through that area.

6

Shapes

As visual elements, shapes come in two forms. The first are positive shapes that consist of the tangible objects seen in an image. The second are the negative spaces between them. For the purposes of the exercises, a positive shape is the visual mass formed by an object that occupies a substantial portion of the space within the frame. The boundaries of many positive shapes are defined by distinct edges, but some amorphous objects such as clouds and flames may have fuzzy edges. In addition, groups of points and lines can agglomerate to the extent that the overall visual effect is that of a shape. These groups are also treated as shapes for the purposes of the exercises.

The ability to recognize negative spaces, and compose with them, is one of the most important in the visual arts. In addition, learning to use such spaces when composing images is an excellent way to enhance the brain's perceiving mode, because the analytical mode is not well equipped to deal with empty space. Furthermore, concentrating on the presence and placement of negative spaces helps to overcome the tendency to devote excessive attention to the subject, which often causes photographers to overlook other important visual elements.

Becoming more attuned to shapes can help you perceive the nuances of light, Shapes consist of mostly varied tonalities that provide many of the visual cues through which viewers infer three-dimensionality. One of the principal cues is the gradation in tones caused by light falling on objects in scenes. Evaluating shapes and spaces in a contemplative way provides a good opportunity to assess the effect of light, particularly with respect to how it affects highlights, middle tones, and shadows.

Positive shapes provide a valuable tool for balancing visual mass. Abstracting objects as shapes is a good means of assessing how masses are distributed with respect to each other and within the negative space in which they fit. This technique is particularly suited to evaluating compositions when changing the camera's distance from a subject, since it provides feedback in the form of altered sizes of mass rather than the less useful distance from the frame.

Negative space provides a tool that is more powerful to use than positive spaces. When composing static scenes, contemplative evaluation of the surrounding negative spaces provides the best possible information for determining how much space to put around the subject and where the subject should be positioned within that space. Learning how to perceive and compose with negative spaces is one of the most effective ways of dealing with dynamic scenes. In many cases, it is far easier to monitor how the negative space between objects is changing than it is to monitor the objects themselves. Photographers who have never used negative space as a compositional tool in action-based genres such as sports photography will be pleasantly surprised to learn how effective they are for monitoring the action.

Exercise 1

Eggs

There are many explanations for why eggs have ovoid shapes, and some seem quite plausible. One theory is that the ovoid shape forms a very strong structure that resists crushing. If you try to break open an egg by squeezing around its shell, you will find that eggs are much stronger than many people assume. In fact, eggs are generally broken for cooking by rapping them against a hard edge so that the force is concentrated on a small portion of the shell.

However, spherical shapes are even stronger, and if strength were the primary reason underlying the shape of eggs, then why aren't they round? A common theory is that if eggs were spherical, they would roll out of the nest and be lost. According to this theory, the ovoid shape is protective because it causes eggs to roll in a circle until they come to a stop. This theory is supported by the fact that many species of cliff-nesting birds lay pointed eggs.

Yet another theory is that the ovoid shape enables eggs to fit snugly in the nest and reduces the air spaces between them. This allows more eggs to fit in the nest and causes them to radiate heat onto each other, which keeps them warmer.

Another theory suggests that eggs are ovoid because they really have no other alternative. When birds lay eggs, the ring-shaped muscles of the oviduct move the egg by peristalsis—pushing the egg by contracting at the rear part of the egg while relaxing at the front part. This action causes each end of the egg to deform from a hemispherical shape to a rounded cone shape. As the yolk passes down the oviduct, it is covered by the albumen (egg white), and then by the shell membrane. The egg then passes from the oviduct into the uterus, where the shell is secreted and calcifies. The hardened shell retains the ovoid shape after the egg is passed through the vagina.

The latter theory has merit because once you think a little about the issue, you realize that not all eggs have ovoid shapes. Fish eggs, for example, do not have hard shells and generally assume a spherical shape after being deposited. The soft-shelled eggs of some reptile species resume their spherical shape after emerging. Egg-laying mammals such as the platypus also lay round, soft-shelled eggs.

This is an egg resting on a black background, and it was photographed from its end. Notice how, contrary to the images on the facing page, there is no light area beneath the edge of the shadow. The reason is that the dark background barely reflects light from the table onto the underside of the egg.

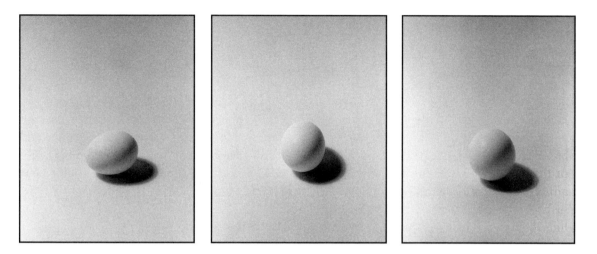

The orientation of three-dimensional objects is important to how they will be depicted in images. Lighting can be important, as well. Note how the form of the egg is indicated by the pattern of light and shadow. The light area beneath the shadow along the middle of the egg is caused by light reflecting up from the table.

About the Genre

Eggs are a popular subject with art instructors who want their students to become proficient at rendering tones. The smooth surfaces and gently rounded contours show fine gradations in both highlighted and shadowed areas. In art classes, the instructors are almost sure to point out the sliver of light that will be found near the base of the egg at the shadow. This is light reflected from the table back onto the egg. These kinds of nuances are essential to drawing or painting eggs realistically. While the camera will automatically pick up highlights and shadows, skilled photographers pay just as much attention as artists working in other media regarding how the tones are depicted during the printing process.

About the Exercise

This exercise serves as an introduction to photographing shapes, and demonstrates that the orientation of the camera to an object can have a critical effect on how the shape will be depicted in the image. To do the exercise, photograph the egg from slightly above and to the side so that its ovoid shape is apparent in the resulting image. Next, photograph the end of the egg from slightly above so that the image shows a somewhat ovoid shape along the axis of the egg. Finally, lower the camera and photograph the end so that the egg appears as a sphere in the image.

Setting Up the Exercise

If you want a solid background, take a long sheet of paper and tape one of the short edges to a support about twelve inches above the table. Let the remainder of the sheet drape onto the table in a curved shape. Place the egg on the flat part of the sheet, a couple of inches in front of where the paper starts to curve upwards. A desk lamp supported about two feet above the egg will make a good light source for the exercise.

Technical Considerations

If your lens will not focus down to twelve to fourteen inches, consider using a close-up diopter to enable closer focusing.

Exercise 2

Gerberas

Gerberas are members of the family Asteraceae, more commonly known as the sunflower family. This is a large and varied plant family, whose seemingly single flowers are actually inflorescences made up of many individual flowers sitting on a capitulum. Gerbera inflorescences have all three kinds of the flowers found in the Asteraceae. The florets in the center of an inflorescence are called disc flowers and have small tubular petals. The flowers arranged on the outer edge of the inflorescence have a large strap-shaped petal and are called ray flowers. The trans flowers, which are located between the ray and disc flowers, have a somewhat intermediate form.

Gerberas are popular as garden plants and cut flowers because their large, showy inflorescences come in a wide range of vivid colors. Most of the commercially cultivated varieties originate from the crossing progenies of G. *jamesonii* and G. *viridifolia*. Gerberas have also been used as subjects for research regarding flower development and the control of indoor air pollution.

About the Genre

The use of flowers as subjects in still-life paintings dates back to the dawn of modern still-life painting in seventeenth-century Holland. Following the end of the war with Spain in 1648, the Dutch economy boomed, and with it, the market in fine art. It is estimated that between five and ten million paintings were created during the golden age of Dutch art. Flowers were an important part of Dutch culture, and the floral paintings of this period typically show lavish

Moving the camera closer to a subject makes it appear larger relative to more distant objects. Likewise, changing the camera angle, even slightly, will alter the juxtaposition of objects and the negative spaces between them. Note the difference in relative sizes between the gerbera and the mouth of the vase in the images to the right. Also, note that the slightly higher camera angle in the right-most image reduces the negative space between the gerbera and the rim of the vase.

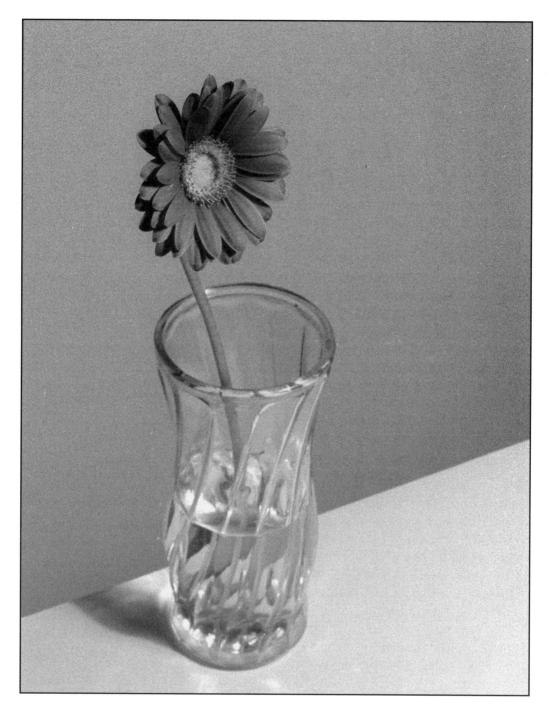

Gerberas make a good subject for seeing how distance and camera angle affect the rendering of perspective. An important aspect of the exercise is to use a container that has a mouth that is about the same size as the inflorescence.

Changing the camera angle will alter the profiles of shapes and affect the information visible within the shape. Moving the camera to the right yields a rounder profile and more clearly displays the ray, trans, and disc flowers.

arrangements of mixed flowers depicted with a high level of botanical detail.

Flowers were also a popular subject with the Impressionists in France. Unlike their Dutch predecessors, the Impressionists dispensed with the fine detail and emphasized the play of light on shapes. In addition, many of the works were limited to a single species of flower. The preference for single species over mixed arrangements is even more prevalent in fine art photography. While the reason for this is uncertain, it could reflect the principle that simplicity in visual presentation tends to strengthen photographs.

About the Exercise

The purpose of this exercise is to examine how relative distances between subject and camera can affect perspective. The basic approach to the

exercise is to set a single gerbera in a container with an opening that is about the same diameter as the inflorescence. While keeping the flower in the same position, you explore the effect of moving the camera closer and farther from the gerbera and also the effect of raising and lowering the camera. Two aspects that should receive particular attention during the exercise are the size of the inflorescence relative to the size of the mouth of the container and their relative positions in the composition.

Setting Up the Exercise

To reduce the tendency of gerberas to droop after a day or so, trim the end of the stem at an angle and place it in the container with water no deeper than two inches. If the stem starts to droop, it can sometimes be restored by retrimming the end.

 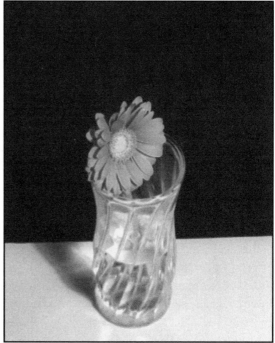

Notice how important it is to be aware of how shapes align in a composition. In these images, the contour of the inflorescence aligns with the opening of the vase. The lack of separation between the foreground and background shapes gives the subject matter a collapsed impression. Also, note how the point of focus and the depth of field differ in the images above. When the

available depth of field is insufficient to render all the objects in a reasonable degree of focus, you will need to decide which compromise works best for you. In general, most viewers prefer that the point of direct attention be rendered sharply at the expense of other elements. For flowers, this will usually be the structures in the center, such as the disc flowers, pistils, or stamens.

Gerberas are sensitive to bacteria, so keep the water clean if you want to extend the flower life.

Use a background that is large enough to encompass the subject when photographed from a wide range of angles and distances. A sheet of poster board suspended next to a table should work well for this purpose. Evaluate and photograph several compositions with the camera positioned at different angles and distances from the inflorescence. Note how fairly small changes in distance and camera angle can affect the relative sizes and juxtapositions of the inflorescence and the mouth of the container.

Technical Considerations

Consider experimenting with depth of field, because the container does not need to be rendered sharply to produce pleasing images. As is the case with most flowers, the best way to maximize the impression of sharpness of a gerbera is to focus on the structures in the center portion of the inflorescence.

Lighting gerberas is straightforward. As long as the light is coming from somewhere in front of the inflorescence, it should work fine. You can fine-tune the lighting by observing where the shadows fall behind the petals of the ray flowers.

Exercise 3

Tangerines

The Chinese calendar is based on the solar year but its months coincide with the 29.5 day synodic month of the lunar phases. An ordinary year has twelve months and can be 353, 354, or 355 days long. Leap years have thirteen months and are 383, 384, or 385 days long. The start of each month is marked by the new moon. The months are named according to the principal term, which is the date when the sun's longitude is a multiple of thirty degrees as measured from a meridian near the east coast of China. Leap years are inserted when there are thirteen new moons from the start of the eleventh month of one year to the start of the eleventh month of the next year.

The Chinese new year occurs on the first day of the first month in the Chinese calendar. In Chinese culture, the tangerine is a symbol of luck, and it is traditional to present tangerines to family and friends during the two-week-long celebration of the Chinese new year. Tangerines that have their leaves intact are supposed to ensure secure social and familial relationships.

About the Genre

Still-life paintings of fruit are believed to have been first created by the ancient Greeks, and thereafter became popular among the Romans, who were strongly influenced by Greek art. Following the collapse of the Roman Empire, still lifes as a genre all but disappeared until the fifteenth century, when Dutch artists such as Jan van Eyck began to incorporate fruit as symbolic objects in narrative works. Fruit and other foods became a mainstay of autonomous still lifes during the seventeenth century, and have been an established part of contemporary art ever since.

About the Exercise

This exercise examines the composition of shapes with attached linear elements. Such situations are fairly common, particularly in dynamic situations involving people. The main consideration is observing the variety of ways that the linear elements of the leaves can be juxtaposed against the affiliated shapes of the fruit.

The placement of a single tangerine with respect to camera angle requires more than simply ensuring that the fruit and leaf fit within the frame. Two important considerations are the sizes and shapes of the negative spaces between the leaf and the tangerine and the orientation of the leaf so that its venation is visible.

Experiment with as many arrangements as you can possibly devise that depict the leaves in different positions in relation to the fruit. In the adjacent images, the leaves are shown aligned in parallel, spiraling around the fruit, and crowning the fruit. Doing these kinds of exercises can help compose images in other settings and genres. Developing a feel for how linear elements can be positioned around shapes can be particularly helpful when photographing dynamic shapes that have associated linear elements.

Setting Up the Exercise

This exercise can be done with any kind of fruit that has its leaves intact. Tangerines are recommended because they are often harvested with the stem and leaves intact to avoid tearing the loose rind. Most other fruit purchased in stores does not have leaves, but harvesting your own is an option if you have access to a fruit tree.

While the exercise can be done with a single piece of fruit, it generally works best with two or three pieces. You will want to set up a background that allows you to photograph the fruit in profile and from higher angles. Because the emphasis is on seeing how lines can be arranged with respect to shapes, a solid background is better for this exercise than is an environmental setting. Using a sheet of paper in the manner described in the egg exercise is a good way to set up the background for this exercise.

Technical Considerations

To maximize the depth of field, stop down to a small aperture. Directing the lighting to come from above works well for this exercise.

Exercise 4

Blocks

Thousands of megalithic monuments can be found throughout western Europe. They range from simple upright stones to elaborate stone circles, the most famous of which is Stonehenge. The construction of these monuments began around 4000 B.C. and stopped sometime around 1100 B.C. Little is known about the people who constructed the monuments or why they would expend the resources required to do so. Not surprisingly, the debate has been extensive and, at times, can be extreme.

The early megaliths shared the characteristic that they were burial places, but it is likely that they had other functions, such as religious rites. Evidence from sites where there are sufficient skeletal remains to permit inferences suggests that the tombs were not reserved for a particular sex or age, since men, women, and children are found in equal proportion. The religious rites theory is plausible because not all the later sites were used for burial. Unfortunately, the artifacts found at the sites do not provide much insight regarding what kinds of practices may have occurred.

Other theories maintain that megaliths were constructed as a means of social expression. For example, it has been asserted that by building large monuments, tribes could emphasize the connection of the culture with its territory and communicate to foreigners that they were visitors. Another theory is that the construction occurred in societies with unequal social systems and reflected the desires of the social elites to represent the territory they controlled.

The prominent theory that megaliths such as Stonehenge were astronomical observatories has been intensely debated. While many megaliths show alignments with astronomical events such as solstices, they are not especially precise. Furthermore, the many lines of sight at the more complex monuments make it likely that some alignments would be expected to occur by chance. Nonetheless, the alignments at some megaliths are set in ways that strongly indicate that the people who built them attached deep cultural importance to the movement of the sun. However, this does not mean megalithic structures were necessarily used as observatories.

About the Genre

The depiction of massive formations and structures is widely practiced in several photographic genres. Examples include images of geologic formations in landscape photography, buildings in architectural photography, and public sculpture in travel photography. Some examples of how different photographers work with this kind of subject can be seen in the works of William Clift, Lewis Baltz, and Howard Bond.

About the Exercise

As the prior exercises have shown, the ability to work effectively with shapes requires that the photographer pay attention to subtleties. The irony is that the need for mastering subtlety is usually at a premium when working with massive objects because of their tendency to overwhelm your visual attention. This tendency is particularly evident in the works of the many photographers who have photographed places such as Monument Valley, the San Francisco de Asis Church at Ranchos de Taos, New Mexico, and the slot canyons of Arizona and Utah.

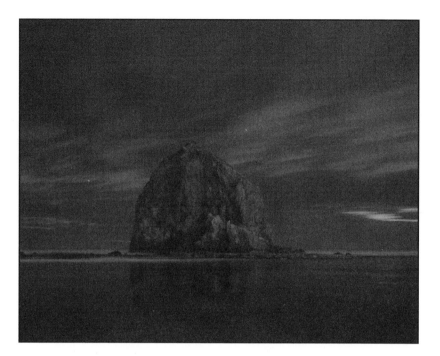

Haystack Rock at Cannon Beach, Oregon, appears in many portfolios, including those of Ray Atkeson and David Muench. Although the 235-foot sea stack is located off a vast beach and can be photographed from many angles, issues such as a no trespassing sign and people in the foreground make composing images a challenge. Photographers have come up with various solutions to these problems. The approach taken in this image was to photograph the sea stack at night with the sign aligned on edge so it would not show.

When working with the shapes of massive objects, two things that are important when composing are to slow down to a contemplative pace and to experiment with many arrangements. While structures with great mass are visually imposing, the edges and interior detail will likely have a significant effect on the ultimate appeal of the image. The negative spaces and the relative sizes between the main subject and the other shapes also warrant significant consideration. When working with massive objects, the brain has a tendency to fixate on the dominant mass and overlook its relationship with other visual elements. In many images, the supposedly subordinate masses and shapes will be far more significant than what is initially presumed.

Setting Up the Exercise

The exercise can be done in many kinds of settings. What is important is to find a massive shape that you find visually appealing. Examples include boulders, concrete blocks, buildings, and public monuments. Objects made of rock or masonry are preferred but not essential.

Technical Considerations

Take care when determining the exposure that you meter on a neutral part of the scene. Otherwise, you run the risk of under- or overexposing the image. What you want to avoid is taking the reading from areas that are too dark or too light. Middle-toned objects such as foliage or the palm of your hand make good targets for metering.

Exercise 5

Doors

While the practice of architecture obviously involves designing the large visual elements of buildings, it also encompasses a myriad of details that affect practical functionality. One such issue is whether exterior doors should open outward or inward. For residential structures, the convention is that doors should open to the inside. The primary reason is that residential doors feature simple pin hinges that facilitate the easy removal of doors to enable tasks such as moving furniture and appliances in or out of homes. For security purposes, these kinds of hinges need to be positioned inside the residence, which means that doors will open inward.

Security is a concern with commercial buildings, but there are other factors to consider, as well. These kinds of buildings need to be designed so that large numbers of people can evacuate in the event of a fire or other emergency. If a crowd of panicked people pushes against a door, it will not open if it was designed to swing inward. Therefore, doors in commercial buildings are usually installed with concealed or protected hinges that are difficult to detach but enable the door to swing outward.

About the Genre

Doors are commonplace and show up in all sorts of art. One of the notable features of doors is that they provide the place of transition between interior and exterior spaces and are often characterized by a change in the quality of light. Light was

One thing to take into consideration when the scene encompasses material in front, and behind a door or window is the disparity in light intensity. Although the human eye can discern a wide range of brightness, film does not have a very high latitude. In order to expose the foreground and background properly, they need to be within a similar range of brightness. When the scene encompasses areas that are illuminated by outdoor light, there will usually be a certain time of the day when the levels of light in the exterior and interior spaces are evenly balanced.

When the optical axis is roughly perpendicular to the plane of the doorway, the image will be depicted in one-point perspective. This photograph gives the impression of one-point perspective because the repetition of the rectangular shapes reinforces the sense that the lines associated with the door frames are parallel. Careful analysis will reveal that the depiction is actually in three-point perspective, although the convergences to the vanishing points beyond the left and bottom edges of the image are quite gradual.

a preoccupation of the seventeenth-century Dutch genre painters, and many of their works depict doors. Examples of photographers whose works have encompassed doors include Gordon Parks and Tina Modotti.

About the Exercise

Open doors constitute negative spaces in which other shapes and negative spaces reside. This exercise entails working with arranging doors in the context of their settings while simultaneously working with the arrangements within the doors. Doors usually exist as rectangular shapes and, therefore, can be viewed as frames within frames. Since most doorways feature two sets of parallel lines (the sides, and top and bottom), the effect of camera angle with respect to perspective should also be considered when composing images. Setting the camera square to the door will produce a one-point perspective that will emphasize the geometric properties of the door. This can be visually striking in the right circumstances. Using two-point perspective can also be effective, although it tends to shift attention from the door to the other subjects.

Setting Up the Exercise

To do the exercise, find a doorway in a setting that features subject matter in the foreground and within the space framed by the door. Experiment with how you can place the doorway in the composition and also with positioning the subject matter within the space bounded by the doorway. You should find that relatively small changes in the height and horizontal placement of the camera will significantly affect how the subject matter is positioned in the doorway.

Technical Considerations

The most important consideration will likely be the intensity of light on either side of the doorway. As noted in chapter 1, cameras cannot record the same range of brightness that humans can perceive, and parts of the image will be under- or overexposed if the exposure latitude of the film is exceeded. The best way to approach this problem is to photograph at a time of day when the light levels on either side of the doorway are balanced. Otherwise, you will likely have to compromise and decide which parts of the images will be inadequately exposed.

Exercise 6

Domestic Shapes

While the effect of the industrial revolution on domestic life may not seem as dramatic as the effect it had on labor, industry, and transportation, it was during this period that many of the inventions that make up the modern household became popular. One of the changes was that utensils and appliances were no longer individually crafted but, instead, became mass-produced items available at low cost. The industrial revolution also made rooms such as root cellars obsolete and introduced labor-saving devices that reduced the need for staff to handle domestic activities in middle- and upper-class homes.

Before the nineteenth century, food was preserved using techniques such as salting, pickling, and drying. Canning was invented in 1795 when the French chef Nicolas Appert discovered food could be preserved by heating it in sealed glass bottles. In 1810, the Englishman Peter Durand patented the packaging of food in airtight tin-plated iron cans. Although chisel and hammer were the first tools used to open such cans, a new kitchen device called the can opener was soon invented. Other utensils that were significantly improved or came into common use were the peeler, corkscrew, and eggbeater.

The industrial revolution also brought about changes in household appliances. Cooking stoves did not become commonplace in most social classes until the nineteenth century. Gas stoves became commercially available in 1826, and coal stoves in 1833. Another appliance that was invented during the second half of the nineteenth century was the washing machine. Although these appliances were hand operated until the early twentieth century, they quickly become popular because mass production and intense competition among manufacturers made them widely affordable

The advent of electricity brought about even more changes. The first electric iron was invented in 1882 and used a carbon arc as the source of heat. Safer designs using electrical resistance were introduced in 1892. The electric stove was invented in 1892 but did not become commercially competitive with gas stoves until the 1920s. Modern electric clothes dryers became available in 1915, but versions consisting of a ventilated drum cranked over an open fire had been available since the early nineteenth century.

About the Genre

Although the industrial revolution resulted in an enormous change in the appearance of households, the art world has for the most part resisted depicting them. Although the Impressionists freely used the newly available paints in metal tubes to facilitate their work outdoors, they seemingly eschewed incorporating modern utensils in their still lifes. Except for a couple of well-known paintings by Paul Cézanne that show a stove, almost all the Impressionist works are limited to classic objects, such as bowls, knives, and bottles. This tradition has continued to the present time. Except for occasional works by pop artists such as Roy Lichtenstein and avant-garde photographers such as Man Ray, still lifes derived from ordinary domestic scenes usually favor classic objects such as bottles and pitchers over modern utensils and appliances.

 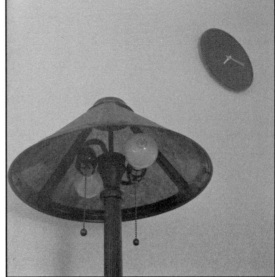

The exercise can be approached in several ways. The image on the left is an abstract created by photographing through the hole in the back of a dining chair. The top of the dining table and the back of the facing chair are visible in the space within the hole. The image on the right shows a lamp and wall clock viewed from an unusual angle. Because households are filled with manmade objects, you should be able to find several opportunities to show arrangements of geometric shapes. Be sure to evaluate scenes from atypical viewpoints.

About the Exercise

The purpose of this exercise is to explore the interior of a residence for scenes and images that feature interesting shapes. Ideally, this will help develop a sense of what can be found in familiar settings when you look hard enough. With a little luck, you might even find some lost socks. There are many approaches you can take, such as documentary, conventional still life, and abstract. The important thing is to look for scenes that visually appeal to you.

Setting Up the Exercise

There is no rigid methodology for doing the exercise, although you may find it helpful to examine subjects from unusual angles. Since you are looking for interesting shapes, do not feel you have to photograph conventional still-life subjects. If possible, find scenes with objects that form interesting juxtapositions. Also, while it is acceptable to photograph objects with interesting designs, the design itself should not be the primary focus of attention. You are trying to depict a scene in a residence, so avoid making images that come across as product shots.

Technical Considerations

This is the kind of exercise that is best done with a tripod. Since long exposures are likely and residential floors tend to bounce a little when walked upon, it may be prudent to do the exercise when people are not moving about.

Exercise 7

Plants

One way to describe seeing is to say that it consists of observation combined with recognition. Plants make good subjects for exploring how to see because they are accessible, static, and far more complex than one might initially assume. One approach to observing plants is to consider them from the perspective of leaf morphology, which is the study of the appearance of leaves. Leaves come in a variety of structures and provide important information for identifying species. Some of the most commonly relied upon physical characteristics are the shape of the blades, the margins around each blade, their attachment to the plant, and how they are arranged on the plant.

Classifying the external structures is by no means the end of what can be learned by studying plant morphology, because it can also reveal information about plant behavior. Although each species has its characteristic morphology, individual plants are capable of modifying their external structures in response to environmental conditions. For example, the leaves will vary in size, shape, and density, depending on the amount of light they receive, the presence of nearby plants, and the ambient humidity. If you observe trees with large canopies, you may notice that in some species, the leaves in exposed areas will have larger open spaces than those in the deeper layers. The open structure of the outer leaves allows more light to penetrate to the interior where the leaves are shaped to intercept it more efficiently.

Species vary in their environmental plasticity; those that can readily adapt to sunny and shady sites tend to be the most plastic. Although plasticity favors adaptability, it may also have a cost. It has been observed that species that tolerate wide ranges of light conditions tend to have shorter leaf life spans than those species which are adapted to specific levels of light.

One way to emphasize form and reduce the amount of background distractions is to move close to the subject. The flower and leaves of a salmonberry plant (Rubus spectabilis) were photographed with the lens about ten inches away. Such photographs require stopping the lens aperture down to get good depth of field, and typically require exposures that last several seconds. Needless to say, the air must be dead calm during the exposure. Calm conditions are more likely to be found during early morning and late afternoon. It is also important that the photograph remain absolutely still during the exposure because moving about can cause air currents that will set the plant in motion.

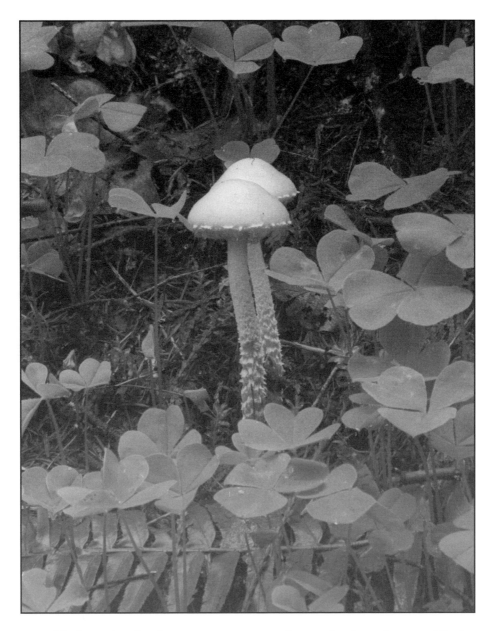

One of the biggest benefits of composing images that feature plants is the opportunity to work with negative spaces. Small shifts in camera angle will significantly affect the distribution of negative spaces within a composition and often require subjective judgment to decide on how best to depict the subject matter. These mushrooms were found on a steep slope amid a cluttered setting of Oxalis oregana and just above the frond of a sword fern (Polystichum munitum). The mushrooms are placed in the space between other plants and necessarily overlap. However, the small sliver of negative space between the stems helps to preserve the visual impression of two mushrooms.

This photograph shows how the diamond-shaped fronds of the lady fern (Athyrium filix-femina) can be composed in ways that emphasize their form. When working with positive shapes in complex settings, it is important to consider the contours formed by the edges, as well as the interior details. A significant aspect of the composition is the alignment of the tip of the frond in the lower left corner of the foreground with the stalk of the frond in the upper right corner of the background.

About the Genre

Much of the fine art photography that depicts plants emphasizes form. Some of the photographers who are known for works that examine the forms of plants as art are Karl Blossfeldt, Imogen Cunningham, and Edward Weston.

Another important role of plant photography is its use in illustrating field guides. Ideally, a field guide should provide sufficient textual and visual information to enable the identification of plants. As noted in previous discussions, plants have many structural characteristics that aid in their identification. A review of field guides will show that many, including some of the most popular ones, rely on photographs that mostly depict blooms and provide little additional visual information about the plant. This approach to documenting species, with its emphasis on the showy aspects of plants, seriously degrades the utility of many field guides.

About the Exercise

When doing the exercise, give extra attention to evaluating the form of plants and their parts. While many of the best photographs of plants show flowers, the work of the most highly regarded fine art photographers often depicts more subtle aspects of plant anatomy. Plant shapes can show themselves in many ways. In addition to the shapes defined by edges, examine the play of light on curved forms and evaluate whether it contributes to a sense of depth.

Negative spaces are extremely important in photographing plants, and the failure to give them enough consideration has ruined many images. It is extremely difficult to show the positive shapes of plant forms to best advantage without giving the negative spaces as much or more attention. Look carefully at the spaces between the elements in the photographs. Plants are typically found in complex settings, and shifting the

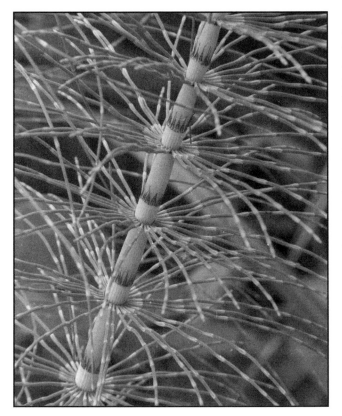

Common horsetails (Equisetum arvense) make interesting subjects because the jointed branches form circular shapes as they radiate from the stem. Although the positive shapes and lines are important to the composition, the negative spaces are even more essential. The two triangular spaces on either side of the stem in the center of the photograph are the most important elements in this photograph.

This is an ancient species that is found in many places throughout the world. The stems and branches contain chlorophyll, while the leaves do not. The leaves can be seen in this photograph as the tooth-shaped structures arranged around the stem just above the nodes, where the branches are attached.

While composition is an essential component of artistic expression, it is also important when the objective is to illustrate a particular subject. The images used to illustrate this species in many field guides fail to show details such as leaves. More than a few field guides use images that show horsetails as nothing more than an incoherent mass of lines.

camera slightly will usually change the negative spaces substantially. This means that you should reevaluate the negative spaces every time the camera is moved.

Background is another important consideration because plants tend to be found in settings that are filled with distracting elements. One way to reduce the amount of background you have to contend with is to move closer to the plant forms that interest you. This approach reduces the amount of negative space surrounding the forms and allows you to use forms to block offending elements from view. One aspect to keep in mind when photographing close to a subject is that slight adjustments to the camera position can radically change the nature of the way that the background will appear in the image.

Setting Up the Exercise

Find an outdoor setting that has a lot of plants, such as a wooded area, weedy lot, or garden. Look for plants with interesting forms, and photograph them while working with the backgrounds as you find them. When you find a promising plant, be sure to evaluate the composition from several angles, including different heights.

Technical Considerations

The technical considerations for this exercise are the same as those described on page 55. Small plant forms are often easier to depict if you move to within a few inches of the subject. To focus this closely with most normal lenses, you will need to use some sort of macrophotography attachment such as a close-up diopter.

Exercise 8

Callas

Callas (*Zantedeschia* species) belong to the Araceae family, which encompasses plants such as the jack-in-the-pulpit and skunk cabbage. Although sometimes called calla lilies or arum lilies, callas are neither arums (genus *Arum*) nor lilies (genus *Lilium*). A distinguishing feature of the Araceae family is that the flowers consist of a spathe that wraps around a finger-like spadix. The spathe is actually a modified leaf, and the true flowers are contained in the spadix.

Callas were introduced to the United States from South Africa during the nineteenth century. There are several species, but the one most commonly seen in stores and gardens is the white calla (*Z. aethiopica*), which has a creamy white spathe and yellow spadix. Other species of callas have yellow, pink, and purple spathes.

About the Genre

Callas are a traditional subject in American art. They are particularly well known for their depictions in paintings by Georgia O'Keeffe and photographs by Imogen Cunningham, Edward Weston, Robert Mapplethorpe, and Man Ray.

Callas make an excellent subject for still lifes because their structure can be expressed in a variety of lines and shapes. The strong shapes and negative spaces associated with callas also provide good opportunities to express metaphor. Even the psychologist Sigmund Freud had something to say about the metaphorical aspects of callas. Interestingly, Georgia O'Keeffe always maintained that her paintings of callas were not intended to be metaphorical, at least not along the Freudian lines.

Because callas have such strong contours, it is easy to overlook the effect that negative spaces have on images. Fairly minor changes in the orientation of callas will substantially affect how the mass and negative space *will be distributed in an image. In these photographs, altering the positions of the tips of the spathes by rotating the stems changes the impression of which flower is dominating the interaction.*

The composition has been changed by rearranging the callas shown on the preceding page and raising the viewpoint. The callas are now aligned so that the outer *contours of the spathes create a continuity that approximates an ellipse. A more subtle effect is made by the implied lines that cross within the negative space.*

About the Exercise

This exercise requires consideration of several elements, including contours, interior lines, and the balance between positive and negative spaces. Subjects that feature more than a single dominant shape require the photographer to consider how those shapes interact and what effect they have on the negative spaces in the image. In addition to strong shapes, callas have complex curves, which present very strong contours. When doing this exercise, pay particular attention to how the negative spaces will appear in the images and the alignment of the implied lines suggested by the contours.

Setting Up the Exercise

Place at least two callas in a vase or jar of water and set it in front of a suitable background. You may find it easier to arrange the callas if you clip the stems to the edge of the container. A black backdrop like the one used to make the photographs on this spread can impart a dramatic feel, but excellent images of callas can be made with many kinds of backgrounds. A single lamp

placed slightly above the callas will suffice for lighting the upper parts, and placing white paper beneath the callas will help light their undersides.

After arranging the callas, take a relaxed and sustained look at them, both directly and through the viewfinder. At the very least, you will probably need to make minor adjustments. Remember to pay careful attention to the continuity effects of the contours, the shapes of the negative spaces, and any overlapping elements.

Technical Considerations

Since the images will be close-ups, you will usually want to maximize the depth of field by stopping down to f/16 or smaller. On the other hand, there is nothing wrong with experimenting with shallower depths of field.

Exposure can be a little tricky, especially with white callas. The simplest way to determine an accurate exposure is to meter off a gray card or your palm. Bracketing the exposures is also recommended. Exposure times will typically be on the order of several seconds, so be sure to correct for reciprocity failure when necessary.

Exercise 9

Clouds

Cloud watching is one of those activities that can be done from several perspectives. As children, many people were fascinated by the fanciful shapes of clouds and would let their imaginations run wild while watching them. With a little bit of effort, it is possible to see animals and other things floating in the sky. Clouds are also a popular subject for teaching art and science to children. One children's poem by Kristine O'Connell George, "The Blue Between," even discusses the importance of perceiving negative spaces.

Clouds are also the subject of scientific observation. The modern system of classifying clouds was developed in 1803 by the English scientist Luke Howard. His system assigned the Latin names to four major types of clouds that remain in use today: cumulus (puffy), cirrus (curly), stratus (layer), and nimbus (rain-bearing). Clouds are important indicators of weather and have been used in forecasting since ancient times. Meteorology is known to have been pursued as a science in India beginning around 3000 B.C., and resulted in a fairly extensive understanding of atmospheric processes such as the different types of clouds and their rainfall capacities.

About the Genre

Clouds are most often seen as important features in landscape photography. Richard Misrach and Michael Kenna are examples of photographers whose landscapes frequently show expansive skies with striking clouds. The importance of skies and cloud shapes can also be assessed by viewing images from different photographers that are taken of the same subject from the same viewpoint. For example, countless photographs have been taken of El Capitan, Half Dome, and Bridal Veil Falls from the Wawona Tunnel view in Yosemite National Park, and many can be seen by searching the Internet.

Looking for clouds with shapes that suggest animals or other objects is a good way to enhance your awareness of skies and how they can affect images. A few days before this photograph was taken of a cloud shaped like a leaping dog, a smaller cloud shaped like a flea was visible in the same location.

Another approach to enhancing your awareness of clouds is to learn how to identify their types. The cloud in the foreground is the upper portion of a cumulonimbus, which is the type of cloud that hosts thunderstorms. A lenticular cloud can be seen behind the cumulonimbus. These clouds are a kind of altocumulus and are generally associated with air flowing over rough terrain. An orange filter was used to darken the sky.

About the Exercise

Not all shapes are formed by objects with hard edges, so it is important to be able to perceive soft shapes such as clouds. The exercise requires that you find clouds with distinctive shapes and photograph them. While it is fine to combine the clouds with other visual elements, the goal in this exercise is to find clouds that are sufficiently distinctive to serve as the dominant subject.

Depending on your intellectual proclivities, or your patience, you can approach the exercise from either the fanciful or the scientific perspective. If you choose the fanciful approach, look for clouds with shapes that suggest other objects. If you prefer science, find reasonably dramatic clouds that are clearly one of the classic types and document their form.

Setting Up the Exercise

If you decide to document a particular type of cloud, you will likely need a reference guide that describes the various kinds of clouds. There are many excellent books and field guides that explain how to identify them. This information can also be found on the Internet.

If you take the fanciful approach, you may need to be persistent in your quest to find suitable clouds (it also helps to carry a camera at all times). You will likely get more out of the exercise if you put forth the required effort without assistance from other people. Nonetheless, feel free to enlist a small child for help if you need it.

Technical Considerations

Using yellow, orange, or red filters will increase the contrast in monochrome images because they darken the blue in skies. A polarizing filter can do the same in color photographs if the sky is generally perpendicular to the sun. However, these filters are not absolutely necessary, and in many cases, their use will detract from an image by obscuring the detail in other parts of the image.

Exercise 10

Reflections from Water

Reflections result from light bouncing off of surfaces. A ray of light is called the "incident ray" before it hits a surface, and is called the "reflected ray" after it leaves the surface. At the point where the ray hits the surface, a line can be drawn perpendicular to the surface that divides the angle between the incident ray and the reflected ray into two equal angles. These angles are called the "angle of incidence" and the "angle of reflection." When the surface is rough, the rays of a beam will reflect in several directions because of the uneven topography of the surface. This creates what is called a "diffuse reflection." The light bounces off in a general way but does not transmit a coherent image. When a beam of light hits a very smooth surface, a high number of incident rays are reflected parallel to each other, and the overall beam bounces off the surface in an orderly manner known as specular reflection. For extremely smooth surfaces, the reflected rays will transmit a well-defined image.

Reflections serve as an important visual cue for the perception of texture. From an early age, people associate specular reflections with smooth surfaces and diffuse reflections with textured ones. However, the brain can also repress information related to reflections. For example, computer users often fail to notice glare bouncing off computer screens, even though it contributes to eye fatigue. Similarly, most people have had the experience of being startled when they suddenly recognized themselves in a reflection.

About the Genre

Calm water forms an extremely smooth surface that artists have traditionally depicted by drawing or painting the reflections. Landscape paintings created during the mid-nineteenth century showed some very different but highly skillful approaches to rendering reflected shapes on bodies of water. Some of the notable artists whose landscape works have featured reflections on

Reflections themselves can work well as visual elements, and it is not always beneficial to show the object that is being reflected. Notice how the vertical aspects of the reflected building are distorted in a manner that is qualitatively different than the horizontal aspects. Another important compositional consideration is how the reflections are placed with regard to objects that are not being reflected. Note how the bird is positioned just below the edge of the reflected building.

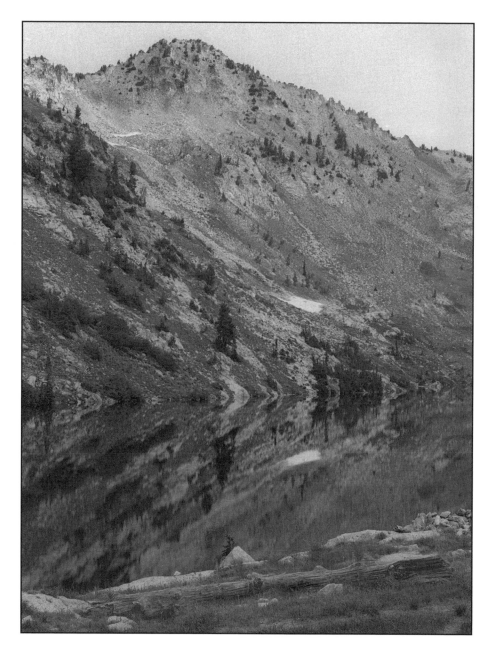

Reflections can have discordant effects on images if not adequately perceived and accounted for while composing an image. This pristine lake in an isolated part of the Wallowa Mountains in eastern Oregon is difficult to discern because the reflections are almost as intense as the subject matter they depict. Some approaches that could have been taken to visually separate the lake from the rest of the scene would have been to wait for the wind to come up and disturb the water surface, to change the camera position to bring the sky into the reflected area, or to photograph in color.

When photographing reflective water where the near shoreline is not visible in the image, it is important to perceive what objects are being reflected and to compose the reflections accordingly. In the image on the left, the band of light colored Alder trees (Alnus rubra) balance the space between the far shoreline and the bottom of the frame. In the image on the right, the shapes of the trees are reflected in the pond even though the actual trees are not visible. Unless reflections are given due consideration while composing the image, the visual balance between tangible objects and intangible reflections will suffer.

water are Albert Bierstadt (1830–1902), Ferdinand Hodler (1853–1918), Christen Købke (1810–1848), and Claude Monet (1840–1926). Photographers who are interested in developing their skills in landscape work would do well to review the works of such artists, paying particular attention to how they placed horizon lines, skies, and the sizes and portions of the reflected shapes.

About the Exercise

Reflected shapes are an important area in which to develop one's perceptual skills because the brain is very adept at filtering out this kind of information, whereas cameras are not. It is not uncommon for photographers to work with interesting subjects, only to find later that the images are marred because the associated reflections went unnoticed and were not properly composed. The point of this exercise is to become more proficient at recognizing and working with reflections from broad surfaces such as water bodies, wet sand, and plate glass.

Setting Up the Exercise

Find a body of water that is large enough to reflect the shapes of the surrounding objects. Lakes, bays, harbors, and slow-flowing rivers are obvious examples, but large puddles and pools can work, as well. The best reflections generally occur when the wind conditions are dead calm or very mild. For each location you find, experiment with several compositions, taking particular note of how the reflected shapes change in appearance depending on the height and angle of the camera. You should pay attention to the degree in which the shapes are distorted when they are reflected, especially with regard to their vertical and horizontal scales.

Camera height makes an enormous difference on the area encompassed by a reflection. Most of the nearest concrete structure is reflected, but very little can be seen of the more distant structure. Note how the reflected shape of the near structure is placed within the confines of the ponded area, and how the saplings on the near side are aligned with the reflections of the saplings on the far side. The concrete structures are the remnants of a closed industrial facility that was vacant for a number of years after a long period of industrial use. Urban redevelopment has since eradicated these interesting forms and radically altered the landscape.

Technical Considerations

Like mirrors, the focusing distance of the reflected shapes will be the distance the light rays follow from the object to the camera—not the distance from the camera to the reflective surface. Therefore, you will want to make sure that you have enough depth of field to bring the important subject matter into focus.

Glare can be a problem when photographing reflective surfaces, although it can sometimes enhance an image. While glare can be controlled by using a polarizing filter, these filters can diminish the intensity of the reflections. If you decide to use one, experiment by adjusting the filter to get the best compromise between reducing the glare while retaining the reflections. In most cases, this will be influenced by a combination of the camera position and the clarity of the water. The angle and direction of the sun will also affect the amount of glare.

Exercise 11

Glare

As discussed in the previous exercise, whether a reflection is specular or diffuse depends on the roughness of the surface. Reflections formed on surfaces that are microscopically rough, such as roads, sand, and foliage, normally reflect light in a diffuse manner that is not particularly noticeable. However, when these kinds of surfaces become wet, the water tends to fill in the spaces between the ridges that form the texture and cause the surface to become smoother. In such cases, the reflections from the surfaces can become more specular and create glare.

The rays that cause glare are reflected in a more orderly manner than they are for diffuse reflections, but not always to the extent that they form coherent images. However, glare that emanates from very smooth surfaces can be specular and can assume the shape of the light source. For example, the catch lights that are visible in the eyes of models photographed with artificial lighting will assume the shape of the light source. General glare coming from somewhat disturbed water is often nothing more than the concentrated reflection of the sky. Sparkling light coming from the same water is most often the concentrated reflection of the sun.

About the Genre

Overall, glare seems to be depicted in photography differently than in the other two-dimensional art media. The reason is unclear, but it does not appear to be intentional. One explanation is that artists working in other media are free to ignore the effects of glare on scenes, while photographers cannot avoid these effects by either ignoring them or discounting their existence.

Another explanation is that glare is more readily emphasized in photographs because the limited exposure latitude of film relative to human vision makes it easier to overexpose highlights and emulate the appearance of glare. Few artists and photographers seem to actively use glare as a visual element, although Lee Friedlander has made some images in which glare is prominent. One of Henri Cartier-Bresson's best-known images, *Place de l'Europe*, which shows a man attempting to jump across a puddle, derives a lot of its visual effect from the intense glare that obscures the surface beneath the puddle.

About the Exercise

Unnoticed glare can be frustrating to photographers because it has a tendency to disrupt otherwise strong images. People tend to tune out glare when going about their normal activities because it is so prevalent. The purpose of this exercise is to enhance the ability to perceive glare by seeking it out as a subject for an abstract photograph. One aspect of glare is that it does not always form definitive shapes, and you should exploit this property to create a work that renders shapes in ways that do not represent recognizable subjects.

Setting Up the Exercise

Glare is not especially hard to find, but you may have to do some contemplation to find a surface than can be photographed in a way that yields a genuinely abstract image. Curved surfaces can present good opportunities, particularly if they are wet. Glare can reflect off objects from many angles, so be sure to expand your search by looking at surfaces in high and low places. Similarly,

This impact shows a very shallow segment of a stream viewed from directly overhead. The composition was determined by placing the area with the most intense glare on the right and the darker-toned area on the left.

glare can form interesting shapes on objects and surfaces at small and large scales.

At a larger scale, metal sculpture and architecture can make good subjects for depicting glare in an abstract image. Furthermore, the glare from such structures is sometimes enhanced by the kind of midday lighting that is unsuitable for many kinds of photography.

At the middle scale, water can make a good surface for glare, especially if it is flowing or somewhat disturbed. However, you should ensure that what you are photographing is generalized glare, as opposed to distinct reflections.

Foliage can be a promising place to look for glare, particularly on plants with glossy surfaces.

Most photographers who have worked with plants already realize their ability to act as intense reflectors of glare. Most of the glare associated with plants needs to be approached on a small scale for this exercise, so use a close-up diopter if it becomes necessary to focus closer than your lens can without such an aid.

Technical Considerations

Intense glare can affect metering, so be careful when assessing exposure. One approach is to meter an area that is near but outside of the glare. Another approach is to bracket your exposures one stop above and one stop below the reading indicated by your meter.

Exercise 12

Boiling Kettle

Steam is an important industrial material that is commonly used to drive turbines and pistons to perform mechanical work. Much of the world's electricity is generated by using coal, oil, natural gas, and nuclear fission to heat water into steam that is used to drive turbine-generators. Steam has a high capacity to store heat and is also used as a medium to transfer heat in industrial processes such as materials drying, oil refining, and pulp manufacturing.

True steam is a colorless gas. However, its temperature drops when it meets cooler air, and it condenses into tiny droplets that form a white cloud. If you look between the spout and the cloud emanating from a boiling kettle, you will see a clear space that consists of true steam.

About the Genre

Steam, fog, and smoke have been used to artistic effect in many genres, particularly since the advent of the industrial age. J.M.W. Turner (1775–1851) was an English landscape painter whose works frequently encompassed these elements in dramatic ways. One visual attraction of steam is how it interacts with light. The photographs of trains done by O. Winston Link, many of which were elaborately illuminated at night, also depict steam with a dramatic effect.

About the Exercise

The indistinct edges of shapes such as glare and clouds give them an amorphous quality, but they can easily be photographed with short exposures.

Taking the photograph while the burner is heating the kettle will record an expanding cloud. Note the clear space between the end of the spout and the cloud where the uncondensed steam resides. This photograph appears harsher than the one on the opposite page. The light source is placed to the right and slightly behind the kettle, and thus does not illuminate the left side facing the camera.

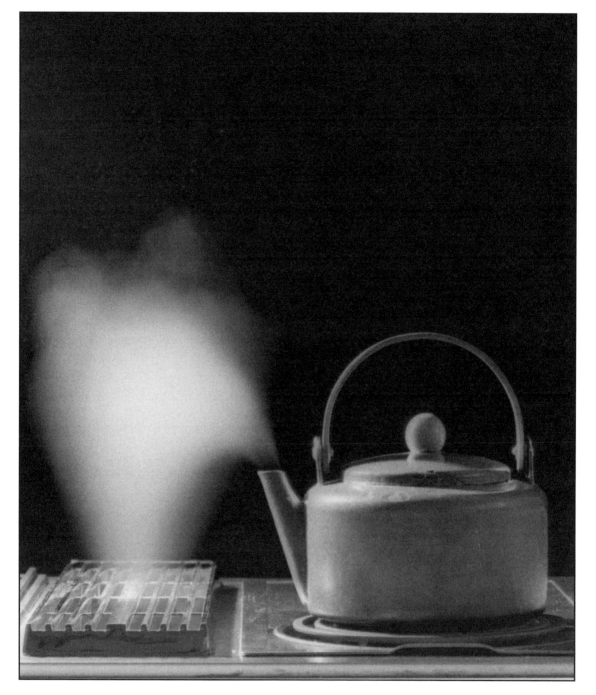

This photograph was taken after the burner was turned off and the steam cloud was receding. The diminishing force of the steam is evidenced by the exhaust vent capturing most of the cloud and the condensation point being located much closer to the end of the spout than in the photograph on page 190.

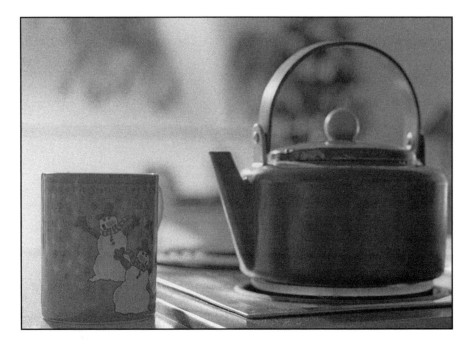

You can experiment with other arrangements and lighting setups for this exercise. This composition involves arranging the shapes of the cup and the kettle with the inverted V-shaped cone formed by the condensing steam.

This exercise challenges you to visualize how an amorphous shape can change over time by having you photograph an expanding or diminishing steam cloud using a long exposure.

Setting Up the Exercise

The exercise involves working with steam generated by a household kettle, so be careful not to get burned or scalded. All adjustments to the background and lighting should be done with the burner turned off and the kettle removed from the burner. Also, be sure to keep the camera and any other equipment out of the path where steam may travel.

The best way to bring out the appearance of steam is to use a dark background with strong side lighting. Black posterboard taped firmly to the wall behind the stove will work for this purpose. The steam can be illuminated by using a desk lamp or similar fixture to direct light perpendicular to the optical axis of the lens. However, other backgrounds and lighting can work well for this exercise, and you are free to use them.

The exercise needs to be performed in a somewhat darkened room, but first set up the background and mount the camera on a tripod. Make sure that you put enough water into the kettle so that it does not boil dry during the exercise. Turn on the burner and bring the water to a boil. Turn off the burner and watch how the shape of the cloud diminishes over time. Turn the burner back on and watch how the cloud grows. Repeat the cycle several times until you get a feel for how the cloud changes when the burner is turned off or on. Next, meter the light on the kettle and determine the proper exposure time. You will generally want an exposure time between five and fifteen seconds.

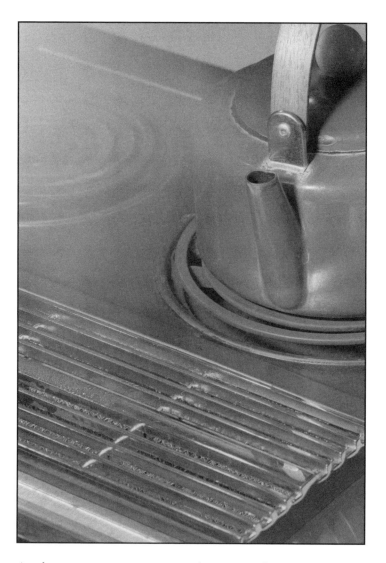

Another way to compose images involving steam, fog, or mist is to consider how they blur the edges of tangible objects.

While trying to capture the cloud when it is in a predetermined range of sizes, take several photographs. This will require you to figure out when to turn the burner on or off, and also when to begin the exposure. Keep working until you think you have at least a few photographs that show the cloud in your selected size range.

Technical Considerations

Putting a hood on the lens is highly recommended. It will keep stray light from the lamp from decreasing the contrast of the image. Shielding the light from the lamp to keep it off the background will produce a darker and more evenly rendered background.

Exercise 13

Street Shapes

Sidewalks and city parks are public places where people generally have the right to engage in activities such as jogging, picnicking, and photography. Because crimes such as prostitution, drug dealing, and robbery are typically characterized by persons standing or wandering about with no apparent purpose, there is the question of what limits governments can legally place on what people do in public places. For instance, can they make it illegal just to be hanging around?

Because of concerns about street crime, many municipalities have enacted loitering ordinances that make it illegal to be present in an area for no legitimate reason. The intent behind these laws is to give the police an enforcement tool to prevent crime before it happens.

Courts have declared many of these ordinances unconstitutional because they fail to distinguish between unlawful and constitutionally protected activities. To be constitutional, a loi-

tering ordinance must provide adequate notice of the prescribed conduct and put reasonable limits on the discretion of the police to enforce it. Faced with the difficulty of fighting legal challenges, some cities have forgone loitering ordinances altogether and instead regulate behavior by criminalizing conduct such as trespassing, obstructing public passages, sitting on public sidewalks during business hours, and disorderly conduct.

In order to enhance the quality of life of the residents in neighborhoods affected by severe levels of gang activity, a few cities have enacted highly controversial ordinances that prohibit loitering by members of street gangs. Some feel that loitering laws targeted at gangs have been responsible for declining crime rates in the cities that have them. Others feel they are counterproductive because they tend to target minorities and increase distrust of the police. In 1999, the U.S. Supreme Court struck down Chicago's antigang

The most direct way to do this exercise is to show a prominent shape in conjunction with another activity. Although the people in the background are not engaged in an activity that is associated with the wheel in the foreground, they establish that the scene is taking place at a fair. Note how the space allocated to the wheel encompasses about half the visual mass of the image.

Shapes can be used in street photography to bridge subjects that would otherwise be unrelated. In the image on the left, the outline of the shopping cart forms a hexagon that visually connects the boy on the left with the man talking on a cell phone on the right. However, it is not always necessary that shapes be formed by tangible objects. In the image to the right, the line formed

by the woman who is walking can be connected to the line formed by the seated woman, which, in turn, creates an implied trapezoid. While tangible shapes are more noticeable, implied shapes can be powerful tools for creating a sense of connection in a composition. Being attuned to implied shapes is helpful when scenes have a lot of visual elements that compete for attention.

ordinance because it did not give individuals adequate notice of what conduct was prohibited and covered a substantial amount of innocent conduct. However, the guidance from the Supreme Court on the permissible scope of such ordinances is somewhat ambiguous, and it is unclear how that case will affect similar ordinances enacted by other cities.

About the Genre

Urban scenes contain lots of shapes and spaces, which by necessity are prominent elements in street photography. Many street photographers recognize the importance of shapes in street photography, and the truly great ones know how to use negative spaces to isolate subject matter in what are frequently busy and dynamic settings. Harry Callahan, Charles Harbutt, and Lisette

Model are examples of photographers who are adept at using shapes and spaces in this genre.

About the Exercise

Approach the exercise by taking two kinds of photographs. The first set should contain a shape or shapes with a strong geometric influence, such as circles, triangles, and rectangles. The purpose of taking these photographs is to improve your ability to recognize and depict shapes in cluttered environments. You should try to present the shapes so they are featured prominently in the image while at the same time showing their surroundings. The second set of images should use negative space to separate multiple subject matter in somewhat dynamic settings. When making these images, concentrate on the space between subjects and monitor how it changes over time.

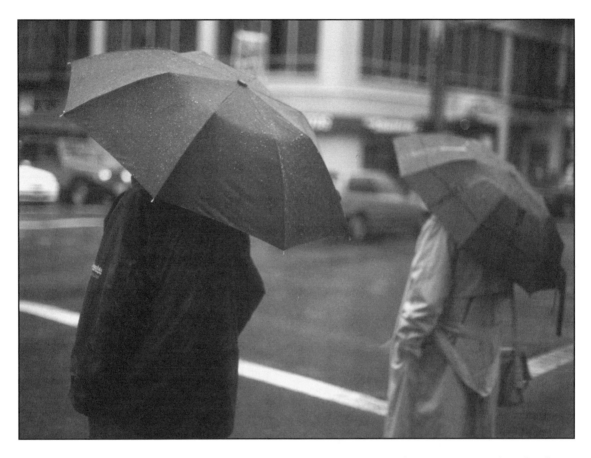

Less common geometric shapes such as the partial circles formed by these umbrellas tend to be more distinctive than the rectangles and other polygons that are *more prevalent in urban scenes. Notice how the above image uses the negative space between the pedestrians waiting at a crosswalk.*

Setting Up the Exercise

As with the previous exercises involving street photography, this one requires that you find a public setting. For the first part of the exercise, it helps to be in places where you can stroll about and look for shapes. Most urban settings contain lots of rectangles, but other geometric shapes can usually be found with a little effort. Events such as fairs and festivals will usually have a large variety of shapes, as well as a lot of activity. Look around for interesting shapes and spaces that can be depicted in conjunction with an activity.

For the second part of the exercise, find a setting that is somewhat dynamic—a scene with people passing by—and observe the spaces between the positive shapes of the subjects. Take several photographs by composing with the negative spaces instead of the positive shapes.

Technical Considerations

Fast shutter speeds, in conjunction with a reasonable depth of field, will likely be desirable for many of these images. The use of fast films is highly recommended.

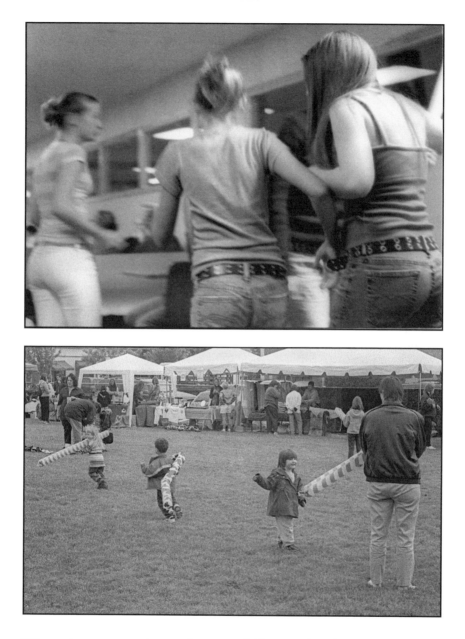

When trying to compose images of dynamic scenes, negative spaces are important aids. The upper image was made by concentrating on the spaces between the passing girls. The determinative element was the amount of separation between them. The lower image relies on the negative spaces between the children to judge when they were the same distance apart. Many photographers find that using negative spaces in this manner requires a major change in their approach to cognition. They also find that learning to do so improves their ability to make images under circumstances they previously found difficult.

Exercise 14

Static Frames

Up until around the twelfth century, artwork was not generally set in frames. Most two-dimensional work from the Paleolithic period into medieval times was set into cave walls or architecture, and there was no need for framing. Frames came into common use when people found them necessary to support otherwise flimsy panels while they transported art from one space to another. Over time, framemaking became an art unto itself and, by the fourteenth century, frames had become so ostentatious that they often overwhelmed the works they were supposed to display.

During the nineteenth century, some artists —notably the Impressionists—brought about a return to simpler frames that were intended to complement the works. In addition to incorporating simpler designs, these frames rejected the gilded finish in favor of more neutral colors. During the late nineteenth and early twentieth centuries, design movements such as the Arts and Crafts and International schools also effected the introduction of simpler frames.

Photography has traditionally been displayed in simpler frames, and elaborate designs are considered to be in poor taste. The classic style is a simple aluminum frame finished in black or a dark shade of gray with the photograph hinge-mounted between sheets of white mat board. An alternative favored by some photographers is to dry mount the photograph and use an over mat.

One of the primary uses of framing is to relate the subject to the activity in an interesting way. By sitting on the merry-go-round and framing the girl between the bars, it was possible to render her sharply against a blurred background to establish a sense of motion.

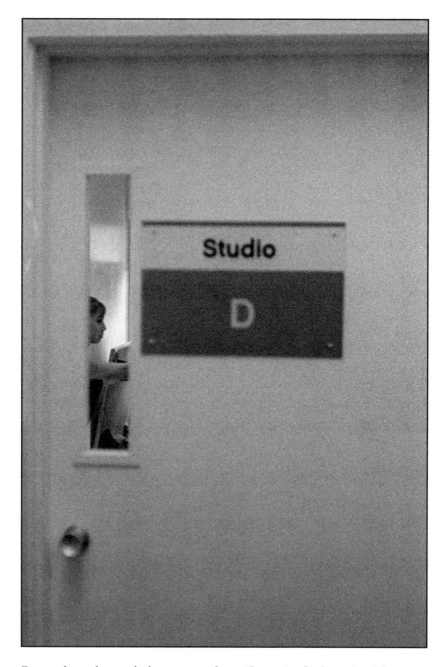

Frames do not have to be large to provide significant visual information. They are also a useful means of communicating concepts when your access to a scene is limited. The door of a dance studio by itself does not reveal much information about the studio, but incorporating the face of a young dancer provides a better sense of the kinds of clients that frequent this studio. In this image, the content within the frame is what establishes the context of the element that serves as the frame.

An appropriate use of framing is to indicate the context of the activity that is being depicted. In this case, it is a meal between friends in a railroad car.

About the Genre

Since people are more comfortable with organization and using frames can provide a sense of containment, framing the subject between incidental objects is a popular design concept. Framing seems to be used more in photography than the other visual arts. It was commonly done in medieval times but afterwards, its use diminished. The popularity of framing in photography may be due to the many books and articles that have recommended it as a way to emphasize subjects or add interest. The use of photographs to illustrate books and magazines may also have encouraged framing as a way to separate the image from other content. However, the overuse of this technique causes many photographs to look contrived.

About the Exercise

Compositional choices involve subjective judgments, and while you should feel free to determine your own style, you may want to approach the use of framing with some degree of restraint. Nonetheless, objects that frame subjects are visually significant, so it is useful to be able to perceive them and use them when they aid the composition in some sort of reasoned manner. The objective of this image is to find situations in which the frames add some sort of relevance to the subject or convey a particular interest to the setting. What you want to avoid doing is making images that evoke the sense of a cheesy postcard in which a landmark is depicted beneath an overhanging tree limb.

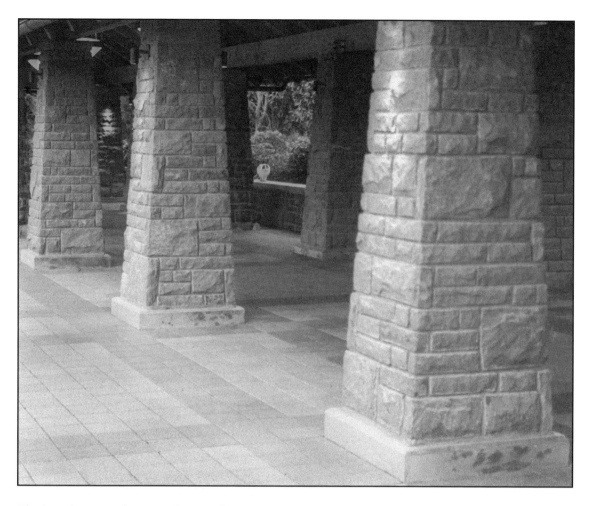

The framed space in the image above nicely encompasses the cat. Framed elements tend to look less clichéd when they are inherently part of the scene and not obviously introduced to produce a framed composition. This image has other strong compositional elements, such as the three strong shapes of the columns in the foreground and the strong diagonal line formed by the tiles running along the base of the columns.

Setting Up the Exercise

Framing can be applied to many genres, so feel free to select one and experiment with framing various subjects between relevant objects. The subject can be either static or dynamic, but the frame itself should be static with respect to the subject. When composing, consider both how the subject is composed within the frame and how the objects constituting the frame are aligned within the edges and corners of the image.

Technical Considerations

The specific considerations will vary depending on the genre and the effect that you are trying to obtain. The only general rule is that the subject is normally best rendered in sharp focus.

Exercise 15

Personal Space

Personal space is the space surrounding people that they claim as their own. It serves several functions, such as self-protection, the buffering of sensory input, communication, and the regulation of intimacy. The size of the space varies among individuals and cultures, but it is generally smallest behind people, somewhat wider at their sides, and larger in the front. Personal space changes for different areas of the body. For example, the personal space around the face is much smaller than around the hands and feet. Personal space also changes in size depending on how well people know the people around them and the nature of these relationships. For example, personal space tends to be large between people who dislike each other and can diminish to zero for people who are close, such as family members.

Encroachment into personal space tends to make people uncomfortable. It also affects how people perceive others. People who get too close are often seen as pushy, while those who stay too distant are often seen as aloof. Some people will abuse the personal space of others to manipulate them. Examples include aggressive salespeople, overzealous law enforcement officers, and belligerent people who have too much ego invested in their political opinions. If you deal with these people often, it helps to have lenses that focus down to close distances.

The size of personal space varies significantly across cultures and affects how people from different countries perceive each other. For example, Italians tend to have small personal spaces compared to Americans, and the Japanese have

Public spaces such as train stations can be good locations to observe how people treat their personal space. In these types of situations, people who are acquainted with one another tend to form groups, while strangers tend to isolate themselves, provided that sufficient empty seats are available. People also tend not to pass each other too closely as they move through the facility. The extent to which people invade the personal space of others also varies according to circumstances. For example, when people in airports are waiting in line and pressed for time, they tend to crowd the people in front of them.

Personal spaces tend to be small when people are jointly engaged in an activity such as piano lessons. The zone of personal space tends to be smaller to the sides than in front of people. The nature of the encroachment also affects the degree of discomfort that a person will feel. People are more sensitive to closely placed torsos and faces than they are to arms and legs.

large ones. Eastern Europeans tend to have very small personal spaces and are not offended by jostling, being leaned into, or similar close contact by strangers. They also tolerate emphatic conversations at close distance with intense eye contact. Americans, with different standards of personal space, often misconstrue such behavior as rudeness or anger. On the other hand, Eastern Europeans can misconstrue Americans as diffident or indecisive.

About the Genre

It is possible to learn a lot about art and personal space by looking at how artists from different periods and cultures depict the personal space between people. One interesting perspective can be seen in the works of John Singer Sargent (1856–1925), the expatriate American who painted portraits in France, England, Italy, Spain, and the United States. Another perspective worth examining is the way that the Soviet realistic painters portrayed Joseph Stalin in the company of other people compared to how they portrayed ordinary citizens of the Soviet Union. Depending on the point they were trying to make, he could be shown very close to children, but was usually shown a respectful distance when surrounded by admiring government officials. For political reasons, Stalin greatly overplayed the extent of his relationship with Lenin and commissioned several paintings that depicted them as close comrades.

About the Exercise

The main purpose of the exercise is to learn how to observe people and the space they allow between themselves and others. Personal space can provide important information about the emotional state and relationships between people, so try to capture some of these aspects in your images. Specific aspects to note are whether the people seem to know each other, the nature of their relationships, and how their personal space varies depending on the circumstances.

Another factor to consider is how negative space between people affects the composition.

Depending on their age and the nature of their relationship, children who are close friends may feel completely comfortable with minimal amounts of personal space. Personal space also varies according to the sex of the individual.

When relating to people they know, girls are more comfortable with smaller spaces, while boys are more sensitive to encroachment. As children grow older, their space requirements increase until adolescence, when they even out.

When possible, it is usually better to use negative space to separate people from the other visual elements in the scene.

Setting Up the Exercise

Because the exercise involves observing how personal space is affected by environmental variables, the photographs need to be taken as candids. While it is acceptable to photograph people engaged in somewhat structured activities, their interactions need to be normal and unposed. The exercise can be done as conventional street photography, but can also involve people that you know personally, provided they are interacting naturally with each other and are not influenced by you acting as the photographer. A good way to approach the exercise is to try documenting groups of people in several different contexts, such as friends, family, and coworkers of the same and different ages.

Technical Considerations

Oftentimes, these kinds of images work well with medium depth of field that renders the subjects in good focus. The hyperfocal method of focusing works can work well in these situations. As with other photography involving candid situations, fast film or high ISO settings are recommended.

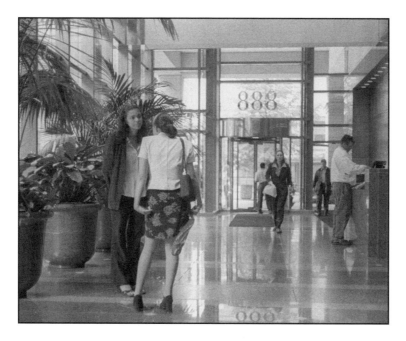

When communicating with one another, women who know each other well tend to have significantly smaller personal spaces than men.

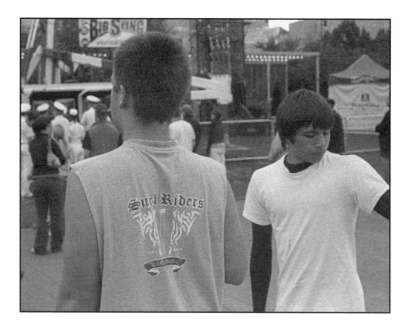

Males tend to maintain larger personal spaces, even when they are good friends. This image shows about three feet of separation, which is the approximate norm among Americans.

Exercise 16

People and Animals

The relationship between people and domesticated animals goes back to Neolithic times. The dog is believed to be the first animal to be domesticated (between 10,000 and 14,000 years ago). One theory is that wild dogs were attracted to camps because of the opportunities to scavenge, and eventually came to voluntarily associate themselves with humans, who, in turn, found them useful for guarding and hunting.

The next animals to be domesticated were sheep and goats in the eastern Mediterranean region. These animals were well suited to the lifestyles of nomadic herdsmen and for the needs of small settlements. It is generally believed that cattle were first domesticated between 8,000 and 11,000 years ago in the Anatolia region of Southwest Asia. It was this domestication that allowed livestock to be raised in groups large enough to sustain urban communities.

Cattle also became a source of motile power when it was discovered that castrated bulls became docile enough that they could be made to draw plows and carts. Dairying is believed to have begun around 3000 B.C.

Horses were not domesticated until about 3000 B.C. In addition to being able to pull plows and carts, horses could be ridden, which gave humans added mobility. The ability of horses to pull chariots also had momentous implications for warfare during ancient times.

A few other species of animals that have been domesticated include pigs, poultry, and cats. However, for the most part, the major advances in the relationship between humans and animals have been improvements in livestock raising and the use of animal products. No economically important species have been domesticated during the last 3,000 years.

Dogs make good subjects for this exercise because they are common, interact well with people, and are very social. Parks that are specifically designed to allow dogs to roam off of a leash are becoming increasingly popular and are well suited for this exercise. Like people, dogs are sensitive about their personal space. If you watch them long enough in an open setting, you can see how their response to encroachment depends on how well they know the person or dog involved. Similarly, their willingness to intrude on the personal space of other people and dogs will depend on familiarity and the nature of the relationship.

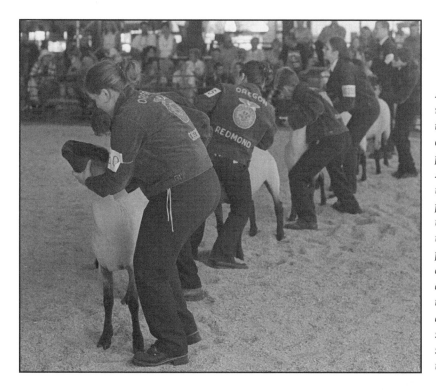

As these trained (but unruly) sheep are showing in a junior showmanship class, getting animals to pose is not always easy. Animals do not understand the concept of having their photographs taken, and therefore photographers need to consider using all their perceptual and compositional skills. One approach in dealing with fidgety animals is to maintain a general awareness of the negative spaces while concentrating specifically on the faces of the subjects.

About the Genre

One of the earliest works depicting people and animals together is a paleolithic cave painting near Lascaux, France, that shows a prostrate man next to a dying bison. Domesticated animals first began to be depicted in art around 6000 B.C. By 3500 B.C., agrarian scenes featuring people with domesticated animals were common subjects in the art created by the Egyptian and Near Asian civilizations.

Horses and people, particularly in a military context, show up in the art of most cultures. Equestrian themes were popular in ancient Egypt, Greece, and Rome, and notable examples date back to 150 A.D. in China, 1000 to 1500 A.D. in Africa, and 1200 A.D. in Japan. Dogs as house pets became somewhat common ancillary subjects in Western portraiture beginning around the sixteenth century.

About the Exercise

People and animals interact in a variety of ways depending on the species, context, and nature of the relationship. This exercise requires that you observe and photograph one or more situations in which people are involved with animals. If possible, try to make images with more than one kind of animal.

During the exercise, you should try to pay attention to the postures and expressions of the subjects. Keep in mind that animals generally do not feel compelled to look at the same matter that attracts the interest of the human subjects, so you need to monitor their heads simultaneously. The negative spaces between the people and animals can be a very important factor in how well the photograph captures the situation. This is particularly true when humans and animals are engaged in the same activity.

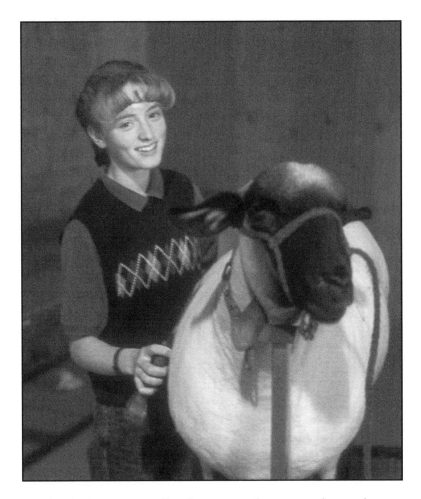

The degree of restraint can affect the way animals appear in photographs. Compare the sheep in this image with the one on the preceding page. Static situations such as these can be treated in much the same way as portraits. Note how the positions of the heads complement one another.

Setting Up the Exercise

There are many kinds of places where the exercise can be done, but events featuring lots of animals will give you a lot more opportunities for the effort expended. Good examples include state and county fairs, dog shows, and equestrian events. Since these kinds of settings usually have a lot of activity, pay particular attention to selecting suitable backgrounds.

Technical Considerations

Fast film is recommended because light can be a significant issue for indoor events. If the animals are actively moving, you will need fast shutter speeds, as well. As is the case with people, the eyes are the best point of focus for capturing the expressions of animals. If the eyes of all the subjects are not on the same plane, you will want enough depth of field to render them sharply.

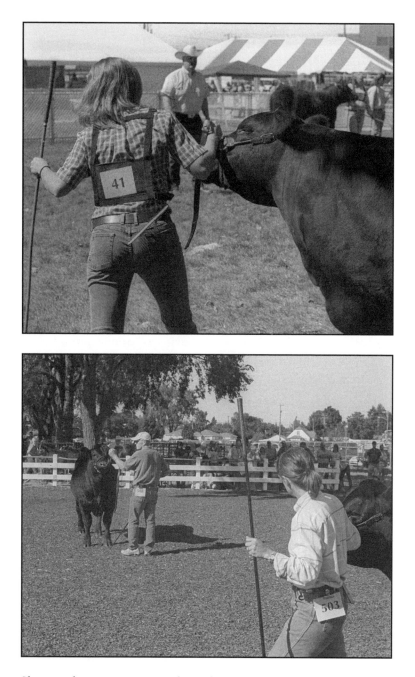

Shapes and negative spaces can be used to good effect when composing images that include people and animals. The top image has large shapes, but the negative spaces add another element of interest. The shapes in the bottom image are more sparsely arranged, yet maintain a psychological connection because the girl is looking at the other competitor.

Exercise 17

Dynamic Frames

Keeping track of objects that are moving in different directions and at different speeds can be difficult. One of the most versatile mathematical tools for analyzing such information is vector analysis. Vectors are quantities that have both a magnitude and a direction. Vector analysis plays an important role in the physical sciences and engineering because it is the most expeditious way to analyze forces and objects in motion. Major advances made during the nineteenth century established vector analysis as a separate branch of mathematics. It is widely used in technical fields such as mechanics and thermodynamics.

Using vector analysis as a means for interpreting diverse measurements has also made it useful in social sciences such as psychology. For his research into how people perceive biological movement, the Danish psychologist Gunnar Johansson made extensive use of vector analysis. Much of this research was done by attaching small lights to the major joints of a human body and filming the scene so that only the lights were visible in front of a dark background. Analysis of the films showed how biological motion could be discerned from just a few points. Work done by other researchers has shown that biological motion can be used to determine the gender of the subject, recognize emotions, and even identify specific individuals. Although much work remains to be done in this field, the ability of vector analysis to distill complex data involving multiple dynamic objects down to manageable inferences has made important contributions to the understanding of human perception.

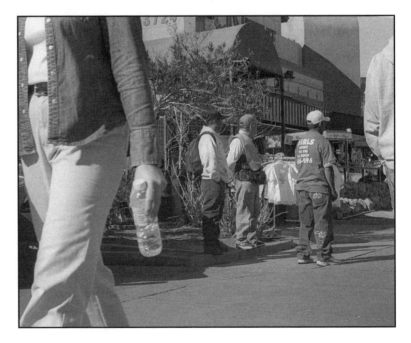

A woman passing by on a Las Vegas sidewalk is one of the elements that frame a group of men pandering for the local sex trade. The other side of the image is framed by a man looking at them. The power of the Gestalt principle of closure is evident in this photograph. Although a very small portion of the man is visible, it is obvious that he is male.

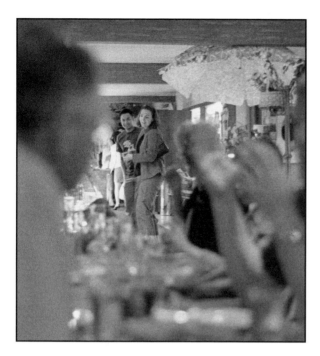

Small spaces can be bounded by dynamic frames that are created by objects that move limited distances. The framing elements in this image, although blurred, provide significant information about the setting and add a sense of ambiance. Although the arms on the right side of the image have a narrow range of movement, they indicate that the negative space varied substantially over time and help to create a dynamic feeling.

About the Genre

While static frames have been used to such an extent that photographers should be wary of creating clichés, using objects that are moving in different directions to frame the primary subject is far less common. Dynamic framing can be seen most often in street and sports photography, although it does not constitute a dominant style among any particular photographer. Lisette Model's *Running Legs* series, made during the early 1940s, is a good example of how dynamic framing can be used.

About the Exercise

This exercise involves the perception of negative spaces created by objects moving in substantially opposite directions. Negative spaces decrease as the objects approach each other and increase as they part. The trick is to become familiar with how the spaces change, depending on the direction and speed of the objects, and to judge the

best moment to frame the subject. This exercise can be a lot of fun, if done creatively.

Setting Up the Exercise

The best way to do this exercise is to find a location where a lot of activity is moving in different directions. Busy streets and sidewalks are a good choice. However, keep in mind that the objects do not necessarily have to be moving fast or even very far to convey the sense of dynamic motion. What is important is to find an interesting subject and frame it in a way that suggests it is in an environment filled with movement.

Technical Considerations

These kinds of images tend to work best when the primary subject is rendered sharply because viewers are more tolerant of the framing objects being blurred. If you are in a low-light situation or otherwise must make compromises regarding the point of focus, make the subject the first priority.

Exercise 18

Traffic

The observation and analysis of traffic patterns plays an important role in managing transportation systems. Many kinds of data are considered, ranging from vehicle counts, speed measurements, and accident reports. Speed limits are usually set by measuring the speeds of motorists and then setting the limit based on statistical analysis. For the most part, speed limits are set to facilitate the faster flow of traffic, rather than constrain vehicles to an arbitrary limit deemed to be safe. Traffic data are also used to determine what kinds of signs or signal devices are appropriate to reduce congestion and maximize safety. The collection of such data by remote sensing devices for analysis by computers has greatly enhanced the ability to time signals so they expedite traffic movement.

Traffic analysis also plays a significant role in enforcing traffic laws. For example, accident records can be analyzed to better allocate law enforcement resources to high-risk locations. Some cities use video or digital cameras mounted on traffic signals to record motorists who run red lights. This enables the collection of fines from violators without the need to maintain a police presence. Although this enforcement tool is constitutional, it tends to be extremely unpopular. Some cities have discontinued issuing fines based on evidence collected by imaging systems because of bitter public discontent.

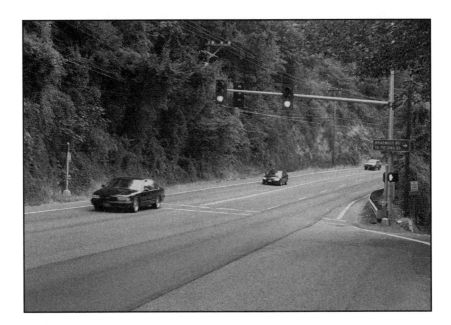

The easiest way to recognize and photograph automobiles that are following each other the same distance apart is to monitor the negative spaces between them.

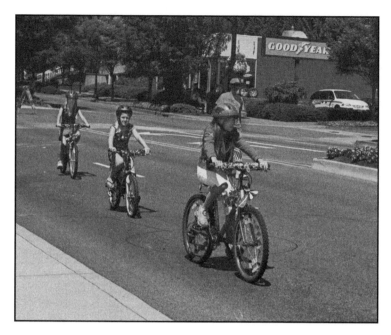

The exercise can be done with bicycles or any other means of transportation that moves on a street. Hills are good locations for doing the exercises because the slope adds a vertical dimension to the negative spaces and helps separate the positive shapes.

About the Genre

Since their earliest days, automobiles have been featured prominently in photography. Jacques Henri Lartigue's photographs of racing cars are among the most enduring action images from the first part of the twentieth century. Automobiles have also been used to depict major cultural and social changes. For example, photographers with the Farm Security Administration depicted cars and trucks in a variety of ways to show the plight of migrant workers during the Great Depression. In the more prosperous 1950s and '60s, photographers such as Robert Frank and Lee Friedlander photographed cars during road trips. Although the use of cars as cultural icons in images has faded a bit since then, their ubiquitous nature still keeps them appearing in photographs.

About the Exercise

This exercise uses the photography of traffic as a means to study the use of negative spaces in dynamic situations. The basic objective is to pho-

tograph vehicles such as cars, trucks, and bicycles in some sort of orderly arrangement by observing the spaces between them. Although vehicles tend to move quickly with respect to the static objects around them, the spaces between them change more slowly when vehicles are moving in the same direction. Spaces that stay the same size indicate that the vehicles are moving at the same speed. Spaces that shrink or expand indicate that the vehicles are moving at different speeds.

Setting Up the Exercise

The exercise requires that you take two kinds of photographs. The first consists of finding three or more vehicles that are traveling at the same distance apart and photograph them. This exercise requires a good vantage point and a little bit of patience to wait for the right grouping of vehicles to come along. Bridges, overpasses, and streets located on hills make good locations for observing such vehicles. Monitor the traffic by watching the negative spaces between the vehicles and

213

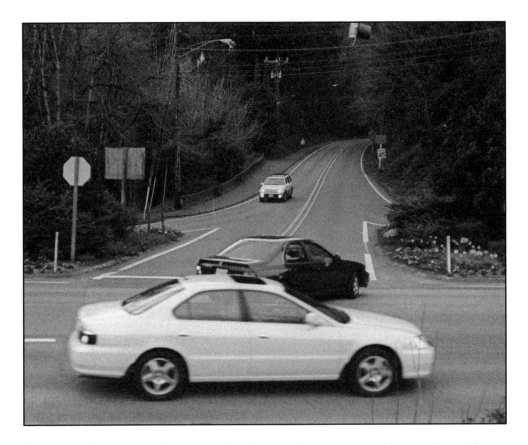

Converging vehicles can also be monitored by observing the negative spaces between them. The dynamic feel of this image comes from the cars moving in horizontal and vertical planes.

largely ignore the vehicles themselves. When doing this part of the exercise, note how the spaces change depending on the angle of the camera to the street or highway.

The second part of the exercise requires that you find a situation where some vehicles are overtaking others and photograph their convergences by monitoring the change in the negative space between them. Intersections, on-ramps, and the entrances to parking lots are good locations for doing this. Roadways that have mixed traffic such as cars and bicycles can be good, as well. If possible, try to obtain a few compositions that have a sense of dynamic tension.

Technical Considerations

Since you will need to freeze the action with fast shutter speeds while simultaneously maintaining a lot of depth of field, this can be a technically difficult exercise. Using fast film or a sensor setting will definitely be an advantage under these circumstances. If you have to make compromises between shutter speed and point of focus, consider whether you want or need to render all the elements sharply. In most cases, you will be better off rendering the slower vehicles sharply at the expense of the faster ones, because viewers generally tolerate fast objects being depicted with some degree of blurring or unsharpness.

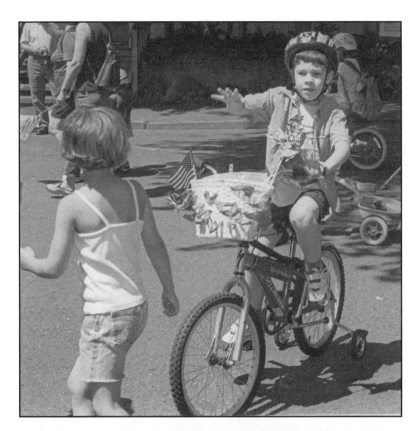

Many kinds of convergences occur in the midst of traffic, but ideally, you won't encounter convergences between traffic and pedestrians. The bicyclist in the top image was moving at a snail's pace, and the girl managed to avoid being hit. Even among mixed traffic, most visual convergences have much less at stake. Streets that have a lot of bicycle traffic can provide good opportunities for photographing convergences because of the different speeds and lanes of travel used by bicycles and motor vehicles.

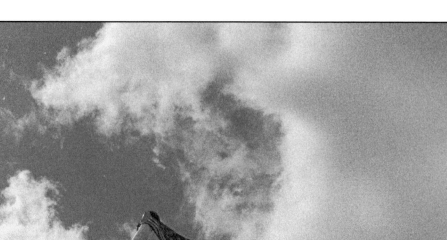

For a real challenge, try photographing a pair of flags in a breeze. Photographing flags in motion requires that you intensely concentrate on how the shapes change. Observing the motion over time will give you a sense of the range of shapes that occur under the circumstances and help you assess the likely shapes at any given moment.

Exercise 19

Flags

Flags are best known for their association with national identity and patriotism, but they also have a long history as a means of communication. The use of signal flags by ships is probably the best example of this. Throughout history, there have been many maritime flag protocols, but the current International Marine System became a standard in 1857. This system consists of forty-two flags that can be used alone or in combination to express different meanings. For example, the combination of the flags for Z and L means that the communicator has received a signal but does not understand it.

Navies developed extensive systems that relied on short coded phrases to communicate more complex messages that were relevant to directing fleet action. At the beginning of the nineteenth century, the British Royal Navy began using Popham's code, a means of communication in which sets of colored flags could be combined to represent 3,000 coded phrases. The most famous message sent with Popham's code was Lord Horatio Nelson's encouragement to the fleet before the Battle of Trafalgar during the Napoleonic Wars. The signal read: "England expects that every man will do his duty." It was made in a series of twelve successive hoists and took about four minutes to send.

Meanwhile, on land, the French developed the semaphore system, in which a series of telegraph towers were constructed beginning in 1792. Indicating signals by moving arms on a tower to various positions, they could send signals over a distance of 120 miles in less than ten minutes. The system, which remained in use until the electric telegraph became widely adopted during the

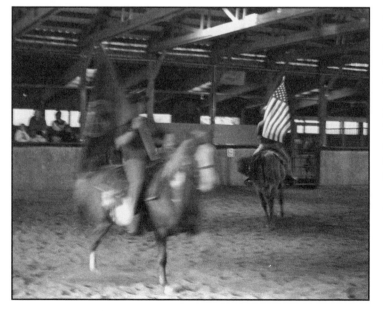

Depending on how they are supported, moving flags can produce a wide variety of shapes. A flag carried by a rider on a horse is subject to gravity, wind, and the jostling of the rider. In this image, the flag on the right is flopped over onto the rider's back instead of streaming backward. Although fast shutter speeds are generally recommended when photographing flags, the image was shot at 1/15 of a second at f/2 because of the dark interior of the arena.

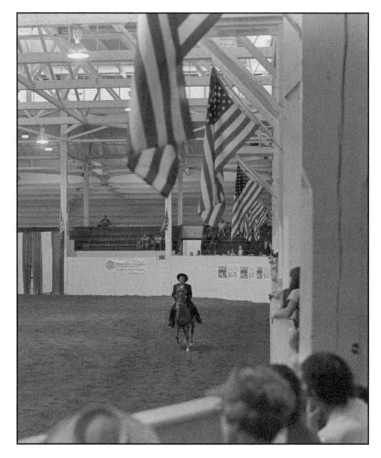

Part of the difficulty associated with photographing moving flags can be discerned by looking at stationary flags. Unless they are supported on a flat surface, flags do not form rigid shapes and are easily influenced by gravity and air movement. Note how the shapes of the flags in this image vary even though they are hung in the same facility at the same angle. When the effect of wind is added, both the range of motion and the rate at which flags change shape are affected.

1840s, was the precursor of the semaphore flag system that communicates based on waving a pair of flags in specific patterns.

Flags are also used to communicate in simpler ways. Waving a white flag is a universal signal for surrender, and originated independently in ancient China and Rome. In the United States, flying the national flag upside down is a sign of protest that many people find offensive. Although the U.S. Flag Code does not impose penalties against violators, it states that the flag should only be displayed in this manner as a signal of dire distress. Similarly, flying the national flag at half-staff is a well-recognized sign of mourning and respect.

About the Genre

Flags have often been depicted dramatically in art because of their cultural significance. Two notable examples are *Liberty Leading the People* by Eugene Delacroix and *George Washington Crossing the Delaware* by Emanuel Gottlieb Leutze. Photographers have depicted flags in many ways in different contexts. Joe Rosenthal's photograph of the second flag raising on Mount Suribachi at Iwo Jima is among the most memorable images of World War II. A lesser-known but very dramatic photograph of the first flag raising was taken by Lou Lowery earlier that morning. Another approach to photographing flags can be seen in Robert Frank's *The Americans*.

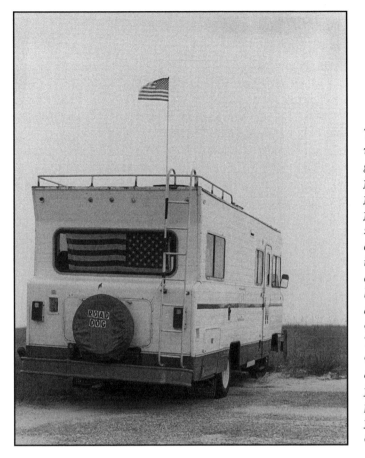

This motor home shows one flag in the rear window and another one blowing in a gust of wind. Although most of the upper flag forms a rectangle, the top corner is flapping over. The physics associated with flags blowing in the wind is complex and still not well understood. Even under conditions of constant wind velocity, small imperfections in the surface of a flag will create turbulence in the airflow. This turbulence will, in turn, cause the flag to deform slightly around the imperfection, which will cause even more turbulence. The amplification of turbulence produces waves that travel across the flag. As the airflow reaches the unattached edge of the flag, it sheds vortices which cause the air pressure to alternate on either side of the flag. The fluctuating air pressure is what causes the edge to flutter.

About the Exercise

Moving flags are difficult to photograph because their shapes constantly change in ways that are unpredictable. This exercise requires you to photograph a moving flag and depict it in a deliberately organized manner.

The key to performing the exercise is to intensely observe the shape of the flag as it moves. Some things to discern are the range of shapes made by the flag, the circumstances under which they occur, and the timing of the flag's movement with respect to the shapes. Because it is almost impossible to predict exactly how and when the shape of a moving flag will change, this exercise has elements of chance.

Setting Up the Exercise

The easiest setups to find are flagpoles with flags blowing in a strong breeze. In these situations, try to factor in the shape of the flag with other shapes in the image, such as buildings, trees, and clouds. You are not limited to flags attached to stationary poles. Flags are often carried during events such as parades and ceremonies.

Technical Considerations

You will usually want to use very fast shutter speeds when photographing moving flags. If the camera is directed upward, you may also want to use a lens hood to reduce the potential for flare caused by the sun.

Exercise 20

Athletics

The amount of exercise recommended to maintain health has varied substantially throughout history. At the beginning of the twentieth century, when strenuous sports were becoming popular, physicians became concerned that the strain put on hearts could cause them to give out. They also feared that the hearts of athletes would atrophy or become fatty when they stopped training. Nonetheless, many people brushed off the warnings about the dangers of "athlete's heart" and continued to engage in strenuous activities.

After a time, this medical wisdom took hold and more people began to refrain from hard exercise. In the late 1960s, a few medical advocates reversed this trend by asserting that the more you exercise, the healthier you become. According to the theories then in vogue, frequent and vigorous exercise would maintain a muscular and healthy heart and extend a person's life. Nonetheless, in a manner similar to the reactions to the earlier warnings about the dangers of excessive exercise, many people disregarded this advice.

Research done in the late 1980s indicated that moderate levels of exercise are sufficient to protect against early mortality. Currently, the dominant view is that even mild exercise is effective at maintaining health, and that the overall amount of exercise is what matters. According to this theory, frequent short bouts of activity are as effective as fewer extended ones. Whereas the former guidance maintained that people need to engage in twenty minutes of aerobic exercise at least three times per week, many experts now advocate that people work exercise into their normal activities by means such as walking up stairs instead of taking elevators. Although adopting this approach to exercise seems relatively easy, the Centers for Disease Control estimate that about sixty percent of Americans still get no regular exercise.

An effective approach to photographing athletic activities that involve groups is to monitor the spaces between people and make the decision to release the shutter based on the size and shapes of the spaces. In the image on the right, it would have been very difficult to monitor the participants, but it was relatively easy to monitor the spaces between them. The spaces formed between the participants of the three-legged race changed quickly in shape and size, but rarely exceeded two in number. Even when dealing with chaotic scenes, it is likely that you will obtain good isolation of the subjects if you release the shutter when spaces open up between the participants.

Monitoring negative spaces is a useful way to capture motion in images. The space formed by the legs of this Celtic dancer actually provides a better indication of *the action than the position of the legs themselves. The image on the right was made by watching the shape and releasing the shutter when it closed.*

About the Genre

Many of the best sports photographs make bold use of negative spaces. Try reviewing groups of photographs of sports such as tennis, football, basketball, and baseball, and separate the ones that appear the most dynamic from those that are less interesting. Analyze the negative spaces between the groups, giving particular attention to the spaces between the arms, legs, and bodies of the athletes. You will likely find that most of the highly dynamic images feature open spaces, whereas the less dynamic ones tend to show athletes as closed shapes.

About the Exercise

The purpose of this exercise is to gain experience at using negative spaces to photograph athletic activity in two ways. The first way is to photograph an athletic activity by monitoring the spaces between the participants with the objective of isolating the key subjects in images. The

second way is to monitor the change in the shape of the negative spaces between the appendages of an individual participant and use those to judge when to take the photographs.

Setting Up the Exercise

Select an event that features a lot of movement. Some suggestions are given in the moving ball exercise in chapter 4. The exercise does not have to involve a sport like football. Activities such as games, dance, and even cheerleading are good choices. If possible, find a location that has a good background and allows you to see the spaces associated with groups of participants as well as those of the individuals.

Technical Considerations

You will want to use fast shutter speeds to stop the action. Also, be sure to stand in a safe place and be careful not to set up tripods where they could injure participants.

7

Thinking Like an Artist

Photography, drawing, and painting all involve rendering three-dimensional scenes by placing pigment on a two-dimensional surface. As means of making images, each medium has its respective advantages and disadvantages. Photography is quicker and less vulnerable to subjective inaccuracies than drawing and painting. It is also the best medium for capturing the decisive moment when a dynamic composition comes together. Nonetheless, photography has a limited ability to isolate visual elements, and it is not always the best media for communicating complex visual information. For example, reference books such as *Gray's Anatomy* usually depict biological structures through drawings and paintings because photographs cannot show this kind of subject matter as clearly.

The general public tends to have a more exalted perception of drawing and painting as fine arts and relegates photography to a less esteemed status. Art is difficult to define partly because of the inherent ambiguity in classifying tangible objects according to an intangible concept and because everyone has his or her own opinions as to what constitutes art. Another reason why many people perceive photography as a lesser art is because they believe the ability to draw and paint is a gift but photography is a mostly mechanical craft that can be learned by anyone. The art education field has shown that both premises are false. By using the proper educational methods, almost anyone can learn to draw realistically in short order. Conversely, teaching people how to expose and develop film does nothing to advance their expressive skills.

Another factor to consider regarding photography's status as art is how the different media have influenced each other. Photography, particularly in its early days, was strongly influenced by painting. During the nineteenth century, it was fairly common for photographers to make images of models in settings that reenacted classical scenes. This kind of subject matter was popular with other artists of that period but has pretty much vanished as a theme in modern times. The desire to emulate painting was reflected in the pictorialism movement, in which photographers used lenses with severe optical aberrations to produce unfocused edges that diminished the appearance of realism.

Ironically, photography has exerted much more influence on painting than the converse. The development of the photorealism movement in painting was motivated by the desire to emulate photography. In addition to enhanced realism, painters who work from photographs often unintentionally incorporate limitations into their works, such as blown-out highlights and blocked shadows, in part because these features have become accepted as visual conventions. The realism associated with photography was likely instrumental to the development of Expressionist and abstract art by providing a comparison that emphasized the strengths and weaknesses of

One way that photography has influenced the other visual arts is that it has changed the conventions by which people interpret visual communication. The blurring created by moving objects photographed at slow shutter speeds has been adopted by artists working in other two-dimensional media as a means to depict movement.

painting. It was clear by the turn of the twentieth century that photography was a stronger medium for expressing the real and, conversely, that painting was much stronger at expressing the abstract.

Photography's status as fine art is accepted by the art community, and the medium has long been treated by museums and galleries as an established category. It has been my experience that most fine artists whose primary media are drawing or painting consider photography to be a fine art that has its own challenges. Contrary to the popular attitude that anyone can take a good picture, it is not unusual for artists with established reputations to acknowledge that they are not very good at photography, despite having studied it in art school or at the university level.

In fact, artists, connoisseurs, and art historians rarely debate whether photography is a fine art. Most of the controversy in the art world on the "what is art" issue revolves around three-dimensional works, such as the urinal that Marcel Duchamp discovered in a plumbing store and exhibited in 1917, or Piero Manzoni's ninety cans of excrement, which he labeled *merda d'artista* and distributed as a series. Although these works did not sell well at the time they were offered, they (or their replicas) have since been purchased by several prominent museums. Although these works and the high prices paid for their acquisition have been highly controversial, museums and collectors have justified their classification as fine art because of what they believed the artist was trying to communicate. For example, some of the various interpretations attributed to *merda d'artista* are that Manzoni was espousing the role of the artist in creating art, explaining the unity

Another contribution of photography to the visual arts is the general acceptance of "quirkiness" by the viewing public. Prior to photography capturing instantaneous events (such as the sign being framed by the window of the truck), most visual art eschewed such conjunctions as improbable, unrealistic, or contrived.

of art and life, or trying to expose the pretentiousness of the modern art market.

Regardless of one's personal opinions about whether photography is a fine art, understanding how it fits into the artistic process is useful to photographers because the basic processes of becoming proficient at photography are basically the same as those for the other two-dimensional media. Being able to see scenes and compose them into images is fundamental to all the visual arts. Likewise, being able to communicate the intended visual information is critical to the success of a work. The underlying purpose of the creation of a work can be important to the choice of subject matter and how it is expressed, but the starting and end points require the same mental processes. Irrespective of whether they intend to create a still life that will be offered for sale in a swank gallery or a medical illustration that will be offered as an exhibit in a jury trial, all artists face the same problem of perceiving the subject and deciding how to best communicate the desired message.

History for the Artist

The benefit of studying art on the grand scale is that you can see what others have done and develop a base of knowledge that you can draw upon when creating your own works. The history that is available to you, which dates back to Paleolithic times, can be thought of as a book that shows the many ways that visual art can be done. Like any book, there are many ways history can be read, but the best way for the creative artist is to use it as a travel guide that can help you decide where you want to go and how to get

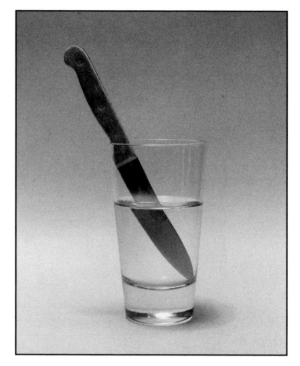

A good way to learn from the works of other artists is to approach a similar visual problem and compare your work to theirs. Knife in a Glass is a well-known painting by the American artist Richard Diebenkorn (1922–1993). The photograph on the left was an attempt to emulate the painting in the same way that Diebenkorn approached the problem, but was made a few days after viewing the painting. Several differences become readily apparent when the photograph is compared to the painting, such as Diebenkorn's choice of a vertically-sided glass, a knife whose blade extends above the rim of the glass, and a skewed angle at which the knife rests on the rim of the glass. The way that Diebenkorn achieved his elegant solution would have gone mostly unnoticed but for trying to solve the same problem and comparing the results.

there. Each work of art, like a traveler's journey, involves a mixture of something new for the artist with something old that has been experienced by others. By knowing what your predecessors have done, and how they did it, you will broaden a base of knowledge that will help you execute your concepts into the desired form. Furthermore, broadening your knowledge of art will help you develop a more distinctive style because assimilating the work of many artists will always provide a larger base of knowledge to draw from than becoming familiar with the conventions of only a few.

Because the history of visual communication goes back several millennia, you should not limit your reading and viewing to the works of other photographers. In many respects, visual communication can be looked at as a set of problems that can be solved in many different ways. What you want to do when viewing art is discern the problems that other artists have faced and how they

solved them. Even if your interests lie elsewhere, it is still important to look at fine art, because this is where most of the history of visual communication has been preserved. Much of the work that is presently considered fine art was originally created for other reasons, so it is useful to look at it from the perspective of why it was created.

When viewing other work, do not limit your evaluation to its appearance and composition. Likewise, do not get tied up in the technical analyses made by art historians, because much of what they have to say is conjecture based on academic perspectives that are irrelevant to the creation of art. To gain the most insight, you need to think about how the artist actually created the work. Specific things to consider are how the scene was constructed, what visual elements were before the artist, and how the chosen medium affected what the artist could and did do. In many cases, you will need to speculate a little because

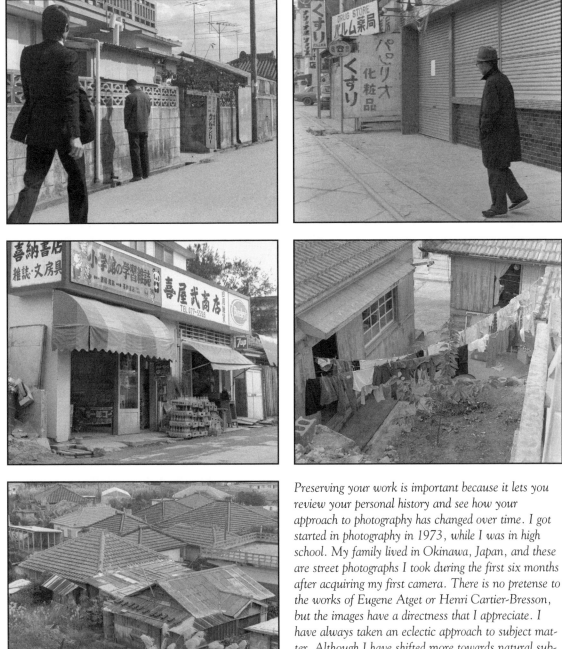

Preserving your work is important because it lets you review your personal history and see how your approach to photography has changed over time. I got started in photography in 1973, while I was in high school. My family lived in Okinawa, Japan, and these are street photographs I took during the first six months after acquiring my first camera. There is no pretense to the works of Eugene Atget or Henri Cartier-Bresson, but the images have a directness that I appreciate. I have always taken an eclectic approach to subject matter. Although I have shifted more towards natural subjects as I have gotten older, I still do street photography, and looking at these images made me realize that my current work has lost much of its documentary feel.

Working with other media, especially drawing, can really enhance your seeing abilities. This drawing of a cottonwood leaf was made about four weeks into a drawing course. Many people do not realize that drawing is reasonably easy to learn if properly taught.

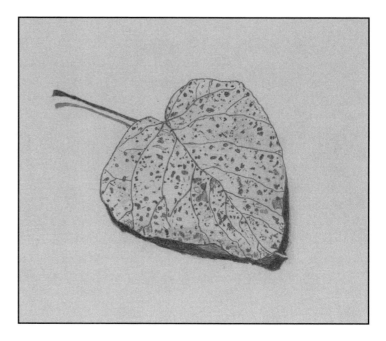

you won't know much, if anything, about the actual setting in which the work was created. However, this can also be a good thing, because the key to getting the most benefit from viewing art is to evaluate it with an active mind.

You can also benefit by reflecting on your personal history with art. Every now and then, it can be a great experience to sort your work chronologically and go through the good and the bad. In doing so, look at things such as your choice of subjects and the approaches you selected to render them. You may find that some material brings back a sense of nostalgia and other material leaves you feeling cold. You may even find some forgotten works that intrigue you. Try to discern how you feel about your previous work and how it might relate to your current and future work. Sometimes, positive feelings about early work can indicate that there is more you should do with that subject. However, such feelings can also indicate that you are ready to move into another area.

Work that no longer appeals to you can provide significant insight into what you want to do with photography. For example, work that is technically good and visually interesting may show you that the subject matter is unimportant to you. In such cases, you might want to reflect on what material will provide a more enduring sense of satisfaction. Conversely, works in which you find the subject compelling but the rendering unsatisfactory might cause you to reflect on how you might approach the subject differently. Keep in mind that introspection with regard to what you have done, why you did it, and the satisfaction you derived, will be time well spent.

The other aspect of personal history is the importance of saving your work. You do not have to save every negative, transparency, or file to maintain a history, but you should save a sufficient amount to enable looking back someday and assessing what you were doing well and poorly at that time. There is really no need to save images with obvious flaws, such as those that are

poorly exposed or blurred, but you shoud not discard every image merely because it doesn't currently appeal to you. You should also factor in the consideration of maintaining your personal history when choosing camera equipment. Print film, slide film, and digital all have their advantages and disadvantages when it comes to photography but have significant differences in the way they are retained. Negatives are usually stored as strips in plastic pages and, therefore, the entire roll is retained irrespective of the quality of individual frames. Slides are also commonly stored in plastic pages, but in their individual mounts. Most photographers edit their slides when they are returned from the laboratory and retain only a few of the frames from each roll. Digital images are kept in storage media, and retention practices vary significantly among photographers. A good history can be maintained with any of the available systems, but you should think about what will work best for you over the long run.

Work Ethic

While reading about photography and viewing art are valuable ways to improve your work, the only real way to become proficient is to get out into the world and start photographing it. Becoming proficient at any kind of visual art requires that you expend a lot of effort. Michelangelo once stated that if people knew how hard he had worked to master painting and sculpture, they would not think his skill was so wonderful. From the scientific perspective, the creation of visual art is neurologically complex, and the skill is developed over time by exercising the nervous system. Quantity of production is as important to the developing artist as mileage is to the long-distance runner. What is important is to ensure that the production is of sufficient intensity and quality to strengthen the biological systems through which you create art.

Experimenting with other media can also help your photography. Drawing is the most fundamental of the visual arts and a potent way to develop seeing and compositional skills. With the exception of photographers, most visual artists begin their educational process by learning to draw. Few, if any, accomplished artists have ever claimed that the time spent learning to draw was unproductive or irrelevant with regard to their future work. There is nothing particularly mysterious about learning to draw, although many people seem to think there is. It can be learned by almost anyone in much the same manner that most people learn to write the alphabet. Photographers who are willing to devote the time and effort to learning fundamental drawing skills will likely find that it is the single best way to improve their photography. A good way to do this is to obtain a basic drawing book that takes an exercise-based approach, such as *Drawing on the Right Side of the Brain* by Betty Edwards. An even better way would be to enroll in a course that uses an exercise-based approach to teach drawing, because of the structure and feedback that will be provided. Such courses are commonly offered by community colleges and community centers.

Knowing Your Goals

It is important to have goals in your photography, although I am not convinced that it is necessary to articulate them verbally. Visual thinking is different than verbal thinking. Even when unarticulated it can be clear and definite. This means that you can understand what concepts you want to express even if you have trouble explaining what they are and why you want to express them. Part of the difficulty lies in the difference between receptive and expressive skills. Receptive skills are important because they determine your ability to perceive your environment and understand at the intuitive level what it means to you. Such

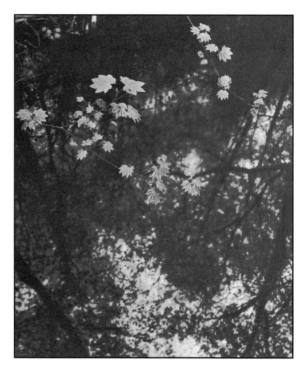

Photography excels when it comes to presenting objective visual information, but it can also be used to suggest the abstract and surreal. This photograph shows the leaves of a vine maple (Acer circinatum) suspended above the slow-moving portion of a stream which is reflecting the surrounding big-leaf maples (Acer macrophyllum). Much abstract photography is done by framing objects closely and isolating them from the visual cues that would otherwise enable them to be readily identified. Although this approach can be effective, it is much more limited than what can be achieved with other media such as painting. Photography has never been capable of the full range of abstract expression such as that achieved by Wassily Kandinsky or even the Expressionist content of artists such as Franz Marc. Understanding the capabilities and limitations of individual media can help you discern how you want to use photography as a means of creative expression.

skills are relevant to your artistic goals because they influence your choices for recording the environment. Expressive skills are just as important to visual communication because they govern how you record what you have perceived. However, unless your goals encompass the desire to perceive, your ability to express yourself will likely suffer.

Because it makes sense that you can know why you are producing something without being able to describe why, you should not feel bad if you cannot articulate your reasons, so long as you know at the intuitive level that you want to create a particular image. Most visual artists are motivated by mental processes that maintain a firm intuitive connection with their surroundings. Likewise, the works that best succeed at registering with viewers do so at the intuitive level.

If you want to express reasoned principles in terms of specific concepts, words are generally a more effective means of doing so. Images excel when you want people to intuitively understand the essence of what is being communicated (i.e., what is being shown). Trying to express highly articulated concepts through visual means does not work as well as the written word because images are directed to the viewer's intuitive feelings. For example, the pastoral works of Jean-François Millet and Vincent van Gogh have had a much deeper resonance with the viewing public than similar works done by the Soviet realist painters, even though their messages are much more subtle when expressed in words.

A good example of articulation gone awry can be found in many of the artist's statements found at formal exhibitions. These statements are placed on the walls at exhibits and are supposed to describe the concerns that the artist deems relevant to the exhibited works, as well as to set the tone of the overall collection. These statements

A major strength of photography with respect to other visual arts is its ability to capture events that happen so quickly that they defy complete comprehension. In some respects, images such as a bolt of lightning frozen in time can be considered an abstracted form of realism because they communicate information that is beyond the tangible experience of the viewer.

are not inherently bad and sometimes provide interesting and useful information. However, the bad ones inadvertently reflect on the incongruity of having to express visual thoughts through a means that is poorly suited for saying what the artist wants to show. It is fairly common to see exhibitions with excellent visual work that are accompanied by artist's statements, which contain a few flowery paragraphs in which the artist expresses supposedly profound thoughts in lofty sentences (that may or may not cause you to weep with the elixir of soul-nurturing mortality). At the gut level, the work at these kinds of exhibits is often quite impressive and registers positively with the viewers. Unfortunately, the value of the prose is frequently worth little more than the nuggets in a can of *merda d'artista*. If you ever have to prepare an artist's statement, they are best written objectively and succinctly, and without pompous verbs and flowery adjectives.

The Artist's Vision

I am somewhat uncomfortable with the phrase "artist's vision" because it implies that artists must necessarily have some predetermined concepts that drive their work. Undoubtedly, there are artists who make art as a means of explicitly commenting on specific aspects of life, but I suspect that most of the great ones simply had a desire to either show others what they have seen or else create scenes that would not otherwise exist.

Photography is particularly suited for depicting what you have seen because it renders whatever is in front of the lens. Nonetheless, artists working in the other media have been the ones who have established the basic approaches to expressing the world and its environments. Realistic art is important because it connects people to where they and other people exist. However, art is also a powerful means of visually expressing things and events that have never happened.

Photography is a feasible way to record a broad range of experiences. Artists in other media must be selective about their subjects because their works typically require several hours, or even weeks, to create. While making images of children bowling might not be considered a worthwhile priority if you were limited to creating a few works each year, productivity is not a constraint when you can make dozens of images in short order.

Most people understand that Venus is a mythical goddess who was not really born in the sea and driven to shore by wind deities. Nonetheless, Sandro Botticelli's *Birth of Venus* makes you envision that it happened. While depicting fictional stories has never been a fundamental strength of still photography (in contrast with cinephotography), it has been effective as a way to make Expressionist art such as the surrealist photographs created by Jerry Uelsmann.

With respect to type of vision, you may find it useful to determine whether you want to record the world as you see it or to create new worlds that would not exist but for your efforts. Both are valid ways to use photography but tend to have very different effects on viewers. Making a record of what exists can help people visually relate to things they would otherwise never experience in that way. By showing people the world in other ways, you can enrich their appreciation of what the world is like. Conversely, making images that show an altered reality enriches people by showing them something that goes beyond the world as it really exists. There is really no reason why you cannot do both if you want, but most pho-

tographers seem predisposed to do one or the other. By ascertaining your preference, you can then channel your energies in directions that are more likely to result in personal satisfaction.

Another aspect of artistic vision is visualizing how the final work will appear. Some critics and photographers maintain that every image should result from an articulated concept and be visualized to the extent that the photographer comprehends how the final image will appear before the shutter is released. Most honest photographers will admit that their best images sometimes result from luck and that they are never completely sure how an image will look when they release the shutter (some are honest about this only when speaking in an unguarded moment). Likewise, honest painters will freely concede that they cannot precisely visualize how the finished painting will look as they begin working on the blank canvas before them. They may have a general idea but it is pretty much the same situation that a photographer faces when looking through the viewfinder. Despite having a sense of what they want to convey. they have to wait until the work is finished to know for sure.

Although urban and natural settings are very different, the basic skills of perception and composition can be applied equally to both. Most people have several areas of interest in their lives, and it is entirely appropriate to explore them through photography. Many of the historically-recognized photographers have been highly proficient in multiple genres.

The final and perhaps most important aspect of personal vision is ethics. It is not my place to tell you what your ethic should be, but based on experience, I strongly encourage that you give the issue some thought. Photographs can record things that are best forgotten, cause people pain, and be a means of unscrupulous exploitation. They can also be repositories of important memories, give people hope, and be a means of motivating people to change their behavior for the better. Because photographs can affect individuals, and even societies, photographers should try to understand the ethical issues associated with taking photographs.

If you do not take the time to articulate your personal ethic, you run the risk of having no ethics when faced with an unexpected situation. One question to ask is whether your photography is done solely for private expression or to show others what you want them to see. Like it or not, people will judge your character based on what you photograph and how you use the images. Therefore, you need to determine how you feel about how other people will perceive you and factor these feelings into your photography. Ethics necessarily involves choices, and choices mean setting limits. Knowing the boundaries to what you will photograph is thus an important part of determining your personal ethics.

Creative motivation, with or without pretense, is what drives most people who are serious about their photography. The widespread proliferation of photography as a means of recording personal memories, reporting the news, and expressing popular culture is a testament to its value and effectiveness. As a prominent form of the popular media, it is easy to lose sight of the fact that photography is a visual art that shares a history that goes back far beyond the daguerreotypes, calotypes, and cyanotypes of the nineteenth century. It is also easy to overlook that photography can be learned in ways that are analogous to learning the other visual arts. Most photographers, irrespective of their reasons for practicing the art, will benefit greatly by viewing photography in its larger perspective. The collective human experience of several millennia of creating and displaying art show the value of careful observation, extensive practice, and unavoidable hard work.

Index